MERVYN PEAKE

MERVYN PEAKE

a biographical and critical exploration

JOHN BATCHELOR

Duckworth

FOR MY PARENTS AND PEGGY

First published in 1974 by
Gerald Duckworth & Company Limited,
The Old Piano Factory,
43 Gloucester Crescent, London NW1

© 1974 by John Batchelor

ISBN 0 7156 0679 4

Printed by Bristol Typesetting Co. Ltd.
Barton Manor, St. Philips, Bristol

CONTENTS

ACKNOWLEDGMENTS

I would like to thank Mr and Mrs E. L. Peake for extensive help throughout and for permission to quote from the 'Memoir of a Doctor in China' by E. C. Peake; also Miss Laura Beckingsale and M. McIver, for permission to quote from recorded interviews; Miss Kay Fuller, Tom Pocock, and Kenneth Williams, for permission to quote from letters to the author; Quentin Crisp, for permission to quote from *The Naked Civil Servant*; Faber and Faber Ltd. (for the late Maurice Collis) for permission to quote from *The Journey Up*; Esmond Knight, for permission to reproduce Mervyn Peake's drawing of a hand as the cover to this book.

I would like to acknowledge the generous help of all those named above, and also of the following: William Evans, Dr Gordon Smith, The Dean of Guildford and Mrs Bridge, Morris Kestelman, Mrs John Brophy, Mrs Joan Jolly, The Headmaster of Eltham College, Mr and Mrs Fabian Peake, Leslie Sklaroff, Lord Clark, Lord Olivier, Graham Greene, N. Asherson, Miss Mary Audsley, John Waterhouse, John Morris, James Webb, Dr and Mrs Hubert Pearson, and the staff of the Imperial War Museum and the National Book League.

<div align="right">J. B.</div>

PART ONE: LIFE

1 The Education of an Artist, 1911-33

To be born into an ancient and alien civilisation at the most turbulent point in its history must, in the nature of things, be rare among British middle-class children, but in the last great days of the Empire before the First World War it was still relatively unremarkable. Yet for Mervyn Peake, to have been born in China on 9 July 1911, the year of the ending of three thousand years of dynastic autocracy and the founding of the Chinese Republic by Dr Sun Yat-Sen, had a lasting and formative effect on his creative imagination and his work as writer and artist.

His father, Ernest Cromwell Peake, was a Congregationalist medical missionary in the province of Hupeh in central China. In 1898 Ernest Peake had qualified in medicine at Edinburgh University and sought adventurous and useful work which would take him abroad for a few years after graduation. Since the early nineteenth century Protestant missions had been well established in southern China and had been pushing steadily into the interior, taking with them not only a profound evangelical fervour but also educational, agricultural and medical improvements which had a profound impact on the Chinese way of life. In a sense these missionaries can be seen as fifth columnists who helped to adapt Chinese attitudes to the incursion of European traders who had set up their stations at the so-called 'Treaty Ports' of Shanghai, Tientsin, and Hankow in central China.

Ernest Peake was sent to China in 1899 by the London Missionary Society with the object of establishing a new medical mission of the Society in the closed province of Hunan, to the west of Hankow, and in an unpublished record of his journey to China he expresses the excitement felt by a young Briton at his first encounter with an archaic and frozen civilisation. He describes the momentary horror that he felt in Shanghai as the ancient city closed in on him with its incongruous blend of splendour and filth. The strange grace of the 'unfamiliar roofscape, shimmering in the morning light', and the children's

kites, 'replicas of birds, fish, dragons, crocodiles', mixes uneasily with the tumultuous throng within the city:

> The constricted thoroughfares were crowded, and thick with a peculiar odour compounded of spices and stale sweat. Every now and again the shouting of soldiers heralded the approach of a richly caparisoned sedan chair, carried high on the shoulders of four coolies, and bearing some official personage; usually of great corpulence, and resplendent in his mandarin hat and robes.
>
> (E. C. Peake, 'Memoir of a Doctor in China'. Unpublished)

The young late-Victorian found here the romance and glamour of the medieval world, and although the filth and the backwardness made uphill work for him, he recognised that it was the backwardness of an ancient civilisation with its own grace and its own values, which believes that it has no more to learn. He describes it as 'paralysed under the spell of the past', reading Confucius and Mencius, worshipping its ancestors, sipping tea, collecting water in buckets from an evil-smelling river and designing beautiful coffins for its dead.

'Doc' Peake, as his sons were later to call him, gives a vivid account of his struggle to set up his hospital and to persuade the people to accept Western medicine. This was made easier by an operation for cataract; with the help of his young Welsh wife and Chinese trainees as assistants, Doc Peake performed the operation, knowing very well that if it failed he would forfeit all credibility with the Chinese. The success of the operation ensured the success of his hospital, but brought another problem: a long procession of Chinese, with many forms of blindness, who came to be cured. On the further cataract cases he was able to operate, but the others left his clinic feeling that they had somehow offended the doctor by failing to observe the correct etiquette towards him.

Doc Peake married in 1903; his eldest child, Leslie, was born in 1906, a still-born daughter came next, and the third child, Mervyn, was born just before the uprising of southern China against the Manchurian dynasty and the north in 1911. The family had been in the hill-station of Kuling, a favourite holiday resort for the European community, when the outbreak began. Doc Peake moved his wife and baby to Hankow, Mervyn

then being two months old (the elder son was at school in Chefoo), and waited with other members of the British community at the British Concession to hear what the London Mission and the British Consul would recommend. When the fighting between the northern and southern forces approached Hankow, the women and children left by steamer and went down river to the relative security of Shanghai. In October 1911, the British Consul ordered the last of the women to leave for Shanghai, and thereafter for four months the European community of Hankow lived in perpetual expectation of a siege.*

The coming of the revolution was the end of the Peakes' hospital in central China. In 1912 they were appointed by the Mission to a practice in Tientsin, a relatively Westernised Treaty Port south-east of Peking where there were well-established European traditions and a large European community with its own schools and facilities. From the age of one to the age of eleven Tientsin was Mervyn Peake's home: every summer he and his parents travelled south to Kuling away from the heat of the plains, and when he was old enough he went daily on a donkey to Tientsin Grammar School, an English school in the British Concession. The porter at the gate wore a broad coolie's hat which young Mervyn would knock off as he rode by.

Mervyn's health was considered delicate, so he was kept close to his parents and sent to this local school while his elder brother went to a larger boys' school at Chefoo, on the Shantung peninsula south-east of Peking.

By the time he was seven Mervyn Peake was a gifted and observant child:

> Mervyn simply drew, all the time. He hardly ever looked up from the table. A most extraordinary little boy. And then his mother wanted to clear the table . . . and he was most indignant, when he had to take all these scraps of paper on which he was drawing and take them off. And the moment tea was over he was back there again with them. It was difficult to get him to go to bed simply because he stuck to this drawing; and that was the first time I knew . . . of this terrific interest.
>
> (Interview with Miss Beckingsale)

*Miss Laura Beckingsale, a teaching missionary and friend of the Peakes, recalls the siege (interview).

The parents of this gifted child were themselves rather striking people. Dr Peake was tall, good-looking, and had a reputation for absent-mindedness; he also had great energy and capacity for work, and a perceptiveness and sensitivity of his own. He made water-colour sketches of his hospital, of Wu-Chang, and of Kuling, and he wrote a remarkable medical diary of the tropical diseases with which he came into contact as well as notes for the vivid and colourful Memoir which he was to write in his old age. His wife was Welsh, with very deep dark eyes and a beautiful singing voice, a woman who created an impression of warmth and affection for all whom she met. She was also a person of great courage, staying with her husband and working with him through-out the early years of Sun Yat-Sen's Republic. She had lost a daughter and her second son was delicate; many women would have felt that the life was too precarious altogether, and caught a boat for England to await their husbands there, but Mrs Peake clearly enjoyed the work, knew she was good at it, and was upheld by the real religious conviction which she shared with her husband.

For a sensitive and perceptive child China offered a wealth of stimuli. There was beautiful Kuling, four thousand feet high, with spectacular mountain scenery on every side. Streams rushed down over the boulders from these mountains, and lilies – arum, tiger and Madonna – grew shoulder-high up the sides of the smaller hills. There were picnic parties with children of other missionaries and businessmen, bathing parties in the pools and under the waterfalls, magical holidays away from the heat and the dust. There were the temples and pagodas of old China, and the fortress-like quality of the old cities. Every city of antiquity was walled, and round these walls clustered lean-to shacks, put up as dwellings or shops and using the city wall as the one draught-proof and solid support. There were the Chinese themselves, with their courtesy and splendidly colourful costumes, and the appall-ing but picturesque squalor in which most of them lived. There were the proud traditions such as the tradition of jade-carving, in which the artist would choose his piece of jade and put it in a place of honour in his house, where he could see it, and watch it each day. Sometimes he would wait months until the jade 'told him' what it wanted to be, and only then would he presume to touch it and release the imprisoned figure within. Clearly the

'Dwellers outside the walls' of the Titus books, who are also the Bright Carvers, owe something to these aspects of China, embedded in Peake's imagination.

His childhood in China was thus divided between two separate ways of life which made up a whole in his mind. The English colonial life-style lived by his parents, with his father's water-colours and his mother's music and tea-parties, and the prim little school in Tientsin, made up one side of the picture; and the other was composed of the mysterious but familiar side of the life of the Chinese which surrounded them. This too, the abrupt and unexplained relationship between the commonplace and the extraordinary, becomes a feature of his mature art.

In 1922, at the age of eleven, Mervyn Peake travelled back to England with his parents, who had retired from the missionary service. His father went to a practice in Wallington, Surrey, and they lived in a roomy Victorian house which was to be Mervyn Peake's home for twenty-five years of his life. Built in the Gothic style and called 'Woodcroft', this house perpetuates, in a way, the contrasts of his earlier childhood; it was a solid upper-middle-class home, large, comfortable and conventional with extensive gardens and a tennis-court, but his parents had filled it with Chinese objects, so that the Chinese influence was one that he continued to live with.

He was sent to school at Eltham College in south London, a school for the sons of missionaries where his brother had already been a pupil, and there Mervyn Peake's talent became obvious and his leading interests were established. Mr McIver, the new art master at Eltham College in 1923, recalls the day on which he took up his new appointment at the school.

Mervyn Peake was then a boy aged twelve . . . the first day I was in the school. You don't know what to do with kids on the first day of the new year, so I dished out some drawing paper and told them to do what they liked. Mervyn Peake did a drawing of a stable with a horse in it which was absolutely brilliant, and I thought if that is the standard of art at Eltham College they don't need me here.

(Interview with Mr McIver)

At school he was lucky to find an atmosphere in which he was

encouraged to pursue his obvious enthusiasms, and not pressed and upbraided for his neglect of his formal studies. He spent much of his life at school in the art room with Mr McIver, and was also a favourite pupil of the gifted English master, Eric Drake, who taught at the school between 1923 and 1927. Eric Drake taught Mervyn Peake to develop his individuality and imagination, and gave this endlessly creative child very congenial work which was in many ways a training for his later work as a writer of fantastic novels. He and another boy worked together on a large ambitious project called 'The Ilond Story'; the inhabitants of this 'Ilond' (which was isolated and tropical) were pirates, Indians and fabulous beasts, and the writing and illustrating of it during English lessons and in the art room occupied Peake for a year or more. It seems to have been a remarkably enlightened approach to education.

The books which Peake read between eleven and sixteen or so were to capture his imagination for a life-time. The most important of these was Stevenson's *Treasure Island*, which stimulated the theme of 'The Ilond Story' and which Peake memorised word for word and loved all his life. In his fourteenth and fifteenth year, while still working on 'The Ilond Story', he drew a series of illustrations to *Treasure Island*; orthodox, conservative drawings, quite unlike his well-known illustrations published in 1949, but already showing a precocious facility and a capacity for assimilating any style of draftsmanship. His reading at this time also included Dickens, Kipling's *Kim* and *Barrack-Room Ballads*, and Scott, for whom he never developed a taste. (Later in his life Peake was to defend his dislike of Scott by saying that his Welsh blood on his mother's side rebelled against the Scottish influence.)

In Peake's later years at Eltham he began to come up against difficulties. His neglect of his formal education became more noticeable when he was seventeen than it had been when he was twelve; his most sympathetic teacher, Eric Drake, left the teaching staff, and a change of Headmasters at the same time brought a brisker and more demanding climate into the life of the school. In many ways Peake was a model schoolboy: he was an excellent Rugby player, a constant attender at the Congregational Church to which many of the boys went, a school prefect. Yet as it became obvious that he would not pass his School Certificate and did not

wish to work for it, criticism of him began to develop among the masters.

> Once at a staff meeting we'd all been discussing Peake's failure to work, and the Headmaster said: 'If that is so he'd better leave'. No question of his being 'chucked out', but he just wasn't working. And I remember I said, 'Well, you may be turning out one of our greatest future Old Boys'. And the Headmaster turned to me and he said, 'Well, if Mr McIver feels that, we'd better take a chance and keep him on another year'.
>
> (Interview with Mr McIver)

The young Peake undoubtedly had a wayward streak, and a technique of adapting circumstances to his own temperament which enabled him to survive while conforming to a minimum of the school's requirements. He won all the prizes going for art but showed no formal capacity in any other subject, not even in English. Mr McIver recalls:

> I said to him, 'It was rather odd you failing an English exam', considering that he had later won the Heinemann prize and so forth, and I remember him saying, 'Well, of course that was just an examination in spelling' . . . which he could never do.
>
> (Interview with Mr McIver)

Doc Peake and his wife both had ambitions for their two sons to become doctors, but the children from early childhood showed clear preferences for other things, Leslie for mathematics and Mervyn for draftsmanship. When Mervyn was sixteen they invited Mr McIver to lunch in Wallington to discuss Mervyn's future, though by that time it was clear to all three of them that Mervyn had decided it for himself; he intended to be an artist.

He left Eltham College in the spring of 1929 to go to Croydon College of Art, but stayed there only one term. In the autumn of 1929 he was provisionally admitted to the Royal Academy Schools, and after passing a preliminary test on 17 December of that year he was awarded a studentship at the Schools to proceed to the Diploma.

When Mervyn Peake arrived at the Royal Academy Schools at

the age of eighteen in the autumn of 1929 he was already a serious artist, and much more mature in matters to do with painting than many of his contemporaries. A friend and fellow art student, Mrs Joan Jolly, recalls that in his first year other students were seeking him out for advice about their work, and that he had a surprising range and depth of knowledge of painters and their work, particularly, at that time, Renaissance and Flemish painters. He would march his friends round the National and the Tate Galleries, and would discourse at length on each painting that interested him: the composition and the colouring, and the mind of the painter.

Mervyn Peake passed his annual examinations at the Royal Academy Schools in 1930, 1931 and 1932, which suggests that during those three years he was following the formal academic course with interest as well as pursuing his own creative work. At the end of his second year at the Royal Academy, 1931, he exhibited a painting at the Summer Exhibition: the work was a formal study of a cactus, and was the first and last work of his to be shown at the Royal Academy. Most of his creative work was done on his own: he developed a *boulevardier*'s habit of working in cafés. He would go with friends to a coffee shop in Gerrard Street, Soho, which was very much a haunt of artists, designers and theatrical people, or to the Café Royal, which was to remain a favourite place all his life. He would sketch on anything that came to hand – a book, a magazine, an envelope, the account book – and sketch the other customers, or, as often, would invent figures from his imagination.

This sketching, which was later to become part of a projected book called 'Head-Hunting in London' (which was never published) was Peake's first love and most prolific talent at this time; but he was also writing a good deal of poetry, and still keeping up the sports that he had excelled in at Eltham College. He went back to play Rugby for the Old Boys' XV (which demonstrates how fond of the school he remained) and throughout this period he continued to live at home with his parents in Wallington, so that his student days did not mean, as they do for many students, a sudden break with the past.

He experimented somewhat with his appearance at this time, as students tend to do, veering from the Bohemian to the formal. When he first arrived at the RA Schools he was a flamboyant

figure in a bright blue shirt, flowing neck-tie and matador hat. Then for the whole of one summer term he dressed with city formality in a morning-coat and bowler hat, which only the hot weather and the persistent mockery of his friends persuaded him finally to discard.

Despite his enthusiasm for his formal studies and the hard work that he put into them, Mervyn Peake was also caught up by the new revolutionary fervour which existed among students inspired by Braque, Klee, Picasso, and the Post-Impressionists. Another close friend of this period was William Evans, the portrait painter, who at that time was very much an intellectual rebel in matters of painting – more so than Peake – and who stayed at the Academy Schools for only a year. Bill Evans lived in Chelsea, and he would accompany Peake on his walks round London, his trips to Lyons Corner House, the Café Royal, and other haunts. He encouraged Peake to do his own work, to strike out on his own, to have confidence in his individualism. The pattern of life was one of formal work at the RA, creative work in the streets and cafés of the West End, and endless discussion of art and life over cups of coffee in Soho: but still Mervyn Peake was very much a private person, always going home in the evenings to the house in Wallington, with its blend of Edwardian orthodoxy and Chinese mystery.

The teaching at the Academy at this time was provided by a strong body of established artists including Shannon, Ricketts (who died in 1931) and Brockhurst, under the distinguished Keeper, Sir Walter Russell. The teaching tended to be traditional and formal, and the students learnt more from each other than from their seniors: among the students at the RA at this time were Leslie Hurry, the stage designer, Peter Scott, Kenneth Crook, and later Anthony Bridge, now Dean of Guildford, and his future wife Brenda Streatfeild.

By 1932 Peake's earlier group of friends had left the RA schools and he himself must have been feeling at this time that the RA could teach him no more. He was by now a very skilled painter and an almost unmatched draftsman, greatly admired by his contemporaries for his extraordinary facility. A scheme which was said to have originated with Lawrence Durrell was put about to the effect that Peake and others should go to Corfu and there found a colony of artists. This scheme came to nothing, but

probably the idea of an art colony on an island germinated in Peake's mind.

His love of *Treasure Island*, his own 'Ilond Story' and now the invitation to go to Corfu: these island-centred dreams were fed further at this time by a work called 'The Dusky Birren' on which Peake was collaborating at intervals with another old school friend, Dr Gordon Smith. They exchanged ideas by post and met whenever Gordon Smith was in London. 'The Dusky Birren' was a dramatic work, also known at different times as 'The Three Principalities Soz, Foon and Chee'; within it is embodied the idea of an enclosed and magical world, isolated from contemporary life. Peake's drawings for it lean heavily on the Chinese decoration he had seen as a small child.

Mervyn Peake and Gordon Smith went on holiday together to Sark, in the Channel Islands, in the summer of 1931 or 1932, and Peake's appetite for islands was further whetted by this visit. Eric Drake, who had taught Peake English at Eltham College, was living on Sark. His American wife, Lisel, had helped him to found an art gallery on the island, and he proposed to Mervyn and his friends, Tony Bridge and Brenda Streatfeild, that they should go to the gallery and live and work there during their summer vacations from the RA Schools, as a way of increasing their range and maturity as artists. All three readily accepted.

The RA Schools encouraged their students to spend the long summer vacations on projects, and the original proposal was that Mervyn should go to Sark for the summers only while continuing with his course, but in the summer of 1933 he failed his examinations and the RA Schools terminated his studentship. With this his links with the Schools were severed, and he went to Sark in the summer of 1933 and lived there more or less permanently for two years.

2 Artist and Soldier, 1933-46

The Sark gallery was in effect a private gallery owned and financed by the Drakes with the object of creating an art centre comparable with, and more interesting than, a place like St Ives. The gallery itself was completed in 1933, in the second year of the experiment: it was a plain, *avant-garde*, attractive structure built partly by local labour and partly by the artists themselves, and was in course of construction when Peake and his friends arrived on the island.

Tony Bridge recalls that when he and his future wife first met Peake he seemed immensely glamorous to them. He was four years older than they and had already been at the Royal Academy Schools for some years; he was astonishingly good-looking, very talented, and seemed to them already an established figure in the world of painting. While Peake lived on the island as a permanent resident after leaving the RA Schools, Tony Bridge and Brenda Streatfeild continued as students at the Schools and went to Sark each year for the summer by a special arrangement between Eric Drake and Sir Walter Russell, who felt that the experience would be good for them.

From Wallington to Sark must have been a sharp transition for Mervyn Peake. It was the first time he had been away from his parents for any length of time (other than boarding-school), and certainly his first period of complete freedom. He was living in contact with a group of young people whom he greatly liked in an isolated place of complete peace which lived by its own rules: a small, close-knit, exclusive situation, like those which characterise his novels. He never had a great many friends and was shy with other men while elaborately courteous with women: he was not naturally gregarious and hardly ever a drinker or pub-goer (which was perhaps an inheritance from his Congregationalist upbringing). With his parents and brother in China he had lived apart from society other than that of the Chinese, and in the large house in Wallington and now with this group of friends on Sark the apartness and privateness of his life continued: in this sense the move from Wallington to Sark was not a break but a natural progression. The sense of a closed world, a secret society,

and a private, independent group of free people, is an essential feature of his life which is clearly reflected in all the characteristic preferences of his work: the pirates and isolated islands of *Treasure Island* and *Captain Slaughterboard*, the close-knit Groan family in the Titus books and the small group of the 'saved' (on Sark itself) in *Mr Pye*.

The Sark experiment was a tearaway period in Peake's life, and in this respect the change from Wallington was great indeed. With the absence of supervision went a shedding of inhibitions, and Peake and his young friends found themselves living in an Eden in which they enjoyed an innocent and Utopian hedonism.

In the winters on Sark when his young friends had returned to London and he was living there alone he had the island completely to himself and, as far as the artists' colony was concerned, his isolation became total. As in his childhood when he had ridden to school as an alien princeling among the Chinese, so here as an exotic outlaw among the Sarkese, Mervyn Peake clung to his solitude and practised his art.

Eric and Lisel Drake provided money for both the gallery and the artists, and the whole venture was really created and sustained by them. In reality the students were their guests, but Eric Drake organised things so that they could feel that they were independent artists employed by the gallery to work both as painters and as labourers: they were paid an hourly rate to garden, to work on his house and to build the gallery itself. During his first winter on the island Mervyn Peake lived in a cottage adjoining the half-built gallery, and thereafter he lived in a room in the gallery itself with no companions other than a couple who were employed as cook and caretaker there. Sometimes during the winter he worked on the building, earning ten pence an hour from the Drakes for this, and the rest of the time he painted, talked to the fishermen, and absorbed and reproduced in his work the landscape of Sark.

The gallery was completed by the end of 1933 and opened by the Dame of Sark. It was due to be opened for the summer season of that year but by the end of August it was still incomplete and Eric Drake was apologising to the Dame for the fact that the ceiling and staircase would be 'completely innocent of their decent clothing' at the opening. The Dame of Sark and her husband were friendly towards the Drakes and their colourful collection of

young people, and the Dame not only opened the gallery but arranged a guest-list of distinguished personalities to be invited to its first private view. For the opening Mervyn Peake painted a picture entitled 'Tintagieu' : a seascape showing a rock which bears that name in one of the Sark bays. The name was later to become the name of a prostitute in *Mr Pye* who is earthy, ponderous, and a symbol of the personality of Sark.

In the second year of Mervyn Peake's stay there and the third year of its existence the gallery came into its maturity and ran a season of exhibitions between May and October 1934. Before the Sark opening on 21 May the Sark Group, as they were now known, exhibited at the Cooling Galleries in Bond Street (1 to 14 May 1934). This exhibition and the subsequent Sark exhibitions attracted a number of favourable notices in the press. The *Daily Sketch* considered that 'Sark has stolen a march on the Royal Academy' by attracting Mervyn Peake, 'a year ago one of the more promising students at the Royal Academy Schools' (*Daily Sketch*, 2 May 1934). The *Daily Herald* had a photograph of Mervyn Peake painting and gave a brief description of how he lived :

> For a time the young man lived in a barn that leaked. He worked in the potato fields to make enough money to buy food, he fished in the sea, he washed his own clothes, and did many 'inartistic' jobs, and he says it is glorious.
>
> (*Daily Herald*, 2 May 1934)

The Birmingham Post stressed the interest of the colony as a social and economic experiment :

> Mr Eric Drake, a young Englishman who . . . has lived much in art circles, is the originator of the gallery. He knew the difficulties young artists had to face. That is why he planned this co-operative and non-profit-making scheme. Even the building of the studio was a help-yourself affair, the artists turning themselves into builders and carpenters for the occasion. Any artist who has in his pocket the fare to Sark, and no more, supports himself by digging in the studio kitchen-garden, by pumping water, making picture-frames, or by any other manual labour, for which he is paid the rate usual in Sark.
>
> (*The Birmingham Post*, 2 May 1934)

21

In its third year of existence the Sark group grew in size and tensions began to develop within it. Such tensions were hard to control in such a small community and by the end of 1934 the Sark Group had had its best year. By 1935 Peake had perhaps become disenchanted with the island: his closest friends, Tony Bridge and Brenda Streatfeild, no longer came out in the summer, the atmosphere of the group was turning sour, and the Drakes themselves were becoming restive and likely to leave. But he returned to London after a period of simple fulfilment and delight, the recollection of which was to colour the rest of his experience and the whole of his creative life. His recollections of Sark were mainly of the landscape, the quiet, the sense of a timeless world with no traffic, of living in a pre-industrial age, together with a number of gentle, delightful and uproarious episodes. He and Brenda Streatfeild had had their ears pierced on the same day and had gone to a circus on Guernsey and sat in the front row wearing gold earrings, their ear-lobes streaming with blood. He had grown a beard, he had lived in a shack with a cormorant, he had loved and enjoyed life and painted.

The experience had not been an introduction to normal life, perhaps, but it had certainly been an introduction to the responsibility of being an artist. The difference between being kept and being employed by the Drakes had been crucial: to be employed gave the students dignity, a sense of being adult artists, a sense of the value of money. Back in London during the winter Tony Bridge and Brenda Streatfeild were acutely conscious of this difference: in London they were students, in Sark they were people. When Peake returned to London in the autumn of 1935 he must have been very certain of what he wanted: he was a painter, and he would live in a studio in London and devote himself to his work.

He took a studio with one of the most serious of his fellow-students from the Royal Academy Schools, Bill Evans, but did not in fact live there: it was his place of work during the day, but he continued to go back to his parents in Wallington at night, and he resumed the café life, the 'head-hunting' and the endless experiment. He also resumed his writing, and Bill Evans recalls that Peake was divided between his arts during this year, and that as he experimented with his poetry and prose pieces and tried to get them into print his painting tended to become spasmodic and

he was seen less and less in the studio. He would get into a routine of wandering round London sketching and writing poems about what he saw, sitting in a favourite place such as Lyons Corner House or the Chat Noir as he had as a student, and sketching the other customers and scribbling notes on backs of envelopes.

It was both a stimulating and an unsettling period for him: in contrast to Sark where the certainty was painting and the need to paint, London offered a host of new friends and interests. He began to meet writers, of whom the most interesting perhaps was Dylan Thomas, who was a friend of Bill Evans. They were both members of a hard-drinking group of young radicals with Welsh connections ('The Welsh Gang' as Bill Evans calls them), and although Peake himself was half-Welsh and proud of it he was looked on as something of an outsider by this group. By comparison with these rough and abrasive young men he seemed rather refined, rather well-cared-for. But he was delighted by Dylan Thomas's poetry and became a friend of his for a time; friendly enough, certainly, to lend him a suit and lose it, although as Thomas became better known the friendship began to fade (Maeve Gilmore, *A World Away*, pp. 62-3).

During the year 1935-6 Peake must have begun work as a part-time teacher at the Westminster School of Art. The prospectus for the School's academic year 1936-7 has photographs of Peake teaching, but there is no mention of him among the staff members which suggests that he was a newly-appointed or temporary teacher. Among his colleagues at the school when he joined it were Mark Gertler and Elmslie Owen, whom Peake had known earlier: Elmslie Owen had exhibited with the Sark Group.

Peake then, was still new to the Westminster School, when he first met his future wife, Maeve Gilmore, in the autumn of 1936, and at this stage he was still exploring poetry, design and prose, as well as painting, as outlets for his creative impulse. He designed at least two stage productions in the late 1930s. The first was *The Insect Play*, at the Little Theatre, in 1936, directed by Nancy Price. Shortly after Maeve Gilmore met her future husband he showed her the costume designs which he had made for this play. They had not been commissioned but he had heard of the plans for the production and hoped that Nancy Price might accept his designs. He took them to her at the Theatre and asked her to look at them. She refused to do so, saying, 'We've already got some-

body to do the designs', so he threw down his drawings and left. A week or so after this a telegram from Nancy Price arrived asking when Peake was going to start work, and in this haphazard way he found himself working for the professional theatre for the first time.

In the course of this work on the costumes for *The Insect Play* Peake made friends with Esmond Knight, the actor, who was playing the Ant Commander and the Parasite in this production. As a leading actor, Esmond Knight was paid only seven pounds a week by the theatre at that time, so that Peake's fee for his costumes must have been small; but he entered into the work with enthusiasm and enjoyed the atmosphere of the theatre. The designs were difficult to translate into costume. Esmond Knight recalls that his Ant Commander costume called for considerable ingenuity, as it was impossible to reproduce the thin connecting cord between the thorax and the abdomen which appears in Peake's drawing. The illusion was created by close-fitting black tights with a white streak down the middle, a huge protecting cage built round the shoulder and another round the hips. The production was successful and was revived with the same cast at the Playhouse in 1938.

The other play for which Peake made designs was *The Son of the Grand Eunuch* by Albert Arlen (from a novel by Charles Pettit), which was produced at the Arts Theatre Club in January 1937. Chinese costumes were required, and Peake would have been well equipped for this: the present writer has not been able to trace these designs. One can surmise that they would have been very effective and successful, as the designs for *The Insect Play* are both intrinsically theatrical and beautiful drawings in themselves.

Peake's friendships always included actors – Esmond Knight, Anthony Quayle and later Kenneth Williams were among them – and he was to maintain an interest in the theatre and to become a playwright himself in the 1950s, but he did not do any more stage design. He did not even design the sets and costumes for his own play, *The Wit to Woo*, in 1957, and it is puzzling that he should have discontinued a line for which he obviously had great talent.

By 1937 the war was already very close. Peake married in December 1937 and continued teaching at the Westminster School

of Art. He was also making portraits of well-known contemporaries in the arts (Walter de la Mare, W. H. Auden, Ralph Richardson, Graham Greene) for the *London Mercury*, on commission, and writing a children's book called *Captain Slaughterboard Drops Anchor*. This book was published in 1939, and was the fruit of Peake's inner imaginative life over ten years or more. He had intended it as a long narrative for children with illustrations, and it was based on drawings of islands, pirates and mythical beasts which had occupied him at school and during the creation of 'The Dusky Birren'.

When *Captain Slaughterboard* began to take shape from the miscellaneous collection of drawings and ideas that preceded it, it was entitled 'Mr Knife', and an early manuscript form of the book shows a series of alternative names for the principal characters of the book. Mr Knife himself also appears as 'Captain Swigg'; Peter Poop, the ship's cook, also appears as 'Peter Pants/ Porter/Prunes'; and other comical names include 'Snick', 'Slosh', 'Smudge' and 'Blob'. These names suggest two principal sources of inspiration for *Captain Slaughterboard*: the first is a whole tradition of island stories, including *Treasure Island*, and the impact of Sark on Peake, and the second is the action of drawing itself.

It seems obvious that the drawings came first and the text later, and for several pages of its length *Captain Slaughterboard* exists only to present remarkable drawings of strange creatures: the Saggerdroop, and the remarkable long-nosed mammals that push their snouts out of the sea. At the end of the book appear three pages of exquisitely drawn fish which clearly arise directly out of Peake's recollections of Chinese art. They have nothing to do with the story, but they provide an effective visual coda to the work, which has now openly become a series of attractive drawings bound together by a transparent narrative.

The Yellow Creature, friend to Captain Slaughterboard, undergoes a curious transformation from the drafts to the published version of *Captain Slaughterboard*. The Creature is the only intelligent inhabitant of a strange pink island where the Captain lands with his pirates; the Captain becomes infatuated with the Creature and sails away with it on his ship. After many adventures all the crew are killed and the Captain retires from piracy and settles down in perfect harmony with the Creature, who cooks for him and looks after him as a wife would. The relationship is

an idyllic one: in one of the later drawings for the book the Yellow Creature leans luxuriously on the brawny arm of the Captain and eats a banana, its eyes rolling suggestively at the reader, while the Captain lies back unconcerned and puffs on his pipe.

This was the first of Peake's published works, issued by *Country Life* just after the outbreak of war in 1939; the stocks of the book were destroyed by a bomb almost immediately and very few copies of this edition survive (there is one in the British Museum). It was reissued after the war by Eyre and Spottiswoode.

For Peake and his wife the approach of the war meant the breaking-up of their newly-formed family and the destruction of many of their hopes. Until September 1939 their lives were falling into a pleasant pattern. They lived in a studio flat in London and made constant visits to Sussex where Peake's parents had built themselves a home on the Downs with a magnificent view of Arundel Castle just outside the village of Burpham, which consists of a row of cottages, a church and a pub, all perched along the edge of the Arun valley. On the other side of the valley Arundel Castle rears up over the river, looming romantically at dawn and glistening under the midday sun. Immediately next to Burpham is another small village, Warningcamp, which has a view of the sea.

When the war broke out Peake and his wife were staying in Stratford: their first child was due in January of the following year and this fact and the threat of Peake being called up before the child was born created a period of unbearable tension for them both. When the air-raids began Peake moved his wife to a cottage at Warningcamp and waited for his enlistment papers to arrive.

During this period he wrote a good deal of poetry which arises directly out of the conflict and sense of unreality imposed by the contrast between the beauty of the Arun valley and the impending threat of separation, military service, and the new baby growing up in his absence: notably the poem beginning 'Be proud, slow trees' (*A World Away*, p. 38). His sense of the unreality of time, of life lived from moment to moment, becomes acute and is finely expressed in his wartime poems, giving many of them considerable stature.

Peake hoped to be employed as a War Artist. Sir Kenneth

Clark, who had bought some of Peake's work in the 1930s, was now Chairman of the War Artists Commission, and a correspondence opened in which Peake put forward projects which might interest the Commission, notably a proposal for a series of drawings inspired by the Welsh mining districts; he sent Sir Kenneth a copy of his poem 'Rhondda Valley', which had been published in the *London Mercury* in October 1937, as an instance of his interest in the topic. The project did not develop, and throughout his military service between January 1940 and May 1942 Peake kept up a correspondence with the Ministry of Information in which he continued to put forward projects and seek employment as a War Artist. He wrote several letters proposing to make portrait studies of German P.O.Ws for War Records but this suggestion was not taken up for security reasons. Early in 1941 he wrote from Blackpool, where he was training as a gunner, sending a collection of his drawings of army life and proposing a major painting based on these sketches. In 1942 he resumed his correspondence with the Ministry, this time from Clitheroe, Lancashire, where he was training as a sapper, and again proposes the Rhondda valley project. There are several letters between early March and the end of April 1942, in which he asks a Mr Dicky of the Ministry of Information to look at his work and consider him for employment 'with the intensification of the propaganda campaign'. Whereas Peake's earlier letters to the Ministry expressed merely a patient hope, these letters were testy and despairing in tone. He exclaimed that the thought of being employed as a War Artist was his 'highest hope', and that the army would be glad to be rid of him because he was unmechanical and the only work that they could find for him was 'fatuous' and 'superfluous'.

There is no letter recording the final decision of the Ministry over the Rhondda valley scheme, but as Peake never undertook the work and remained officially attached to the army for another year it is obvious that the scheme was rejected. By June 1942 Peake was in the Army Military Hospital at Southport recovering from a nervous breakdown and it is possible that there was a connection between this disappointment of his hopes and the collapse of his mental stability: if so, this pattern was to be repeated in 1957 when *The Wit to Woo* was presented, after a long period of anxiety and deferred hope, and the cool response

from the critics hastened Peake's psychological decay.

Other pressures could have contributed to the breakdown in 1942. His mother had died, his son Fabian had been born earlier in the year and Peake had found it difficult to obtain compassionate leave in order to visit him, and his elder brother, Leslie ('Lonnie'), had been taken prisoner by the Japanese. It is possible to see him as a man torn by conflicting emotions : he had written to his sister-in-law, Ruth, after the imprisonment of his brother expressing despair at the dreadfulness of the war and the way in which it separates and disperses families, while simultaneously describing his own delight at the birth of 'the little urchin', Fabian.

After six months in the 'Neurosis Centre', as Peake called it, he returned to Burpham and stayed with his family in a cottage next to his parents' house. A further period of recuperation was followed by a training course in the use of theodolites and a resumption of the correspondence with the Ministry of Information. He was now writing to Elmslie Owen, who had been on the staff of the Westminster School of Art in the 1930s and before that had exhibited with the Sark Group. This time Peake's application met with success. In January 1943 he was commissioned by the Ministry of Information to make a series of drawings of a glassworks in Birmingham; the subject was the making of a television tube, and he was to be paid thirty-five guineas for the drawings.

In March 1943 Peake wrote to Elmslie Owen to say that he was due to go before a medical board and then to return to the army unless the Ministry of Information could offer him further work. Shortly after this he was commissioned to make further drawings of industrial subjects and a large painting of the manufacture of cathode ray tubes for a fee of £162 10s. The Ministry of Information asked for a further three months' deferment of his military service to enable him to carry out this commission. Notes on this correspondence show that Peake was not expected to be passed by the medical board, and one can assume that he was again showing signs of mental strain – his wife says that he was 'on the edge of another breakdown' (*A World Away*, p. 49) – and that the medical board declared him unfit for further military service in June or July of 1943.

Birmingham, a factory, and the manufacture of a cathode ray tube; neither setting nor subject were obviously congenial to

Peake's romantic temperament, and yet the process of glassblowing became the subject of a remarkably rich painting and stimulated what is arguably Peake's best poem, in which he writes about a job of work being done and transmutes the topic, through the synthetic power of his imagination, so that it becomes a convincing amalgam of the romantic and the realistic. It is the title poem of Peake's prize-winning volume, *The Glassblowers*, which won the Royal Society for Literature Award (with *Gormenghast*) in 1951.

During the summer of 1943 Peake worked on the studies and subsequently on a large painting of the glassblowers, a group of figures holding their glass tubes in a variety of graceful positions on a red background. The figures seem to be taking part in a dance, and the whole picture justifies Peake's description of the scene as a 'ballet of gold sweat' in his poem. One can guess that the picture was finished late in 1943 as it was not until 20 December that Peake received his first payment (of eighty pounds) for the work.

In 1944 he painted another large important painting commissioned by the War Artists Commission. Called 'Interrogation of Pilots' it shows a group sitting round a table 'debriefing' a team of airmen after a raid. This painting did not fire Peake's imagination and is merely workman-like, presenting an interesting contrast with the other painting where Peake has made the subject his own and given the whole of his creative being to it.

An odd feature of these commissions is that Peake apparently failed to acknowledge the first letter from the Ministry of Information inviting him to make the glassblowing painting. In December 1943 a note appears in the file saying that the letter of commission has not been acknowledged but that Peake has done some of the work, and that eighty pounds is to be paid for the work completed so far. The note adds: 'Could you please send him payment for £80 and get it off as soon as possible as he is hard up'. He was never business-like at any time, and these letters indicate that, being delighted with the commission when told of it, he simply set off and got on with the work, without attending much to the administrative side of things. In this as in everything he was first and always an artist.

His wife's Memoir and the tradition among his friends testify to this inability to deal with money, of which another example is revealed in the course of 1944 in his letters to Gollancz, the

29

publisher, in connection with a small book called *Prayers and Graces* which Peake was illustrating. He asks for two guineas a drawing, which will bring him a lump sum of sixty guineas in all; this sum was increased by Gollancz (perhaps to three pounds a drawing) and Peake, whose financial situation was very precarious during 1944 as the teaching work had stopped and his Ministry commissions were bringing in a mere eighty pounds a year, asks for the money to be sent immediately as his bank manager is, he writes, becoming restive. There were no royalties with the book: Peake sold his drawings outright, and *Prayers and Graces* sold 40,000 copies at Christmas that year, so one can take it that Gollancz got their money's worth.

During the war Peake led three separate lives. His life as a soldier and commissioned artist was only one. The second, and most important for posterity, was the inner life during which he wrote *Titus Groan*, which was a continuous process from the end of 1939 to the end of 1945, and the third was his growing career as a book-illustrator. As the sales for *Prayers and Graces*, quoted above, demonstrate, Peake's drawings were in demand during the war. An observer writing of 1943 was able to describe Peake as at that time 'the most fashionable book illustrator in England' (Quentin Crisp, *The Naked Civil Servant*, p. 141). For Chatto and Windus he produced the earliest and most famous of his illustrated books, *The Hunting of The Snark*, drawn throughout 1941 while he was a serving soldier and published as a Christmas book at the end of that year. During 1942 he worked on the drawings for *Witchcraft in England*, by Christina Hole, which was published by Batsford (in 1945), and during 1943, his busiest year during the whole of the war period and indeed of his whole career to date, Peake had four major projects in hand: his work for the Ministry of Information, his enormously successful drawings for *The Ancient Mariner* (published by Chatto and Windus again, who had also published his poems and whom Peake by this time regarded as 'his publisher'), his drawings for C. E. M. Joad's *Adventures of the Young Soldier in Search of a Better World* (Faber 1943), and his drawings for a real literary oddity, *All This and Bevin Too*, by Quentin Crisp.

Quentin Crisp, who was then working for Nicolson and Watson, the publishers, describes the genesis and publication of this work with self-deprecating wit in his autobiography.

The art editor told me that if I wanted to write something for publication, the time and place were now and here. During the war, though there was a widely advertised paper shortage, publishers would issue any old muck. Even so I thought it prudent not to attempt anything long. I decided to write a mere pamphlet in verse. The idea had come to me some time before when a friend had uttered in my hearing a limerick about a kangaroo who offered himself to the Zoo.

It ended:

> But whenever he tried
> The committee replied
> 'We already have plenty of you'.
> (*The Naked Civil Servant*, p. 140)

Like Peake himself Quentin Crisp was aware of the evil of un- or under-employment, and he went ahead to write forty-eight limericks of 'slashing indictment of the Ministry of Labour' and 'decided to try to ensnare Mr Peake into illustrating it'.

> He frequently sat in the Bar B–Q in Chelsea and was not in the least inaccessible. When talking to him I allowed it to seem that Messrs Ivor Nicolson and Watson had already commissioned the book and he declared himself willing to illustrate anything that was certain of appearing in print. These words had hardly issued from his lips when I leapt up and ran all the way to Manchester Square to tell the publishers that Mr Peake was simply dying to illustrate a book I had written. They expressed their interest in anything that Mr Peake chose to work upon. Running to and fro and making a series of statements that seemed increasingly positive but could never be used against me was much harder than writing the verses. These only took two afternoons. That was as it should be. It was certainly not the writing but the chicanery that ensured publication.
> (*The Naked Civil Servant*, pp. 140–2)

This book did not sell so well as some of the others. Quentin Crisp gives a postscript to his anecdote:

> When the book came out, anxious to know if sales were booming, I crept into Hatchards where a pile of copies was on

display. To my delight there was a man staring at the upper-most of these. This, however, turned out to be Mr Peake.

(*The Naked Civil Servant*, p. 142)

The relative neglect of *All This and Bevin Too* was undeserved. The drawings of the poor anguished kangaroo seeking to imitate a whole series of other quite different creatures (such as a mole) in order to receive employment are drawn with detail, care, and a poker-faced literal-mindedness which suits the tight form of the limericks.

> If you like you may leave us your name
> So that we may go into your claim
> And then doubtless you'll hear
> In the course of the year
> An evasive reply to the same.
> (*The Naked Civil Servant*, p. 140)

An artist employed as a soldier, Peake knew what it was to be a kangaroo who is pressed to become something quite alien to his own nature, and his work here reflects the absurdity and pain of that experience.

With *All This and Bevin Too* and *The Adventures of the Young Soldier* the artist and authors worked in harmony. Professor Joad had walked up the path of Peake's parents' home in Burpham one day and introduced himself, and he and Peake thereafter became friends. Peake never shared Joad's politics but was willing to enter into the spirit of irreverence with which Joad was prepared to treat the war. With the Lewis Carroll and Coleridge texts Peake was familiar and happy, but *Witchcraft in England* was, curiously, a less congenial assignment. Peake had his own ideas of how the witches should be and made of them grotesque and supernatural beings, while the text is sober, historical and anthropological. The effect is of author and artist working steadily against each other, the author stripping witchcraft of its magic and the artist putting the magic back.

The year after the war ended was an *annus mirabilis* in Peake's career. It saw the publication of *Titus Groan*, which, with its luxuriant treatment of a totally alien world and its rejection of the twentieth century and its works, found an immediately responsive

post-war public, and the publication of three more illustrated books: Grimms' *Household Tales, Alice in Wonderland* and Maurice Collis's *Quest for Sita.* It was also in this year that Peake was finally sent out to record his own impressions of the European battlefields, not for the War Artists Commission but for a periodical, *The Leader.*

He accompanied Tom Pocock, then a young journalist of nineteen who had joined the staff of *The Leader* a few months before. The editor, Charles Fenby, had seen some of Peake's work and had published a drawing of Hitler by him, and now commissioned him to undertake a sketching tour of Germany as the Allies moved in. The war had ended before Peake and Pocock were ready to set out, so their assignment became a commission to record the aftermath of the conflict.

Tom Pocock recalls flying to Paris with Peake, starting from the RAF terminal in St James's Street, where he had watched with awe the affectionate farewells between Peake and his wife, and staying first at the American public relations headquarters in Paris (their work in Germany was to begin in the American zone). They next stayed at the War Correspondents' Press Camp in the Scribe Hotel near the Opéra, and from here Mervyn Peake and Tom Pocock walked up into Montmartre to explore the night life.

Mervyn's gentle magnetism was here demonstrated remarkably. As we sat in a succession of night clubs he would sketch, and the bar girls, waiters and customers would drift up to watch and talk. There was no cadging of drinks from us, only quiet and interesting conversation. Some of the raddled denizens of the boîtes seemed to find Mervyn wonderfully restful and rewarding company. He talked just as easily with the tarts (who never seemed to think of importuning us) as with a group of American artillerymen, just back from the furthest limits of Patton's advance, who insisted on buying us champagne.

(Letter from Tom Pocock)

It is interesting to see how Peake's personality struck a much younger man at this time. All who knew him testify to his gentleness and his physical beauty, and Tom Pocock's portrait of him adds to this a sense of latent power and innate decency:

His dark, sombre good looks and the deep-set, troubled eyes

might have belonged to a most forceful person. But he was intensely gentle, and, although I must have been at times rather bumptious (full of my own knowledge of the Continent) he was a delightful and generous companion.

<div align="right">(Letter from Tom Pocock)</div>

From Paris they flew first to Wiesbaden, and then travelled by road to Aachen, which was in ruins, and there they witnessed the bones of Charlemagne being restored to the Cathedral, which had miraculously survived the onslaught. The first war-crimes trial, forerunner of the long, bleak meting-out of justice at Nuremberg, took place at Bad Neuenahr in the Rhineland, and was witnessed by Peake and Pocock. The defendant was a minor Nazi called Peter Back who had shot a surrendering American parachutist. The evidence was detailed and he and several others were later sentenced to death; the visiting journalists were allowed to visit him in prison (Peake was asked to sketch him) and even to attend the hanging itself. The latter spectacle they declined, but other journalists attended, 'one photographer complaining to the prison governor that it would make a great picture if all could be hanged in a row' (letter from Tom Pocock). As they followed in the wake of the victorious army Peake unsurprisingly found it difficult to enter into the spirit of things.

For him the most harrowing example of man's inhumanity to man was witnessed at Belsen which he visited for a day from the British base near Minden in Westphalia. Pocock himself had seen the camp immediately after it was liberated several weeks before and had no wish to see it again. When Peake reached it some of the worst horrors had been mitigated by the liberating army, the mass graves filled in and the prison huts burned with flame-throwers, but there were still hundreds of prisoners dying of typhus, starvation and tuberculosis. Peake made several sketches during the day, and in the evening when he rejoined Pocock he sat very quietly writing verses. Some of his most powerful drawings and poems are the products of what he saw on this day, and the figure of the Black Rose, victim of the monstrous Veil in *Titus Alone*, is based directly on this experience. The visit to Germany took not more than a fortnight in the first part of June 1945, and the visit to Belsen took a single day; like the visit to Birmingham and the glassblowing factory, this brief visit was to

last Peake for a lifetime of creative art. The immediate product was publication in *The Leader* of a joint feature on 30 June 1945, and of sketches by Peake on 14 July and 4 August.

3 Sark and Smarden, 1946-52

In 1946 Peake's life had reached a culminating point. Until this date his history had been that of a young man extending his experience and his range as student, Bohemian, soldier and journalist, and feeding the fruit of that experience into his steady production of poetry, painting, prose and illustration. Now, at the age of thirty-five, he must have seen his life as having reached a new plateau: the war was won, his first novel was published with considerable acclaim, his children were growing, his education by life was complete. Although in retrospect it seems that some of his best work had come out of the war, to Peake himself it naturally seemed that much of his time had been wasted, and that the moment had arrived at which to establish a home where he could live and work peacefully and express the abundant ideas thronging his imagination. Sark was the place he loved best and in which he felt most at home, more than London or even Arundel, and he resolved to settle there permanently.

It was a perfectly workable scheme. Sark was a cheap place to live, he had an advance for another Titus Groan novel and would be able to write it there free from distractions; there was every reason to suppose that the commissions for book illustrations would steadily continue and increase, he could travel to London if necessary but most of the business could be conducted by post or through an agent. Now that the war was over Peake and his wife felt a wish to leave London and live quietly together after so much enforced separation.

They took the lease of a large uncomfortable house called Le Châlet, a white elephant with no amenities but a lovely outlook and a huge garden, and there they settled for what was to be a stay of four years, stoking the Aga and lighting oil lamps all winter, and picnicking and gardening in the summer in the intervals left by Peake's unremitting work. His wife's Memoir in its account of this period of their lives shows that Peake's creative life was a seamless web; at all times he was engaged with a drawing or with his novel, or composing verses in his head. Also there was no distinction between his working life and his family life; he would spend the day asking his children to pose for illustrations

to *Treasure Island* or *The Swiss Family Robinson* (both published in 1949) or sitting in an armchair in the living-room with a board across his knees writing *Gormenghast* and interleaving the manuscript with sketches of his family. The primitive conditions made things hard for him in the winter. There was always the stove to be stoked, and being absent-minded about material things he would tend to forget this and would then have to spend the morning in bed in order to keep warm enough to proceed with *Gormenghast* (*A World Away*, pp. 67–84).

Several letters to his friend Maurice Collis from Sark during the period 1946–9 throw an interesting light on Peake's attitudes to the island. Late in 1947 he writes to Collis complaining of the cold in Sark and enclosing a drawing of himself writing, wearing a muffler with ice hanging from his hair; in front of him stands a death's head, a *memento mori*, holding a pound note as bait for the struggling artist, and a second letter in December 1947 declares that Sark is a failure and that islands should be 'left to the imagination'. Yet he stayed there: it was, after all, cheap, his family loved it, and it was a place where one could get work done if the immediate pressures of cold and poverty would hold off.

Despite the cold he enjoyed authorship, and an important letter to Maurice Collis reflects on the nature of this delight. The author must not seek to imitate God and control his characters down to the minutest detail; they must be allowed free-will within the limited predestination their creator has designed for them. This tolerant, free-Church approach to his characterisation will perhaps be found to be at odds with a critical examination of his work.

In 1948 Peake appealed to the Royal Literary Fund for a small bursary to help him to finish the Titus book; this bursary may well have helped to postpone the return to London for another year and undoubtedly contributed to the completion of the book. Although Peake enjoyed book illustration his letters show that he was anxious to be free of it for a time, to clear a space in his life for *Gormenghast* and nothing but *Gormenghast*.

Peake's financial worries were very real. His wife had a small income of her own but this was certainly not enough for the needs of their growing family, and Peake himself found it desperately difficult throughout his life to earn an adequate income from his writing and drawing. It seems unlikely that he ever earned more than a thousand pounds in a single year, and during the Sark

period his annual income was probably more like five hundred pounds, or less. An article on Peake which appeared in *Picture Post* in December 1946 suggests the poverty in which he worked: Peake and his family were already in Sark by the time the article was published as it had been based on interviews made during their final months in London during the summer of 1946.

The article has some characteristic photographs of Peake; he is shown mounting the steps of Trafalgar Studios in Manresa Place, leafing through pictures in a Chelsea junk-shop to find an old canvas which he can strip down and paint over, and drawing a children's book illustration with his two small sons advising him.

Curiously *Titus Groan* is not mentioned in this article despite the fact that the novel had been published in May, eight months earlier. Perhaps Peake himself had directed the interviewer's attention to his work as a painter and away from his writings. It is certain that throughout his life, despite his winning of the Royal Society of Literature Prize with *Gormenghast* in 1951 and his ambitions to be a playwright which lasted throughout the 1950s, Peake thought of himself as a painter and constantly invested a great deal of his time and energy in his paintings.

The article remarks that:

> He thinks of himself as a painter first and foremost, but for his bread and butter he must rely mainly on illustration. His pictures will sell at anything from £30 to £60, and he considers it normal that, at his last exhibition of paintings, he sold eight pictures out of twenty-five.
>
> (A. L. Lloyd, 'An Artist Makes a Living', *Picture Post*, 21 December 1946)

The article goes on to stress his reputation as a book illustrator:

> To all popular intents, his reputation has been made by his exuberant and grotesque illustrations to *The Hunting of the Snark* and *The Ancient Mariner*.

And his financial difficulties:

> A painter of Peake's standing – the standing of an established and serious artist – can consider himself lucky if he makes more than five hundred pounds in the course of a year. To do that,

as a rule, he will have to devote quite half of his time to some kind of commercial work.

Presumably the author of this piece is quoting Peake himself when he continues:

> About 10,000 people in Britain claim to be professional artists. Of them, not more than 700 painters and 30 sculptors are actually able to earn a living by the sale of their work; the rest have private means; or they teach; or they make money on the side by commercial art, industrial design and book illustration; or they starve.
>
> Once it was different. Once, artists lived on patronage. In the Middle Ages they were subsidised to paint propaganda pictures for the Church; in the eighteenth century they were 'kept' by aristocrats to produce portraits, landscapes, murals and sculpture to decorate handsome homes and fine parks; in the nineteenth century they could still live pretty comfortably as a rule, for the captains of industry, with more money than taste, were eager to buy pictures, if only for prestige.
>
> ('An Artist Makes a Living')

The only patron among modern artists in recent times had been the War Artists Commission, remarks the author. He goes on to quote a comment which, if it came from Peake himself, is generous, in view of Peake's own frustrations with the War Artists Commission:

> A big chance came for him during the war, when the War Artists Commission – the nearest thing Britain has had to a State art patronage scheme – arranged for him to paint some industrial subjects.
>
> ('An Artist Makes a Living')

The article goes on to say that the War Artists Commission 'bought his well-known "Glassblowers" for 150 guineas'. This is of course a somewhat rose-tinted version of what the Commission in fact did for Peake: they paid him the equivalent of eighty pounds a year over two years, during which time he painted 'The Glassblowers', 'The Interrogation of Pilots', and a number of sketches.

In addition to his book illustration during the war he had several exhibitions of his paintings and drawings, a large indivi-

dual one at the Calmann Gallery in 1943, and a very successful one where a number of drawings were sold at Peter Jones in 1944. In 1946 his work on four fronts, painting, illustration, novel writing and poetry, was enjoying relative celebrity, and yet his earnings remained very modest. Living in Sark, then, or anywhere, with his family, was bound to present him with financial problems.

Gormenghast grew steadily between 1946 and 1949 while the family lived on Sark, and there is a good deal of Sark in the novel, the Sark of summer picnics, midnight bathes, mystery and romance. A children's book, *Letters from a Lost Uncle from Polar Regions* (Eyre and Spottiswoode, 1948), perhaps reflects Sark in the winter, a place of primitive conditions, limited communications, relentless cold and stoical good-humour. Cold, an endless bleak seascape and solitude are the characteristics of the 'Polar Regions' from which the Uncle addresses his letters, as they must have been of Sark in winter. The work has no plot. The Uncle and a creature known as a turtle-dog, whose name is 'Jackson' (related perhaps to the mysterious figure in the poem 'An Ugly Crow Sits Perched on Jackson's Heart') proceed on a quest for a White Lion, King of the Polar Regions, which expires majestically and turns to ice as the pilgrims approach it.

It seems likely that the *Letters from a Lost Uncle* were a product of the diaries which Peake drew for his children over the years in Sark. These were a daily or (at least) weekly amusement. The two boys had little exercise books from their father and each day he would put a new drawing of a mythical beast or weird person with another episode in the endless narrative which these diaries composed. *Letters from a Lost Uncle* also has a strong family resemblance to *Gormenghast*, which was being composed simultaneously. The Uncle with his peg-leg and his irascible individualism resembles Barquentine, and his sharp-nosed wife from whom he has escaped to wander in the Polar Regions is a twin sister of Irma Prunesquallor. The inverted dining-table on which the Uncle launches out into the Arctic ocean clearly anticipates the devices to which the inhabitants of the Castle resort in their efforts to escape the flood at the end of *Gormenghast*.

Much of Peake's major work, including the first two Titus books, can be seen as the expression of his responses to the births and growth of his children (see below, Chapters 6 and 7). On Sark, at a very simple level, his two sons were providing new

subjects for his art; they were the stimulus for *Letters from a Lost Uncle*, they were models for many of his book illustrations and the subjects of several poems and drawings, and they were a constant source of entertainment.

In her Memoir his wife suggests that the two boys tended to run wild on the island (*A World Away*, p. 65). Certainly his son Fabian destroyed a haystack with some friends by making a hole in it and lighting themselves a small fire: the haystack went up in an instantaneous blaze, and fortunately the children were upwind of it and escaped unharmed. A policeman arrived, the farmer had lost several hundred pounds' worth of hay, and the small boy thought that he would be sent to prison or at least beaten, instead of which his father's attitude was one of tolerance, quiet amusement, and a wish to comfort his son.

Being so large, Le Châlet was an accommodating house: Peake had a work-room, but it was not sacrosanct, and his sons were free to wander in and watch him working and receive advice about their own little drawings whenever they wished.

In the other fifteen or sixteen rooms a kind of commonwealth prevailed in which no one room belonged to any particular person, and cats, children and paintings could lodge wherever they wished. And just as the children would enter into his world so he would enter into theirs, devising intricate methods of jumping over the duckpond and competing with them in all manner of sports: running, football and archery. The space, the freedom, the absence of traffic and the art-world of London with its pressure of a teaching commitment made the family a compact and mutually delighting self-sufficient group. In the evenings Peake would draw his money-earning book illustrations (mornings were reserved for *Gormenghast*) by the light of an oil-lamp while his wife read to him: Dickens, Voltaire, Evelyn Waugh.

In 1949 a third child, Clare, was born. I describe elsewhere the relationship between the birth of this long-awaited daughter and the evolution of the character known as the Thing in *Gormenghast* (see below, Chapter 7). Peake had already been thinking for two years of returning to London to live, and the added financial burden of a third child, and the difficulty of leaving his wife to cope with three small children during his stays in England, convinced him that the family must return to the mainland. Since 1935 he had rented a studio in Trafalgar Studios

41

in Manresa Place, Chelsea, where he stayed on his visits to London. He now took a flat which was within reach of this studio and began to work at the Central School of Art, Holborn, two days a week (normally Monday and Friday). This provided a basic source of income, and he continued to work at this job until illness prevented him from continuing in 1960.

The first symptoms of this illness began to show themselves as early as 1951, although this year was in many ways the most successful that Peake enjoyed throughout his life. In 1950 *Gormenghast* and *The Glassblowers* had been published by Eyre and Spottiswoode and in April 1951 he was awarded the Royal Society of Literature Prize for them both. Earlier in the same year they had moved from their small flat to a delightful house in Kent.

With a mortgage and a legacy of his wife's he had bought The Grange, Smarden, a handsome Queen Anne house where his family could recapture the sense of space and freedom that they had lost since they moved from Sark. A play called *The Connoisseurs*, based on a short prose piece of the same name, was performed with success by the village amateur dramatic society and this stimulated him to write a full-length comic verse play. He had several actors among his friends, and a growing interest in the theatre led him to this venture in which he received friendly advice and criticism from Esmond Knight, whom he had known well since his *Insect Play* designs of 1936. As well as being a professional painter he was now a well-established writer with new horizons opening for him and a beautiful setting in which to live and work.

The tableau must be held in one's mind: the graceful house with its orchards and cottage and hop-gardens lying round it, the writer working with passion and enthusiasm on a new play and also on two new novels (the third Titus book and *Mr Pye*), and paintings still being produced, while the boys made friends in the village school and the baby girl slept in the garden. It must have seemed a perfect blend of the simplicity of Sark and the amenity of London, a paradise miraculously realised in the everyday world.

On 26 June Peake went to receive his prize from the Royal Society of Literature, accompanied by his wife and an old friend, Maurice Collis, who had championed Peake's writings from the appearance of *Titus Groan* onwards and whose *Quest for Sita* had

been illustrated by Peake. Maurice Collis remarks of the cere-
mony:

> Rab Butler was in the chair, not yet fifty but Chancellor of the
> Exchequer. His speech introducing Peake was not as good as
> the way he introduced the Budget. He admitted having only
> looked at *Gormenghast* for the first time that afternoon. No
> doubt he meant well, but he managed to give the impression
> that it was not his cup of tea. As Peake's fervent admirers, we
> were indignant, silly of us since the Society had chosen
> *Gormenghast* as the literary event of the year and so the chair-
> man's speech did no harm. A lecture on Humanism followed. It
> dragged badly. Mervyn, however, endured the proceedings with
> amiability, every now and then feeling the lovely cheque in his
> pocket.
>
> (Maurice Collis, *The Journey Up*, p. 112)

A hundred pounds ('tax-free' as well) and the prestige of the
award placed Peake on a crest with a well-merited sense that
recognition had come, and that at last his life and work were
beginning to fall into a satisfactory pattern.

4 Wallington and London, 1952-68

Sark and then Smarden had been ideal places in which to live, ideal settings for the artist in Peake, in the sense that they were both places in which the outer world approximated to the inner vision and the artist could feel that his imagined beauties had their actual equivalent. No earthly paradise is perfect. The difficulties with Sark had been that it was cold, primitive, and remote, while Smarden, ideal in every other way, was simply too expensive.

On Christmas Day 1949 Peake's father had died leaving houses to his two sons. The house in Burpham, near Arundel, was left to his elder son who had spent a strenuous professional life in the Far East, and the large Victorian house in Wallington, Surrey, where the family had been brought up, was left to his younger son. Wallington had many disadvantages. The house was too large for the family, and it would separate them from their London friends almost as effectively as Sark had done. On the other hand there was an adequate rail service enabling Peake to fulfil his teaching commitments at the Central School of Art in Holborn two days a week, and there was plenty of room for two artists to paint and for three children to be brought up. Peake had the house valued with the possibility of selling it in his mind, but the valuation was not very promising. Eventually the family bowed to the inevitable and went to live there.

For Peake himself this was not necessarily an exile. He had been brought up in Wallington, he had lived there with his parents continuously until his marriage, it was little hardship for him to return there. Ownership of this house eased the difficulty which had dogged him in Sark and which overwhelmed him in Smarden, the difficulty of matching income to expenditure.

During the remainder of 1952, before the move from Smarden to Wallington, financial pressure provided a motivation for the massive productivity of this year, but Peake never responded well to pressure and not all of this writing is of his best. *Mr Pye*, most of which was written at Smarden in an attempt to employ his Sark experiences to make some money, was remaindered after publication. This seems unjust; though less interesting than the

44

Titus books *Mr Pye* is not a negligible work, though one can understand how its balance of satirical sharpness and evangelical fervour might have left its first audience untouched.

The other major piece of writing in this year was the first draft of *The Wit to Woo*, which was revised and added to continuously until its production at the Arts Theatre in March 1957 (*A World Away*, pp. 90-129 and *passim*). Peake wrote at least five plays, of which only *The Wit to Woo* and the one-acter, *The Connoisseurs*, were performed. The others were a children's play called *Noah's Ark*, a piece called *Mr Loftus* written in collaboration with Aaron Judah, and a piece called *In the Cave* which gives an allegorical history of man: all these were written or at least conceived during the year in Smarden. He was later to write a commissioned radio play, 'The Voice of One', and dramatic adaptations for radio of *Titus Groan* and *Mr Pye* (see below, pp. 50-1).

The first and shortest of these, *The Connoisseurs*, based on a short story which appeared in *Lilliput* in 1950 (see below, Chapter 9), is under twenty pages long. It develops from the two-page short story in several directions. There are three characters and they are all named: the fat and thin anonymous aesthetes who are the only characters in the original story have become Mr Forge and Mr Splice, and a new character, Mrs Hollow (the owner of the vase), is introduced. The simple sharp joke of the prose piece has become a satirical triangle in cameo. As in the story, they can discover whether the vase is genuine Ming or not only by breaking it, but what is notable about the playlet is that the additional character of Mrs Hollow is a thoroughly successful creation. She is a convincing monstrosity: a middle-aged divorcee seeking release from her boredom and from the effeminate connoisseurs who pester her over her pretty vase by smashing it with a poker, remarking that she had not had such a 'great big original thrill' since her husband left her. She is confidently and flamboyantly drawn, and she is certainly a promising opening to Peake's career as a comic dramatist.

The Wit to Woo only partly fulfils that promise, although it might well have made more impact on theatre-going London if it had been presented in 1951 instead of in 1957. It belongs to the world of *Salad Days* and *The Lady's Not for Burning* and it was not produced until after London had seen *Look Back in Anger* and *Waiting for Godot*. It is essentially frothy, delightful versified

45

nonsense which could well have made money for its creator if he had been luckier with the timing of the production. He wrote the part of Percy Trellis, the central figure who is a timid lover who feigns his own death and disguises himself as his own imaginary, flamboyant younger brother, with Laurence Olivier in mind, with the hope that Sally Devius, the girl to whom this bashful lover is addressing himself, might be played by Vivien Leigh, with her father, Old Man Devius, played by Esmond Knight. He sent the manuscript of the play to Olivier and it is clear from the letters quoted in *A World Away* that Vivien Leigh was attracted by the piece and that there was for a time a distinct possibility that she and Olivier might play it. In the event these three parts were taken by Colin Gordon, Zena Walker and Wensley Pithey respectively.

The setting of the play is a country house, a somewhat Gothic establishment which is rooted (but only to a shallow level) in the soil which produced the castle of Gormenghast. It contains a suit of armour, it is hung with grotesque ancestral portraits, it is dominated by a magnificent Queen Anne staircase which sweeps down and round to the centre of the stage, and the woods around it are frequented by owls: the play opens and closes, in echo of its punning title, with an owl's distinctive cry.

The whole play is written in iambic pentameters, but beyond this the versification is unlike that of other verse playwrights. The punning and mechanical verbal effects taking place within the lines belong more to W. S. Gilbert than to Shakespeare, and as with Gilbert the verbal wit is often too slight for the stage. One cannot imagine, for instance that the pun on 'eel' in the following lines would get across in the theatre.

> WATKINS [one of the undertaker's men]
> . . . 'e went as red as lobster pie
> And stared at 'er, and turned upon 'is 'eel.

Indeed the whole piece should probably be understood in terms of the conventions of the best of Victorian light entertainment: Gilbert and Sullivan, music-hall, pantomime, Lewis Carroll, Harry Graham, Edward Lear. As in pantomime there is a troupe of stand-up comedians who appear first as undertakers and later, classically, as the Broker's Men. There are songs, there is a comic drinking scene, there is a man disguised in a suit of armour who is taken

for a ghost. The motivations for all the villainous characters are ruthlessly financial, and the undoing of these villains turns on preposterous legal circumstances. Under the legal extravagance of the decidedly complicated plot is an essentially Victorian device, the Death Joke.

The Death Joke is played mutually by two sets of conspirators. Percy Trellis, of course, feigning death and impersonating his artist-brother 'October' Trellis to win the hand of Sally Devius, plays it. So do rascally Old Man Devius and wicked Dr Willy, who are promoting the same match for the sake of Percy's money: Devius pretends to be on the verge of death to hasten Sally into a decision before his own bankruptcy is exposed. Despite all these interests, it takes three acts of Peake's iambics to make the marriage a certainty, largely because of Sally's teasing reluctance to marry any other than a 'romantic' man, and because of the wiles of the respective seconds. Kite, Percy's manservant, persuades the 'dead' Percy to make a will by which he disinherits himself, and Dr Willy having signed his death certificate refuses to allow him back to life.

Like the intricacy of the word-play, the complexity of this action might well elude an audience, especially as it tends to double back on itself. Is Old Man Devius actually on the verge of death, as well as pretending to be? Is Kite playing Mosca to Percy's Volpone and preparing to inherit Percy's money himself?

Despite these contrivances and obscurities, the play is very diverting and contains a fairly sober portrait of the artist in Trellis's personification of 'October'. The artist is virile, irreverent, red-waistcoated, a lover of Rembrandt (as Peake himself was) and redolent of turpentine. He has no use for the conventions and wins Sally by his romantic unorthodoxy. With this figure of the artist Peake retrieved and established the meaning of his absurd plot by showing that it is no more than a reflection in the eyes of an artist of the absurd world. After Percy Trellis has demonstrated that he himself is 'October' Trellis, and therefore not dead, he laments:

> . . . all this is nothing
> In the sour eyes of the official tape-worm.

The world of wills and death certificates and all other forms and formulae is regulated by an inhuman, and therefore insane, code.

47

The image of the official tape-worm recalls a bitter period of Peake's life and one of his most brilliant book-illustrations, the Red Tape Worm from C. E. M. Joad's *The Adventures of the Young Soldier in Search of a Better World* (see above, Chapter 3). This revolting invention, with the head of a flabby middle-aged clerk and its three prehensile hands (the third is on the end of its tail) expresses the disgust that bureaucracy inspired in Peake when he was seeking work as a War Artist, and the hatred that the young men who did the fighting must have felt, at times, for the old men who held the cards.

With Zena Walker as Sally Devius and Kenneth Williams as Kite the play can be said to have had a cast of actors who were both gifted and celebrated, but it is possible that a longer run, enabling the cast to settle down, would have done it more credit than it received. Kenneth Williams feels that the play was a good one and perhaps did not have the right kind of production for its virtues:

> Mervyn Peake's dialogue for the play was full of verbal conceits, wonderful imagery, natural fluency, and above all, theatrically effective. I had no hesitation in accepting the part of Kite: I thought it glittered with malevolence and vituperative wit and knew that I could encompass it vocally. I was a bit perturbed about the physical side of the role but I know that I managed to get a lot of slithering into it.
>
> The play needed wholehearted theatrical bravura acting and vocal relish. In the event it was played in a modern high comedy manner with considerable 'throw away' technique.
>
> (Letter to author, 27 November 1971)

The reviews of the production at the Arts Theatre Club were disappointing, and Peake was heartbroken by the cool reception of the play over which he had laboured so long, at intervals for five years, and in which he had invested so much love and hope. Immediately after the reviews appeared and the audiences began to drop, Peake's illness became markedly worse, and his wife in her Memoir dates the beginning of his final decline at this point (*A World Away*, pp. 176-7). The kinder reviews noted merit in the first two acts of the play and disintegration in the third, and it is perhaps worth quoting two of the notices.

The farce is embellished by some odd characters – a Smollett-like bed-ridden old gentleman who is lowered on pulleys into the hall surveying the landscape through a long telescope [Old Man Devius] – a tippling old doctor with an unseemly mind [wicked Dr Willy] – and the lugubrious undertakers who turn into brisk Broker's Men. But eventually it becomes clear that the author can think of no more odd characters and odd happenings. He is left to do what he can with his verse, and the piece gradually turns into a painful imitation of Christopher Fry . . . Manfully prepared to make the best of a farce without style, we are inflicted in the end with a fantasy marred by a bogus style.

(*The Times*, 13 March 1957)

At the centre of Mervyn Peake's fantastical comedy lies a theme that has a more serious note and it is a pity that the author allows the comic possibilities to run away with him. For one and a half acts the play holds interest with its wit and genuine poetic feeling, but after that it sinks away into absurdity.

(*Theatre World*, April 1957)

Perhaps in the 'more serious note' this second critic was recognising the importance of 'October' Trellis's perception that the world surrounding the artist operates according to alien laws.

The presentation of *The Wit to Woo* in 1957 marked an enormous upheaval in a life which had otherwise been ordered and settled since the move to the Wallington house in 1952. To a considerable extent Peake's history between 1952 and 1960, when illness forced him to stop work, is the history of a man writing. He finished *Mr Pye* (published in 1953) and then wrote the whole of *Titus Alone*, last of the Gormenghast trilogy and by far the most difficult to write, which was published in 1959. He also wrote his other plays, a number of pieces for broadcasting and several small pieces including 'Danse Macabre', 'Same Time Same Place', and 'The Weird Journey' (see below, Chapter 9), and he was commissioned to write 'Boy in Darkness' which was published with stories by other authors in *Sometime, Never* (Eyre and Spottiswoode, 1956).

The sense of fun and of pleasure in life were not diminished by the more settled existence in Wallington, the pressure of work, the anxieties over his play, and his steadily progressing disability. His family all had mixed feelings over Wallington. His wife

D

loved the house but hated the place, and his sons, now adolescent and being educated at a Catholic grammar school in Wallington, missed the excitement of Chelsea and the sense of belonging, of living in a world where one might run into Peter Ustinov, Epstein or Graham Greene. But his youngest child loved the house for what seemed to her its vast size and its rambling attics and it clearly provided Peake with a stable background in which to live and work.

Throughout this period it seems that Peake's essential personality remained unchanged: somewhat absent-minded and dreamy, laughing, inventive, fond of small fantastical doings which would illuminate family life. He would set out French rolls from the larder in the shape of a pair of hands on the kitchen table; he would hide in the airing cupboard and then jump out and say 'Boo!'; he would clown for his children with a characteristic Frankie Howerd backward kick expressive of greeting or disdain and a knack of jumping over the back of a chair instead of merely sitting in it. Letters for his children would arrive with drawings all over the envelope and elaborate decorations round the stamp, to the delight of their school-fellows. He never went to church himself, but he supported the Catholic upbringing of his family: when very young his daughter stole a grape and was so oppressed by guilt that she confided in her father who advised her, gently and wisely, to postpone the sense of sin until she was old enough to make her first confession. And when she was nine or ten she heard a shout from the kitchen and went in to find her father sitting under the table, triumphant, having written the last pages of *Titus Alone* there. However tired, ill, or disappointed, Peake remained charming, unpredictable and totally individual.

In 1956 and 1957 he wrote three dramatic pieces for radio: dramatic versions of *Titus Groan* and *Mr Pye*, which were broadcast in February 1956 and July 1957 respectively, and a Christmas play for radio which was broadcast on 18 December 1956. The scripts of the dramatisations from his own works show massive cuts, particularly in *Titus Groan*, where the problem of compressing the work to fit an hour's playing time must have been intense. Peake was not altogether happy with the dramatisation of *Titus Groan* and yet it reads well and suggests that his facility as a dramatist was increasing with practice. The dramatised version

50

of *Mr Pye*, the last of the series, was in a full count his ninth serious attempt at dramatic writing. He could, then, reasonably be considered a seasoned dramatist at this stage of his career, and the text of this play (entitled 'For Mr Pye – An Island') has economy, tightness and fluency. The prolonged business of Mr Pye's wings and horns sprouting alternately in response to his spiritual condition is cut out in the dramatic version. Peake had included Mr Pye's trip to London to see a distinguished Harley Street surgeon, but this is also cut from the production so that the whole action takes place in Sark and the mood and unity of the place are preserved. The portrayal of the artist Thorpe is attractive, the dialogue between Miss Dredger and Miss George is sharp and lively and there is a strong sense of the island as a community which comes over as an effective piece of *genre* painting reminiscent of *Under Milk Wood*. With original music composed and conducted by Malcolm Arnold and a strong cast which included Wilfred Babbage, Ysanne Churchman and Mary Wimbush this must have been a most attractive production.

Unfortunately it came too late for Peake's peace of mind: he had already suffered the crushing disappointment of the unfavourable reviews of *The Wit to Woo* when 'For Mr Pye – An Island' went out (10 July 1957), and he had gone to Sark itself for a holiday to recuperate and did not hear the broadcast (*A World Away*, p. 124).

In the Christmas play, 'The Voice of One', Peake brings together several aspects of himself into a single work: the painter, the poet, the dramatist, the Christian and the individualist. It is a simple fable in which he explores the subject of the artist in opposition to the world. A vicar commissions a Christmas mural for his church. The painter of the mural, Jarvis, paints a moderately futuristic painting which provokes bewildered rage in the hearts of all the congregation except one, a small child who takes intuitive delight in the picture and calls it 'Jesus in a space-ship'. Many years after he has painted the mural Jarvis returns to the church and finds an ironic change in the attitudes of the congregation: the painting is now thought of in lukewarm terms of approbation such as 'nice' and 'pretty'. Only the vicar has been able to penetrate to some degree the nature of the artist's vision.

Under Milk Wood is again present in the technique of this play, which is introduced by a story-teller, who 'flicking the pages

of a gull-winged bible' observes the unconscious egotisms of the members of the congregation as they mutually compete to present the best exhibits in the harvest festival display. The artist's right to his freedom is roundly asserted by the vicar as he introduces his proposal to commission a mural of the Nativity.

Artists do not see things as we see them. Nor do they imagine things as we imagine them. They go their own way. That is their right and that is their glory.

('The Voice of One')

The artist appears and wrestles with his conscience: should he, lacking a formal faith, accept the commission? He is treated perhaps a little too deferentially by the vicar who enters so completely into his point of view that there is no conflict of any kind between the two and therefore no dramatic tension in the relationship, and the two men become like twin lay-figures illustrating Peake's argument for the supremacy of the artist. The artist insists that 'if you commission me, I shall be given a free hand', and the vicar recommends him to the congregation as 'young, prickly and proud. As we all have been'. The vicar defends the artist's unique vision and his right to 'spread intolerant wings and fly! Fly to his coloured Kingdom!'.

Intolerance seems to characterise the portrait of the artist in this work. In my discussion of Peake's attitudes to the role of the artist (see below, Chapter 5) I shall suggest that he was normally humble in these matters. He saw himself as an instinctive romantic artist who is convinced of the importance of his own visions without wishing to assert his own ego. To read *Titus Groan, Gormenghast* and the better poems and to sense the writer's absence of self-consciousness and his unabashed delight in his inventions is to recognise that in the 1940s Peake the writer and Peake the critic were being true to each other (see discussion of Peake's romanticism in Chapter 5, below).

None of his work in the 1950s is as successful as his earlier work. *Mr Pye, Titus Alone* and *The Wit to Woo* lack the depth and confidence of the earlier Titus books; they are sharper, more satirical, and one can sense in them the effort of their contriving. Perhaps as his art lost its power Peake's sense of the artist's importance became defensive and somewhat mechanical, so that in place of the assured modesty of his attitude to the artist in the

1940s one has the shrill assertiveness and the elaborately exalted claims of 'The Voice of One'. It is not a very attractive work, and in justice to Peake one must remember that the attitude to the artist here is quite different from the attitude evinced by him at the height of his powers: then he saw the artist as a selecting and transmuting eye, a humble human agent, a translucent medium for the wonderful and engrossing visions granted to the imagination. It is this pure romantic vision of the artist which is most characteristic of Peake and which one ought to retain.

Peake's work in the 1950s did not stop at nine plays and two novels and miscellaneous short pieces: he continued to teach at the Central School long after he was able to fulfil all his duties, through the kindness of Morris Kestelman who was head of painting at the school (interview with Morris Kestelman; see also *A World Away*, p. 136), and he was still producing a steady stream of paintings and books with illustrations. *Figures of Speech* (Gollancz, 1954) was a clever guessing-game presented as a series of drawings each illustrating a set phrase: 'severing relations' shows an elegant young man in a bow tie slicing off the heads of an uncle and aunt, both of whom look politely startled. Two of his illustrated books of this period were by Burgess (H. B.) Drake, Eric Drake's brother, who had been a friend of Peake's since Eltham College days and was godfather to Peake's daughter. Peake created a set of detailed and charming drawings for a children's book, *The Book of Lyonne* (1952) and another set of drawings which enlivens one of Drake's school textbooks for the Oxford University Press (see bibliography).

Perhaps the most remarkable of these later books is Balzac's *Droll Stories*, illustrated for the Folio Society (1961). Peake's illness at this stage was so advanced that he could scarcely understand the stories and had difficulty holding a pen (*A World Away*, p. 139), yet the finished drawings are charming and appropriate additions to the text.

When one looks at the 1950s, the last working decade of Peake's life, two salient facts present themselves. He had put aside Gormenghast Castle, that astonishing creation which had occupied his imagination for the previous ten years, and the work of this period is less good than the work which preceded it. A reader who responds to and delights in the first two Titus books is bound to feel that in the later works Peake descends from the romantic

heights to the ironic foothills, and that he no longer 'pours' himself out 'through the gutters of Gormenghast' (letter to his wife, *A World Away*, p. 107).

He greatly loved 'Woodcroft', the house in Wallington, and it is tempting to see a significance in the pattern of his relationships with that house. From 1911 to 1937 the Wallington house was Peake's home. He then left it for fifteen years, and for ten of those years (1940–50) he created and amplified the castle of Gormenghast. In 1952 he returned to Woodcroft and remained there until 1960; until the end, in other words, of his creative life, during which time he was not impelled to write about Gormenghast Castle with the single exception of the travesty presented in Cheeta's party at the end of *Titus Alone*. Gormenghast Castle, then, can be seen as an aspect of Woodcroft, an ample, gloomy, protected, stable way of life which formed the background to his formative years of late childhood, adolescence and early manhood. Separated from this house and plunged into the stress of war and the new experience of family responsibilities in the 1940s, Peake responded by mapping out a world which had the qualities of Woodcroft in an exaggeratedly Gothic form. When in 1952 he returned to his parents' house as its owner the instabilities receded and the need to reproduce images of Woodcroft diminished.

5 Romanticism and the Role of the Artist, 1940-68

During the second Sark period, 1946-9, Peake made frequent visits to London in connection with his work, and one of the most valuable things he was able to do at this time, from the financial point of view, was to make broadcasts. He and his wife had taken part in an 'In Town Tonight' programme in the 1930s; after this first broadcast he did nothing on the air until 1947, when he made two broadcasts for the Pacific Service of the BBC (intended for listeners in Australia and New Zealand) and took part in a discussion of *Titus Groan* on the North American Service of the BBC. The opportunity for the talks on the Pacific Service, Peake's first important broadcasts, was provided by Kay Fuller, a friend whom Peake had met at the Café Royal during the war.

> The painter Elmslie Owen and his wife Margaret invited me to a birthday dinner at the Café Royal. As was the custom there in those days – where everyone knew everyone – several people joined our table at the coffee stage. I think Michael Ayrton was one and certainly Mervyn was another. Mervyn and Elmslie were old friends, both having lived and painted in Sark. There was animated discussion about ends and means, I remember, in which harsh things were said about Sickert's habit of painting from snapshots, about modelling versus carving, about the scraperboard technique and so on. Rashly, in the presence of the professionals, I maintained that the effect was all that mattered, however achieved. This went down very well with Mervyn who moved up the table to sit beside me. We continued the conversation a day or so later and thereafter met at intervals over a good many years.
>
> (Letter to author from Kay Fuller, 5 March 1972)

Miss Fuller became a Talks Producer in the Pacific Service of the BBC in 1947 and invited Peake to make two ten-minute talks under the general title, 'As I See It'.

> I asked Mervyn to describe the particular way an artist looks at the world of physical objects. This talk, called 'The Artist's World', was broadcast on 26 May 1947. I must have found it

satisfactory as I asked him to do another talk in September of that year, this time on book illustration.

(Letter to author)

The first of these talks is an interesting blend of classical and romantic aesthetic doctrine. It was obviously carefully written by Peake and has all the marks of his characteristic prose style: rich colourful vocabulary, much detail, much amplification. He opens with the proposition, 'we do not see with our eyes, but with our trades', and he illustrates this notion with the image of a tree: to a farmer a tree is an obstruction in his field, to a carpenter it is the material of his craft and to a child it is a plaything, while 'to a poet, it may be that a tree is a green fountain'. Despite these analogies an artist should not, says Peake, seek significance in the forms that he perceives: to do so is a distortion of his function. His duty is simply to 'see', to receive and report what the eye observes.

Considering the word 'it' in the title of his talk, 'As I See It', Peake concludes that the world of visual experience is a seamless web: 'The "IT" was, for me, the visible world around and about me.' A passage of impassioned purple prose follows in which he expresses the nature of this visible world, its colours, its shapes and its 'rhythms' which 'flood' incessantly in front of the artist's eyes: 'the faint glaze that spread across the sky because of the glass that divided me from rocks, plants, waves, lizards, sunflowers, wall-papers, a fruit, a cat, a child' ('As I See It: The Artist's World').

Despite the heightened language and intensely personal tone of this conclusion it is clear that the last lines are a faithful recording of the landscape of Sark (where Peake then lived) seen through a window with his own garden in the foreground. So although the vision can be modified by the perceptor (to a poet a tree is a green fountain) yet it is the duty of the artist not to interpret but to receive; a state of things analogous, perhaps, with the classical doctrine that art is the 'imitation' of life.

This doctrine is at variance with the introduction to a collection of Peake's drawings *(The Drawings of Mervyn Peake)*, published in 1949 in which he presents what is essentially a romantic concept of the artist as hero. What the artist is, in this introduction, is an essential precondition of the quality of the work, and

the work in turn reveals the nature and quality of the artist and the nature and quality of life.

> 'Does *life* matter?' — 'Does *man* matter?' If man matters, then the highest flights of his mind and his imagination matter. His vision matters, his sense of wonder, his vitality matters. . . . Art is the voice of man, naked, militant, unashamed.
>
> (*The Drawings of Mervyn Peake*, p. 10)

Art, then, is both a faithful and vigilant record of the artist's vision and an expression and embodiment of the personality of man at its most heroic. In Peake's own art the latter reading seems to prevail: and yet even at its most fantastic his drawing and his writing had a detailed quality, a concreteness and concern for verisimilitude which draws one's attention back to the ancient duty of 'imitation' which is implied in his remarks on the artist's vision in his first broadcast. There is no doubt that for the observer Peake's art is essentially romantic, but probably Peake saw himself as an artist seeking what he calls 'equipoise' between the classical and the romantic, the personal expression and the mimetic form.

> The finest examples of any master's work . . . are balanced on a razor's edge between the passion and the intellect, between the compulsive and the architectonic.
>
> (*Drawings*, p. 9)

When he is writing about his attitudes to art as a whole Peake's tone tends to become ambitious, rhetorical and unfocused. One has the sense that he is bringing his mind to bear on a majestical calling which cannot clearly be seen, its loftiness endowing it with a certain mystification. But when he writes about his own drawing his tone becomes cheerfully practical, suggesting that when he speaks as a craftsman Peake descends from the clouds and is found happily engrossed in his studio with a student, perhaps, looking over his shoulder.

In his broadcast on book illustration, which he made for Kay Fuller on 20 September 1947, Peake describes how it was that he first became diverted from painting into book illustration:

> All my life I have been painting and making drawings but I only started illustrating books when I was conscripted in 1940. I was a poor soldier and was constantly on the move from unit

to unit – and even from regiment to regiment. The Royal Artillery and the Royal Engineers claimed me twice apiece and appeared to vie with each other as to which could get rid of me the quicker. This constant moving about gave me little scope for painting, and I found myself continually packing my kitbag and away again with yet another canvas too wet to travel.

('As I See It: Book Illustrations', quoted in *The Listener,* 27 November 1947, p. 926)

When he was invited to illustrate *The Hunting of the Snark* (1941) he set out to see as many notable drawings as he could as a basis for his technique: Rowlandson, Cruikshank, Bewick, Palmer and Leach; Hogarth and Blake; Doré and Gronville; Dürer; Goya. He followed no particular school or period; he went to these artists primarily for the quality of their line, for their methods. He gives a fascinating account of an early influence on his own visual perception: an artist called Stanley L. Wood who drew for the *Boys' Own Paper* in his childhood:

This man was my secret god. His very signature was magic. His illustrations for a serial called 'Under the Serpents' Fang' were so potent upon my imagination that I can recall them now almost to their minutest detail – the stubble-chinned adventurer knee-deep in quicksands, his eyes rolling, the miasmic and unhealthy mists rising behind him – I remember the tendons of his neck stretched like catapult elastic and the little jewelled dirk in his belt.

('As I See It: Book Illustrations')

Like Blake's, Peake's imagination was catholic and would embrace anything that pleased it.

This broadcast on book illustration is notable for two features; it records Peake's own acknowledgment that the vicissitudes of war had pushed him into book illustration as well as into his writing, and it shows his remarkable humility when confronting the authors whom he was asked to illustrate. He has a writer's respect for writers and holds that the illustrator must subordinate himself totally to the book, must 'slide into another man's soul'.

A little book on drawing, *The Craft of the Lead Pencil* (1946), gives one an excellent sense of Peake the craftsman and teacher. The subordination of illustrator to text in his book illustration

broadcast modulates here into the subordination of hand to vision, ego to subject:

> Scrutinise the object for a long while. Try to understand its shape, its solidity, or outline, or texture, or whatever it is that interests you about it – and then after the long stare – when you know what you *want* to record, begin. Perhaps you will have made but a single line.
>
> (*The Craft of the Lead Pencil*, p. 3)

Neither prescriptive nor adulatory, the attitude to the artist here is cool, lucid, tolerant. The will and personality of the artist are, of course, still important, but as a filter, a selecting and transmuting agent. As in the letter to Maurice Collis referred to above (see p. 37), where he subordinates the will of the author to that of the characters, Peake the teacher subordinates the will of the draftsman to the integrity and function of the object.

The problem of relating the pressures of the personality to the integrity of the object is an acute one for Peake, whose mind resembles the minds of his preferred artists (Dickens, Goya, Blake, Rembrandt) in that the intensity of its inward visions could threaten to blot out the real world entirely. In a piece called 'How a Romantic Novel was Evolved' he described the way he began to write *Titus Groan* and the function of the drawings in the manuscripts of that book, which were used as models 'which helped me to visualise the characters and to imagine what sort of things they would say'. This provision of what they *would* say, what the character, the exclusive product of Peake's vision, would do if it had free-will seems impossible, and almost wilful, but one which Peake seems to have taken perfectly seriously, and which provides an important clue to his method of work. Even if the object is discovered within the artist's own head, its integrity is as sacrosanct as the integrity of the tree outside the window, the rocks in the bay. In this special sense, then, Peake literally fulfils his own demand that the artist should discover the 'equipoise' between the personal and the objective, the intuition and the function, the romantic and the classical. But simultaneously and un-equivocally he allows *Titus Groan* to be described as 'a Romantic Novel' ('How a Romantic Novel was Evolved', pp. 80–9).

In June 1947 Peake took part in a broadcast in which he was interviewed by a number of critics on his book *Titus Groan*. Two

friends, Kay Fuller and John Brophy, the novelist and art critic, were among the panel, and the Chairman was the Canadian broadcaster Rooney Pelletier, who had been greatly impressed by *Titus Groan.*

Asked about the method, purpose, and origins of his book, Peake insisted on the intuitive and personal nature of his writing, and was reluctant to talk about its significance, its plan, or its origins. He rejects vigorously the notion that the book might have had psychological origins: 'It was really a case of self-indulgence, the whole book – I enjoy the fantastic.' Throughout this debate he clings to the liberty and autonomy of the romantic artist whose first and highest duty is to know himself and his own tastes accurately: 'You can do whatever you like in Art so long as you know that you really like it – and that is what takes a lot of hard thinking, hard feeling, to know' ('The Reader Takes Over: A Discussion of Titus Groan').

Will, preference, delight, and whim, even, are placed above order, 'imitation' and the integrity of the object. Indeed here Peake comes close to a form of aesthetic totalitarianism when he confesses the delight of writing to be like the delight of wielding power: the will is supreme and 'no dictator on earth can say what word I put down'. Here the romantic side of Peake's nature eclipses 'equipoise': the artist is supreme, his will is law, his vision sacred. Throughout Peake's art it seems fair to say that this was the prevailing attitude and indeed was the conviction that gave him strength to carry on when the disappointments of the 1950s began to crowd in on him. But the subtlety and complexity of the man is such that he was a romantic without egotism, an authoritative but not a self-righteous artist.

A later broadcast in which he again discusses his art went out on 12 December 1954 and was entitled 'Alice and Tenniel and Me', and deals with his illustrations to *Alice in Wonderland.* Here the humility is immediately apparent because Peake was dealing with a text in which he had immersed himself, a text that he loved. He finds Tenniel's technique somewhat dull, but nevertheless delights in the illustrations and feels that he was himself over-bold in following the great Victorian and that *Alice* is in any case a work that almost defies illustration.

His reluctance to illustrate the first edition of his Titus books is thrown into relief by this. His refusal seems odd in retrospect.

The books might well have sold more promptly and reached a wider audience on their first appearance if he had published the drawings with them, and he certainly felt inclined to publish some of the drawings for *Titus Groan* immediately after the appearance of that novel, because he published several of them in the piece which appeared in *A New Romantic Anthology*. Nevertheless in the later Titus books he continued to present just the printed page. Perhaps his instinct was justified by the fate of *Mr Pye*, his one illustrated novel, which did not sell when it first appeared and was remaindered.

Although Peake says that he dislikes the terms 'romantic' and 'classical' and that he seeks the 'equipoise' between the two, it is obvious with regard to his writings, at least, that in the long view of the experienced reader he was an out-and-out romantic. Everything he said and did not say about art – that it should not be planned, that it should be intuitive, that it should spring from the 'excitement' of 'a piece of white paper and a pen in one's hand' – points to a writer who, like Keats, put forth his art as a tree puts forth leaves. Moreover, Peake's refusal to acknowledge that order and planning were part of the preparation for his work and his insistence that he writes what he delights in for his own pleasure fulfil the doctrine of simple, direct speech, of breaking away from known moulds and forms. The fact that Peake's practice is at odds with his theory, that his novels are highly artificial forms and that his poetry is intensely 'literary' in the bad as well as the good senses, places him firmly in the mainstream of romantic art, since the work of all romantic writers has shown just this contradiction: Wordsworth writing in the manner of Gray and Cowper, Coleridge imitating the medieval ballad and Keats pouring his soul out in forms borrowed from Shakespeare, Milton and Spenser, all argued that they were speaking the language of common men. And in a sense they were right; by freeing them from the need to master a single style their doctrine forced them to become masters of all styles, and the diversity of their forms and the multiplicity of their grand designs and unfinished projects can be seen as aspects of the practical consequences of the 'liberty' that they embraced.

Peake is also a romantic in a sense which is important for the twentieth century: he creates and firmly inhabits a world which differs from that of anyone else, and a recent critic has termed

this the criterion of romantic success in any creative writer (John Bayley, *The Romantic Survival*, Constable, 1957, p. 83). He does this with intensity but also with humility, a combination of qualities rare in any artist, decidedly rare in a romantic artist convinced of the importance of his own visions. *Titus Groan* is the inevitable overflow of his response to the war, an overflow which he neither forced nor wished for, into a form with which he was unfamiliar, and for which he was both untrained and in a sense unequipped. The result is a work which is immediately delightful, a rich and strange narrative which a whole generation of articulate people greatly enjoy, but which has on the whole been treated with neglect or suspicion by critics.

Just as his work stands outside the common run of literature so Peake the man stands outside the common run of life; he begins and ends his life in England in an unexciting suburban house, but his birth in China, his life in Sark and his war-time experiences make for a pattern which denies this suburban colouring. Also, as well as being unworldly Peake was wilfully eccentric: when he bought his house in Smarden he knew that his income would not enable him to pay for it, and after his second return from Sark he bought himself a car and failed to tax or insure it, and came close to being arrested. His wife's Memoir suggests that he did not know that these things were required (*A World Away*, p. 94) and that when he borrowed money for his house he had thought that interest meant just 'to be interested' (*A World Away*, p. 95), but his brother Leslie Peake denies this, arguing that Mervyn may well have failed to pay his interest or tax his car but that he would certainly have known that these things were necessary (letter from E. L. Peake, 17 January 1971). Perhaps the unworldliness was deliberate; perhaps Peake courted disaster and instability. If so, one may suggest that the artist in him knew, instinctively, that the security of Woodcroft would dry up the springs of his art, and that a certain tension between the vision and the desire were essential for his creative life.

PART TWO: WRITINGS

6 *Titus Groan*

1. The writing of *Titus Groan*

With its extraordinary combination of extravagant comedy and imaginative depth, its astonishing vision of a unique world, its assured writing and its compelling sense of coherence and integrity, *Titus Groan* is a first novel of genius. If Peake had written this and nothing else his standing as a writer would be assured. His wife has described how he began to write the book in publishers' dummies in the first year of the war and sent them back to her one by one, the strange narrative unfolding, interleaved with startling drawings (*A World Away*, pp. 39-40, 48-9).

There were twelve volumes of *Titus Groan* in manuscript of which the present writer has seen all but the first. The second in the series is headed 'Goremenghast, continued Mervyn Peake', and the first entry begins under the heading 'Dartford [where Peake was undergoing training as a gunner] 3 October 1940'. The manuscript begins at the thirteenth chapter of the published text, 'Mrs Slagg by Moonlight', which is here headed 'Keda'.

The names in the manuscript are interesting: at this stage of the writing the family name of Groan and the women's names, Gertrude and Fuchsia and the higher servants' names (Swelter, Flay, Rottcodd) were already established; and Titus's own name remains unchanged. But Lord Sepulchrave for the first part of the manuscript is 'Lord Seuma', and Steerpike is 'Smuggerly', while some other names show minor differences: Prunesquallor is 'de Prune-Squallor' and Slagg is consistently 'Slag'. Apart from Seuma these names release clear meanings: 'Smuggerly' recalls the pirates of *Captain Slaughterboard* (which Peake had just seen into print) and *Treasure Island*; the Gallicised and hyphenated version of Prunesquallor's name suggests both the Anglo-French upper class that Peake encountered on Sark and a Dickensian shabby gentility which retains the diction of prunes and prisms; 'Slag' suggests the wasted slag-heap life of an old spinster and the sagging of her unloved breasts. 'Goremenghast'

and 'Titus Groan' themselves are mock-Gothic names in the tradition of Peacock's *Nightmare Abbey*. The meanings are self-evident, though it is worth remarking that the 'Gore' in this earlier spelling increases the probability that *Titus Andronicus*, that blood-sodden piece, furnished Peake with his hero's name. While the other subsequent name-changes make for less obvious type-casting in the published text, the change in the Earl's name from 'Seuma' to Sepulchrave seems to be a change from the obscure to the straightforward: 'he who craves a sepulchre'.

A curious note appears in the manuscript under the date 11 October 1940; in the course of Chapter 14 called 'First Blood' Peake wrote 'Pentecost: Region of Miracles and Imagination'. Pentecost is the Head Gardener of Gormenghast, and appears only in this one chapter, but the care that goes into his making suggests that at this stage Peake intended him for an important role. He is a hideous old man with a magnificent head and an innate romantic sensibility: 'Of flowers he had a knowledge beyond that of the botanist, being moved by the growth . . . the organic surge' (p. 99). The energy in his plants excites him more than their blooms: he is a pantheist, worshipping life wherever he finds it. 'He knew that what was important for him, what he really understood and cared for, was below him, beneath his slowly moving feet' (p. 99). One suspects that this figure was to have become a romantic prophet endowed with the gift of tongues, celebrating the mystery of the earth; he perhaps reappears transmuted into the Brown Father who nurses Keda after her flight from Gormenghast, but this is his only appearance under his own name.

The manuscript of *Titus Groan* settles into a reasonably consistent relationship with the published text. The published text followed the order of the manuscript exactly, but in its details it has been heavily cut; Peake made substantial changes at the proof stage (*A World Away*, p. 49) and probably at the typescript stage as well. The changes at the proof stage were so numerous that Eyre and Spottiswoode were obliged to make it a condition of publication of *Gormenghast* that the alterations in proof would be limited.

Dr Prunesquallor's personality, as well as his name, undergoes slight changes between manuscript and publication. In the former he is a mathematician as well as a physician, an all-purpose eccen-

tric intellectual, scarcely human in the agility of his mind, his high-pitched laughter and his epicene manner:

> Even in his bath he wears his glasses and peering over the side
> to recover a piece of scented soap, he sings *of the Trapesius* as
> though it were his love, *his high shrill laugh breaking into his
> own singing as some aspect or other of his quick gull-like
> thought amuses him.*

All the italicised words are cut from the printed text, *the Trapesius* is replaced by 'his external oblique', and the whole is transposed into the past tense (pp. 100-1). Also Prunesquallor is located in his own house in the printed text, whereas the manuscript has 'De Prune Squallor *in his apartments near the Tower of Flints* is singing to himself in his morning bath'.

Prunesquallor's effeminacy is reduced by significant cuts: from p. 175 the whole of the following passage is omitted:

> Drink to the Coloured Things; and he swept his arm up in an
> ornate circular movement until his hand was poised high above
> his head, at which extremity the tips of his thumbs and little
> fingers made contact with an effeminate pretentiousness.

The book was progressing quite fast in October 1940, while Peake was billeted in Blackpool with his wife and first child (*A World Away*, pp. 41-4). The second volume ended with the Christening of Titus as published, and the third begins with an intriguing list of contents for the book which includes two earlier chapters which have vanished from the published text. Headed 'Chapters already completed in the rough', the list begins: '1. A Room by the River. 2. Goodbye to Stitchwater.' A later note at the end of volume four of the manuscript repeats these headings, and adds the phrase 'Lord Titus at 40'. This suggests that these opening chapters were a framing device for the whole narrative; that Titus in middle age would recall the circumstances of his birth and first two years rather as Sterne's Shandy sits down to write his earliest auto-biography.

The names of Seuma and Smuggerly remain unchanged in volume four of the manuscript which contains the first draft of Smuggerly/Steerpike's climb over the rooftops, written in billets in Blackpool in October-November 1940. The manuscript version of Steerpike's climb is considerably longer than the published

text and includes much business with Steerpike's pipe and the coldness of his hands. All the cuts here are good ones, leaving Steerpike's first vision of dawn as a clean and unique visual experience, uncluttered by other impressions.

It is a conscious piece of fine writing, and an examination of the insertions and deletions from manuscript to text in a single short passage shows how Peake worked to find the appropriate phrasing (*italics* = insertion, () = deletion):

> Then came the *crumbling* (ripping) away of *a* (another) grey *veil* (shawl) from the (sinister) face of the night, and beyond the *furthermost film* (furthest façade) of the *terraced* (midnight dark cloudy and sliding) clouds there burst *of* (on) a sudden a swarm of (starlike hunters) burning crystals, and, *afloat* in their centre, a splinter (curved and burning) of curved fire (a sickle moon in a cold pool of midnight).

(p.134)

By the end of the climb over the rooftops the name 'Steerpike' begins to appear in the first draft of the text and the name 'Smuggerly' is withdrawn, which perhaps suggests that Steerpike's personality had now hardened and become his own, and his creator has a clear notion of his characterisation.

Fuchsia's characterisation also benefits from the cuts made in the draft, which has a direct statement in the opening paragraph of Fuchsia's soliloquy in Chapter 22, 'The Body by the Window' (p. 145): Fuchsia is suffering an 'ungovernable tide of resentment against her mother and father, and all in the castle who knew of the event before she herself had been told and even against the innocent baby himself'. The 'event' of course is the birth of Titus. The cutting of these lines improves the presentation of Fuchsia's difficult personality, with her fits of envious rage and her neurotic need to be loved which can now be 'shown' by the action instead of being 'told' by the narrator.

Volume three of the manuscript of *Titus Groan*, still at this stage called 'Goremenghast', finds Peake nearly half-way through the book and facing up to the technical problems of writing an extended narrative. The notes at the end of this dummy show his sense of the need to impose order on the free, inspired and intuitive writing which has prevailed so far. The chronology of the notes suggests that they were scribbled in the back of the

book before the composition in the book began, since the notes begin with 'Smuggerly left in locked room', and volume three contains, as we have seen, Steerpike's escape from the locked room and his climb over the rooftops.

A list headed 'Ideas' on this page includes several possible lines of development which Peake later rejected:

> Fuchsia sets light to the North Wing [the germ of the burning of the library by the Twins].
> The Coast!
> The pirates.
> Elephants? Terrible Ears. Telescopes.

One of the difficulties with the composition of *Titus Groan* was the characterisation of Nanny Slagg; it is never easy to portray a bore without running the risk of boring the reader, and in the publication of this novel Peake must have become alive to this danger, as much of Nanny Slagg's tedious diction is cut. In the manuscript for Chapter 28, 'Flay Brings a Message', whole paragraphs of Nanny Slagg's monologue have 'revise' pencilled against them and are removed from the printed text.

Volume four of the manuscript for *Titus Groan* was written between December and February, 1940-1; it contains Nanny Slagg and the cuts attendant upon her, and also a good deal of the material associated with Braigon and Rantel. The reader of novels tends to take the basic organisation of the work for granted, but in the case of *Titus Groan*, where a whole world and its customs and history have to be invented out of the artist's mind as he writes down each sentence of his narrative, the organisation becomes a major problem, and one is not surprised to find it going astray in places. For one small example: in Chapter 33, 'Keda and Rantel', Peake explains that the Dwellers have a custom of pausing under the hut-lights as they pass each other (p. 232). When Keda encounters Rantel he explains this custom again in a shorter and slightly different form: clearly the repetition is a mistake (p. 235). All the writing of the Keda, Braigon and Rantel plot argues that Peake found it difficult to concentrate on these figures; much of their dialogue in the manuscript was drastically cut and yet still remains rather unsatisfactory in the final text. Keda returns to Rantel's fulsome greeting:

'You have come back', he said as though repeating a lesson. 'Ah, Keda – is this you? You went away. Every night I have watched for you.' His hands shook on her shoulders. 'You went away', he said.

(p.236)

In the manuscript this greeting lasts for a whole paragraph of rant, which depends heavily on repetitions of Keda's name and of the phrase 'You have come back' for its effects, and which concludes with an absurd crisis: 'He dropped his hands from her and beat the wall with his fists. "She has come back", he said between his teeth.'

Peake writes a note to himself in the manuscript recommending changes in the personality of Rantel: 'Rantel. More awkward. Gauche, Overgrown boy. Fiery.' But in the event nothing is done to make the changes indicated here beyond heavy pruning, which may make for a Rantel who is more taciturn and thus more masculine than the original, but does not make for greater interest.

The notes to volume four of the manuscript are again clearly written before the main narrative in the book was composed. They throw some light on the cuts and recasting that took place and significantly they make no mention at all of Braigon, Rantel and Keda, suggesting that Peake invented this subplot with no advance planning at all, which may well account for its dramatic feebleness. There is a long note in which Peake plans for the Twins (here called the aunts) to burn down Sepulchrave's library, and a short additional note which urges, bewilderingly, that (the Twins) 'must make more active part'. Since Peake has arranged for the Twins to destroy the library and thereby kill Sourdust, master of ceremonies within the castle, promote the villainous Steerpike and send Lord Sepulchrave into a melancholy decline which leads to his death, one would have thought that the Twins had been allotted action enough within *Titus Groan*. A planning note on Fuchsia shows that at this stage Peake was meditating a violent death for her too, but this device was later abandoned; there are already too many violent deaths in *Titus Groan* and one may be grateful for the omission of this one, even though it is only postponed until the writing of *Gormenghast* where Fuchsia drowns herself by leaping from a window.

A feature of these notes is that they look outwards towards

Gormenghast and even *Titus Alone* by anticipating characters and events beyond the period of *Titus Groan*. Throughout the manuscript of *Titus Groan* Peake scribbles lists of names in which he experiments with different versions of the names of the characters; Steerpike, for instance, whose name seems to have given Peake more trouble than any of the others, appears, variously, as 'Pierspike', 'Peerspike' and 'Shierspike' as well as 'Smuggerly'. In one of these lists of experimental names in *Titus Groan* appear a number of names which were later allotted (with modification) to the Professors in *Gormenghast*: 'Primcock, Mashmallow, Maudlin Tite, Corpse Brown, Opus Flake, Shred, Swivel, Magna Stewflower, Irk.' In the same list appears the name 'Flannelfoot' which seems to suggest Footfruit, the hero of an unfinished project of the 1950s, and 'Hollowpatch', which suggests Muzzlehatch, the towering father figure who protects Titus in his picaresque adventures in *Titus Alone*.

As well as problems of naming and organisation, problems of language are confronted in Peake's notes as the book advances. Volume seven of the manuscript contains the following list of words inside its back cover: 'Lacuna (hiatus). Cavil. Plasm – the living matter. Gibbous – hump-backed. Nascent, cosmic, null. Soffit – ornamented underside of ceilings, archways, staircases, etc. Gore-bellied – gluttonous. Plasma – liquid part of blood.'

In the summer of 1942 Peake's military service was interrupted by a nervous breakdown. In the course of this nervous breakdown the end of volume seven of the manuscript and the whole of volume eight (a short exercise book) were written. They form Chapters 56 and 57 of the novel, 'The Dark Breakfast', and 'Reveries', in which Peake makes a significant narrative experiment. In place of the omniscient third-person narrator who has presented the whole of the action to this point, he adopts the device of the interior monologue, and gives each of the characters a long paragraph of thought in which to develop his point of view. These 'reveries', as Peake calls them, are given to Cora (one of the Twins), Dr Prunesquallor, Fuchsia, Irma Prunesquallor (the doctor's sister), Clarice (the other Twin), Gertrude (Countess of Groan, wife of Sepulchrave and mother of Fuchsia and Titus), Nannie Slagg, and Sepulchrave himself. All the reveries except the first appear in volume eight of the manuscript, which is a small exercise-book headed 'Occupational Therapy, Southport

Neurosis Centre'. The exercise book was filled during June and July 1942. For nearly two months, then, Peake had leisure to devote himself entirely to his book, and indeed was encouraged to do so as part of the treatment for his illness. The new technique is a product of this greater concentration. The characters are seated round a table, and their reveries are bound together by a thump as Fuchsia's head strikes the board (she has fainted). A note at the end of volume eight of the manuscript indicates that Peake felt that the reveries brought the novel to some kind of conclusion. He writes: 'End of Book One (at last) Southport 24 July 1942.'

At the beginning of volume nine of the manuscript of *Titus Groan* Peake writes out a full list of the chapters which is complete (with variations) as far as Chapter 62, 'Gone', in the published text. He heads this list: 'Goremenghast. Part One. Background for Titus.' This heading indicates that at this stage Peake saw the whole of the narrative which he had written so far as mere introduction and scene-setting, and that the story proper had not yet begun: the story proper, presumably, being the unfolding of the life and career of Titus himself. Presumably then, 'Goremenghast' existed in Peake's imagination at this time as a project so vast that no single man could hope to finish it, if it was to be written to the same scale as the 'introduction'. But it seems clear that in the course of writing volumes ten and eleven Peake began to see that the 'introduction' to his enormous project was itself already a book, and that although Titus was not yet two years old the narrative had better be brought to an end. In volume eleven of the manuscript there are two title pages, The first reads: 'Titus Groan, Part One (continued) GORMENGHAST' (the first appearance of the revised spelling). The second reads: 'Titus Groan by Mervyn Peake.' This is, of course, the first appearance of the title in the form under which the book was published, and it marks a significant and decisive change. Peake now sees that the bulk of manuscript that he has already completed will make a complete book in itself, and he now works for an appropriate ending to a narrative which has been largely expository. He finds this ending in a culminating exposition: Titus receiving his titles in the ceremony of the Earling, which eclipses the Christening and even the Dark Breakfast in importance. The interior monologues in the Dark Breakfast may well have been inspired by Joyce, whom

Peake admired, and in the notes to the book he looks to Joyce for an ending. Bearing in mind that *Ulysses* ends with the word 'yes' Peake suggests to himself 'last word of the book "Nevertheless" ' (volume nine of the manuscript). In the event he moves away from the example of Joyce and finds in the elaborate ordered tableau of 'The Earling' a conclusion more suited to his own talent.

Although *Gormenghast* becomes properly the title of the second of his novels, it seems clear that he wrote most of *Titus Groan* as a preface to an enormous work called 'Goremenghast' and that in the last three volumes of manuscript the intention clarified and changed. This indicates that the 'Gormenghast Trilogy' is not properly a trilogy. The name refers to three self-contained novels, the second of which, *Gormenghast*, is quite different in scale and scope from the huge dimensions anticipated by the first. The third book, *Titus Alone*, is not set in Gormenghast Castle itself and the hero's function is to be an innocent, a Candide-like eye, contemplating a corrupt world. The 'Gormenghast Trilogy' refers, then, to a body of fiction which is not a trilogy and which moves away from Gormenghast itself. Since the persona of Titus Groan is the only element which is common to the three books, it is perhaps preferable to refer to them as the 'Titus Books'. That title can be extended to include the fragmentary manuscripts of a fourth Titus novel, known only as 'Titus 4', which Peake left at his death. In 'Titus 4' Titus is taken into old age and embarks on a greatly extended series of picaresque adventures of the kind that we have in *Titus Alone* but he never returns to Gormenghast Castle. As a collective name for the books, then, 'Gormenghast' becomes even less suitable when one bears in mind the existence of an unpublished 'Titus 4'.

2. The patterns and themes of *Titus Groan*

The strongest stimulus in *Titus Groan* is the visual stimulus. One can tell immediately that the writer is not accustomed to linear narrative, and that the mode of expression which is easiest for him is the creation of a stylised tableau which he then fills out with detail. His friend Gordon Smith suggests that Dickens is the major inspiration for *Titus Groan* (interview with Dr

Smith, 25 February 1971) and bearing in mind that Dickens's imagination was fired in the first instance by the drawings for *Sketches by Boz* and *Pickwick Papers* one can see certain parallels between Peake's creative method and that of Dickens. Throughout the manuscript of *Titus Groan* Peake included sketches of the characters as though it was difficult for him to progress without visualising the figure in advance; some of these drawings were published to accompany the brief account of his writing method which appeared in 1949 under the title 'How a Romantic Novel was Evolved' where Peake comments on the drawings as follows:

> As I went along I made drawings from time to time which helped me to visualise the characters and to imagine what sort of things they would say. The drawings were never exactly as I imagined the people, but were near enough for me to know when their voices lost touch with their heads.
>
> ('How a Romantic Novel was Evolved', p. 80)

The idea of Gormenghast grew out of a process of writing which was 'automatic':

> A mixture of serious as well as nonsensical fantasy began to pour itself out, without object, sentences growing out of their precursors involuntarily. About three chapters were written like this and then scrapped when the idea of Gormenghast began to evolve.
>
> ('How a Romantic Novel was Evolved', p. 80)

Peake was unlike Dickens in that he had no natural capacity for creating plot, and has to learn how to organise his narrative as it progresses. Sudden death is a convenient means by which a novelist can get his characters off the stage and his plot forward, and Peake often resorts to this to give shape to his narrative in the Titus books. *Titus Groan* itself is punctuated by a series of conflicts, each of which ends with the death of one of the combatants: the struggle between Swelter and Flay removes Swelter from the action, Sepulchrave and Sourdust are destroyed by Steerpike who prompts the Twins to burn down the library as part of his scheme to gain mastery of Gormenghast, and Braigon and Rantel die in their battle for the love of Keda. These outbreaks of violence present Peake with opportunities to write virtuoso

pieces; otherwise the narrative depends heavily on exposition, the creation and filling out of settings and characters.

Titus Groan has twenty-two main characters, and much of the book is devoted to presenting these figures, with their settings and circumstances. In its published text the work has sixty-nine chapters, of which at least thirty consist of exposition: in some cases this covers several sections, as when Steerpike is crossing the roofs of Gormenghast, but the characteristic method is for a whole chapter to present a single character. Some of these have the name of the character presented: 'Swelter', 'Sepulchrave', 'Fuchsia', 'Keda', 'Prunesquallor's Kneecap', 'Mrs Slagg by Moonlight'. Others use the name of the setting, and present the character in it, particularly in the early part of the work. Chapter 1, 'The Hall of the Bright Carvings', presents Rottcodd, curator of the Hall, and uses the Carvings as a theme round which a brief introduction to Gormenghast, and some idea of its inhabitants, can be organised. Chapter 2, 'The Great Kitchen', places Swelter, the monstrous cook, in the context of his role in the castle. This section is organised round the ideas of gigantic scale, and of correspondence between form and function. Swelter embodies both ideas, his vast belly reflecting his job as a cook, and his swollen proportions defying the human norm. The immense kitchen which he rules is drawn according to his scale, and the other inhabitants of it have physiques drawn according to their functions: the Grey Scrubbers are flat-faced and featureless like the wall they work on, the *legumiers* are red-headed and the *sauciers* wear green scarves, and the apprentices are an anonymous group of small boys in striped jackets and white caps.

Perhaps the most effective of the expository chapters which match setting to character is 'Tallow and Birdseed', Chapter 7, in which the Countess first appears. The title gives the leading motifs: the drippings from the candles lead into a description of the disorder of the Countess's bedroom, which is deep in tallow-like bird droppings, with the absence of light and cleanliness in the castle reflecting the absence of energy or purpose in the Countess herself. The birdseed leads into the Countess's positive qualities, her love for natural creatures and her role as a mother. The section is designed to give no reference until the end to the fact that the Countess has just given birth to Titus.

This expository method in which each figure in his setting,

Keda and the Dwellers, Fuchsia in her attic, the Prunesquallors in their elegant Georgian house, is revealed in slow detail, calls for an innocent eye to record the images as they go by. In the first stages the innocent eye is that of the reader who explores the castle and wishes to see more of it, and the opening phrases of some of the earlier sections are like extracts from a guide-book :

> Gormenghast, that is, the main massing of the original stone . . .
>
> (Chapter 1, 'The Hall of the Bright Carvings')

> Every morning of the year, between the hours of nine and ten, he may be found, seated in the Stone Hall.
>
> (Chapter 9, 'Sepulchrave')

Peake also makes persistent use of a technique in which the innocent eye is that of one of the characters. From Steerpike's point of view the novel is the story of a quest in which he seeks to escape from his servitude in the kitchen and gain mastery of the crumbling society in the castle. Steerpike is an 'eye' in a literal sense in Chapter 3, 'The Spyhole', where he is led by the disgruntled Flay to a peep-hole from which he can observe the Groan family; the reader thus benefits from his first impressions of Sepulchrave, Prunesquallor and Fuchsia. But in Chapters 17 to 21, 'Means of Escape', 'A Field of Flagstones', 'Near and Far', and 'Dust and Ivy', the use of Steerpike has become sophisticated, and the revelation to the reader, through him, of the rooftops of Gormenghast, is bound up with his characterisation, his role in the book, and the movement of the work as a whole.

On the day of Titus's birth Steerpike has been locked into a small room by Flay and then forgotten; he escapes through a window on a roof, and spends the night there. The following day he explores the roofs of the castle until he discovers an ivy-covered tower with an accessible window which admits him to a secret attic which is Fuchsia's private playground. Within this framework Peake explores very elaborately the extent to which visual impression can be rendered by means of language. Steerpike witnesses the approach of dawn :

He felt, rather than saw, above him a movement of volumes.

Nothing could be discerned, but that there were forces that travelled across the darkness he could not doubt; and then suddenly, as though another layer of stifling cloth had been dragged from before his eyes, Steerpike made out above him the enormous, indistinct shapes of clouds following one another in grave order as though bound on some portentous mission.

(Chapter 19, 'Over the Roofscape')

After this remarkable image of darkness as something tangible bandaged over the eyes comes the release from darkness in Chapter 20, 'Near and Far', in which Steerpike sees with sharpened focus and with a heightened responsiveness to colour and line, 'where the last detail is perceived in relation to the corporate mass'. He sees two figures (whom one later learns to be Cora and Clarice Groan, Sepulchrave's twin sisters) emerge from near the top of a tower onto the trunk of a dead tree which grows horizontally from it: 'They appeared about the size of those stub ends of pencil that are thrown away as too awkward to hold . . . Beneath them swam the pellucid volumes of the morning air.'

A distant lake seems 'about the size of a coin', and a crow which flaps its way from the rim of the lake towards Steerpike 'grew from the size of a gnat to that of a black moth'. These images indicate the gigantic scale of the scene before Steerpike, who has become endowed with more than human perceptiveness, newly re-created as a seeing eye. Within the simple framework of Steerpike's climb over the roofs Peake composes an ambitious virtuoso piece in which he explores the nature of vision.

For nearly half its length – the first twenty-eight chapters – the book lingers round the day of Titus's birth. Within these chapters Peake takes some liberties: Chapters 12 to 16 are ostensibly set twelve days after the birth of Titus, but within them are a number of recalls (e.g. Nanny Slagg going in search of a wetnurse among the Dwellers) which take the action back to the day of the birth. Chapters 17 to 26 revert to the day of the birth and the day following, on which Steerpike invades Fuchsia's attic and is introduced to the Prunesquallors. Nearly half the narrative, then, can be regarded as exposition which presents Gormenghast and its characters on a single day.

In a sense the whole book is expository, and comes to an

end when the inhabitants and characteristics of Gormenghast Castle are fully revealed, but there are two distinct lines of action which serve, from Chapter 29 to the end, to knit the tableaux together into an articulated pattern. Steerpike's plot to destroy the Groan family is counterpointed by the story of Keda's return to the Dwellers and the fight to the death between her two lovers.

Steerpike's plot to destroy Sepulchrave's library in order to subordinate the Groans takes up much of Chapters 29 to 51, and occupies a single short period of dramatic time, the third month of Titus's life. Steerpike leads the Twins to set fire to the library when the household are gathered there in the hope that they, as the only surviving Groans, will inherit Gormenghast; his hidden motive, of course, is to become the saviour and therefore the master of the Groans by rescuing them from the flames. Sepulchrave goes mad, imagines himself an owl, and is eaten when he tries to join the actual owls in the Tower of Flints; and Steerpike is further rewarded in an unexpected way by the death of Sourdust, Master of the Rituals, which means promotion for Steerpike as assistant to the new Master, Barquentine.

Although exposition and visual concretion remain central throughout the book, Peake's use of language becomes steadily more important and controlled as the work progresses. Before *Titus Groan* he had published no prose (apart from the text to *Captain Slaughterboard*) but was a prolific poet, and many of the characteristics of his verse carry over into the writing of *Titus Groan*, where the alliterative passages, the colourful palate of adjectives and the string of noun-phrases in apposition without a formal sentence structuring can all be seen as features transposed directly from his poetry. From his nonsense rhymes come other characteristics; the perpetual punning or transformation of words, and the taste for phrase patterns which repeat themselves without reference to the sense. Wordplay and nonsense rhymes had been part of Peake's childhood, and the writing of such things was second nature to him and his brother when they were small. One piece they composed when Peake was about seven gives an example:

> I saw a Puffin
> In the Bay of Baffin
> Sittin on Nuffin
> And it was Laffin.

There are some nonsense rhymes interspersed in the narrative of *Titus Groan* in the early chapters (spoken by Fuchsia and the Poet) showing that Peake's mind still ran on this kind of material. Some of Fuchsia's nonsense verse reappears in his 1944 book of nonsense poetry *Rhymes Without Reason*.

An element which does not arise from his poetry is his use of habits of speech as a source of characterisation. With some of the characters this technique is overplayed and becomes tedious, particularly in Nanny Slagg, whose leading notations are self-pity and unusual terms of endearment: 'Just because I'm of the energetic system my dearheart, they give me everything to do' (Chapter 10, 'Prunesquallor's Kneecap').

In the earlier chapters it is clear that Peake has not felt his way into this technique. Swelter's drunken speeches depend on gratuitous alliteration and meaningless patterning:

> Lishen well to me, chief chef of Gormenghast, man and boy forty years, fair and foul, rain or shine, sand and sawdust, hags and stags and all the resht of them done to a turn and spread with sauce of aloes and a dash of prickling pepper.
>
> (Chapter 3, 'The Great Kitchen')

The temptation to make nugatory decoration on the surface of his prose is one that Peake always finds it hard to resist.

The use of dialogue as a means of characterisation is seen at its best with the twins, whose deadpan intonation and insane logic gives their speech a consistent interest and flavour:

> [Steerpike to the Twins] 'I am delighted to have the honour of being beneath the same roof' . . .
> Clarice turned herself to Cora, but kept her eyes on Steerpike.
> 'He says he's glad he's under the same roof as us', she said.
> 'Under the same roof', echoed Cora. 'He's very glad of it.'
> . . . 'I like roofs', said Clarice. 'They are something I like more than most things because they are on top of the houses they cover, and Cora and I like being over the tops of things because

we love power, and that's why we are both fond of roofs.'

(Chapter 31, 'Reintroducing the Twins')

Flay, Sepulchrave and the Prunesquallors are also successful in this respect, Irma Prunesquallor having a trick of repeating the least important of her phrases which is used effectively, unlike the repetitiousness of Nanny Slagg and Swelter. But the best uses of the speaking voice often occur in monologue or in narrative associated with the mind of a single character. The wild swinging of Fuchsia's adolescent emotions is accompanied by expressions which strike one as odd but right, reflecting her unstable personality: she glares out of the window as the clouds go by.

'Seven', she said, scowling at each. 'There's seven of them. One, two, three, four, five, six, seven. Seven clouds.' [She then chalks '7 clowds' on the wall of her room.]

(Chapter 10, 'Prunesquallor's Kneecap')

Obviously Peake, like Dickens, can write lazily, carelessly, and badly, and it is true that some of his language will not stand up to close examination. It is curious that his writing is consistently weak with the Keda, Rantel and Braigon subplot, where there is no debt, conscious or unconscious, to Dickens, but there is a certain flavour of Lawrence and perhaps of Mary Webb. Among the castle people there is no sexuality; Steerpike is to become a sexual threat, like Dickens's Steerforth, in *Gormenghast*, but in this novel that role is only hinted at. The Dwellers beyond the walls, on the other hand, live entirely in a Lawrentian world of dark passions where the flame of life flares briefly and then expires. When he writes about the Dwellers, Peake completely loses his wit and grasp of detail, and the language becomes unfocused and emotive; Keda and Rantel making love on the floor of Rantel's hut, Keda wandering in the woods and being protected by the Brown Man, Keda witnessing the battle between her two lovers, are all subjects which somehow fail to inflame Peake's interest. When he is dealing with the inward, static, childlike world of the castle, a world trapped in the immobility which precedes decay, Peake can explore its details with fascinated attention. When he is writing about the fast-moving, passionate and adult world of the Dwellers he presents it in

loosely-written, ill-organised scenes which are little more than outlines illustrating a theme.

When it appeared in 1946 *Titus Groan* created a minor sensation, and Anthony Burgess suggests that it had a special significance in the context of post-war experience. He sees *Four Quartets*, *Brideshead Revisited*, and *Nineteen Eighty-Four* as representative of post-war writing, 'built round a separable idea, which may be summed up as man's impotence to be good or happy without cherishing the values the war nearly quelled for ever'.

> One book, however, resisted and still resists the shelling-out of a central sermon or warning. The world created in *Titus Groan* is neither better nor worse than this one; it is merely different. It has absorbed our history, culture and rituals, and then stopped dead, refusing to move, self-feeding, self-motivating, self-enclosed.
>
> (Introduction to the Penguin edition)

Contemporary responses support the view that part of the attraction of *Titus Groan* was that it was difficult to place and without 'meaning'. One of the best critics Henry Reed, expresses this response as follows:

> *Titus Groan,* though long and Gothically detailed, is not wayward; it has a genuine plot in the strictest sense, and it persuades you to read on simply in order to know what will happen: in spite of its settings, there is nothing particularly dreamlike . . .

He shows a significant reluctance to interpret the relationship between the Dwellers and the Groans: 'Even a Marxist might find so riotous an embellishment of his favourite theme a little frivolous' (*New Statesman*, 4 May 1946).

The responses to *Titus Groan* were generous, in some cases extravagantly so. Quentin Crisp, in a long piece called 'The Genius of Mervyn Peake' (1946), sees *Titus Groan* as a work which defies criticism, and taking Peake's career as poet and illustrator into account as well, hails him as a genius greater than Blake. The piece by Henry Reed quoted above is discerning as well as favourable, and the point he makes about possible 'meanings' of *Titus Groan* is an interesting one.

A modern critic, Paul Green (again in the *New Statesman*)

refutes this notion, seeing the work as a pure fantasy, remarkable but gratuitous; he notes the debt to Dickens, and suggests further comparisons with Kafka, the Powyses and Tolkien (26 January 1968).

The suggestion that the book reflects war-time experience seems to be wrong. It is clear that the book was made possible by the war, but that is very different from saying that Peake the soldier was writing about the war as a public event, however cryptically. On the contrary it is his private life that seems to furnish the themes for *Titus Groan*; he had been dragged away from his home and from all that he loved, and *Titus Groan* can be seen in part as a private world created to replace the one he had lost.

During the years 1939–43 the central events for Peake were not the public events but his own anguish, the death of his mother, and the births of his two sons. Birth is one of the central themes of the novel, much of it being organised round metaphors of birth and growth. It is punctuated by four ceremonies, each of which is occasioned by the birth and growth of Titus : the Christening, the meeting two months later in the library (which the Twins then burn down) to make plans for Titus's first birthday Breakfast, the Breakfast itself, and the Earling, where Titus aged fifteen months receives his late father's titles.

Much of Peake's own childhood, also, provides stimuli for *Titus Groan.* The settings of the novel can be seen as based on the homes Peake had known as a child, Woodcroft and his father's hospital in China, Woodcroft providing much of the imagery for the castle itself and Peake's Chinese recollections providing images for the lean-to huts inhabited by the Dwellers and the whole tradition of the Bright Carvings, sole objects of the Dwellers' otherwise dingy lives. Swelter and Flay could well be products of Peake's life-long obsession with *Treasure Island*, Swelter appearing as a monstrous pirate and Flay as an ageing but gallant officer whose loyalty is impugned (he is banished from Gormenghast by the Countess for throwing one of her cats at Steerpike).

With Fuchsia, and Titus himself, Peake returns to his own generation. Fuchsia is based on his wife, to some extent : 'She was the one who hated people, like Fuchsia in the Gormenghast trilogy, who speaks many lines she actually spoke and was

probably modelled on her' (Alex Hamilton, 'Mervyn Alone', *The Guardian*, 5 January 1972). His close friend Gordon Smith suggests that Titus himself 'apart from being Mervyn and a lonely artist in a bourgeois world has a curious touch of his son Sebastian' (interview, 25 February 1971).

This last attribution would certainly support the notion that the novel is organised round metaphors of birth. Peake began writing the novel soon after the birth of Sebastian, and his meditation on the response of members of the household to the birth of Titus, the central position held by Titus as soon as he is born, and the elaborate ceremonials in his honour, have an obvious connection with this event.

Steerpike's career in the novel can also be seen as a metaphor of birth; he emerges from the kitchens where he is dominated by Swelter, and his first glimpse of the Groans' aristocratic way of life (which he is to inherit) is through Flay's peephole, just as Alice in *Alice in Wonderland* first sees the rose garden through a keyhole. Empson (in *Seven Types of Ambiguity*), suggests that in Lewis Carroll this is the unborn child's first view of the world and the symbol seems to work in the same way for Steerpike, whose next experience is being shut in a small tunnel-like space (Flay's octagonal room), through which he has to escape through a difficult aperture (the window).

With Flay as midwife, then, he escapes from the swollen flesh of Swelter, who as well as being Steerpike's mother on the metaphorical level has other female characteristics: his spite, his terms of endearment to the apprentices, his delicate skill as a cook. Steerpike's crossing of the roofs of Gormenghast continues this metaphor of birth, where the darkness is a physical barrier which 'thins' and has to be pulled like 'veils of flesh' from his eyes. When he emerges into the light he experiences the world with sharp but innocent vision: he is bewildered by the spectacle of a mare with her foal swimming in a lake on top of a tower, which is itself a clear metaphor of procreation with the tower as male and the lake as female symbols.

This is the only point at which lust and procreation are related to each other in the novel. Otherwise, as in many children's fantasies, childbirth on the one hand and sexuality on the other are significantly divorced from each other. Gormenghast itself revolves round childbirth, but it is impossible to imagine sexual

83

attraction between the Countess and Sepulchrave, who have en-
gendered Titus, and none of the other figures have sexual
characteristics apart from Fuchsia whose adolescent sexuality is,
indeed, very sensitively drawn, but it is a solitary excitement
with Steerpike as a somewhat remote focus. Sexuality is excluded
from the castle and exists only among the Dwellers where it
brings cruel consequences. The Dwellers reach a peak of physical
beauty and then go into rapid physical decline at the age of
twenty. In the castle itself the pace of life is slowed so that
growth and change (unless violent) are barely perceptible, but
among the Dwellers, life is speeded up to a point at which love
and death succeed each other in a rapid and relentless cycle.

The rejection of sexuality is felt in Fuchsia's response to the
birth of Titus, which displaces her as the only child. Her inarti-
culate rage, and the way in which she twists her hair as a form
of expression, are observed with remarkable sensitivity, suggesting
that Fuchsia suddenly feels unloved, and finds the notion of
the sexual act followed by birth repugnant and horrifying: 'Oh
how I hate! hate! hate! How I *hate* people! Oh how I *hate*
people!'

For both Fuchsia and Titus the Prunesquallor household offers
an alternative to their own home. The Prunesquallors are extreme
caricatures of somewhat remote next-door neighbours, fussy,
friendly, middle-class and celibate. The elegance of their Georgian
house, standing incongruously within a medieval castle, and the
intense cleanliness and precision of their lives, sets them in
balance with the decay of the castle and the slovenliness of their
masters, the Groans. As Fuchsia grows towards a kind of emotional
stability, so the reader's perception of the Prunesquallors alters.
Early in the novel they are merely grotesque, with a hint that the
epicene Doctor is homosexually attracted by Steerpike. As the
novel progresses the focus alters so that the Prunesquallors are
seen as kindly folk, genuinely concerned for the two children in
the midst of their general neglect. Their outstanding fault is their
continuing inability to see the evil in Steerpike, the children's
greatest enemy.

The reader's perception of Steerpike also alters as the novel
proceeds. Emerging from the metaphor of birth, and deriving
directly from it, are the themes of freedom and stability. Both
these are seen as necessary to the growing child; yet there is a

essential conflict between them, and the novel explores the development of this conflict. Gormenghast is a frozen civilisation, with the Book of Rituals as its code of laws, morality and religion, and Sourdust as its high priest and uncrowned dictator. Sepulchrave, ostensibly the ruler, is in effect Sourdust's puppet, and so much a slave of ritual that his identity is bound up with Gormenghast. 'How could he *love* this place? He was a part of it. He could not imagine a world outside it; and the idea of loving Gormenghast would have shocked him' (Chapter 9, 'Sepulchrave'). When his ritual is upset by the destruction of the library he cannot survive. Sepulchrave, then, is fairly clearly representative of the old class structure of imperial Britain, and Titus, born very late into this system with Steerpike already threatening it, must adapt it in order to survive.

Titus unconsciously seeks to adapt to change by resisting the rituals throughout the first year of his life. At his Christening Titus slips from Sourdust's arms and tears a page of the sacred book: 'This was his first recorded act of blasphemy. He had violated the Book of Baptism' (Chapter 16, 'Titus is Christened'). In the final ceremony of the Earling, he symbolically rejects his father's titles by dropping the symbols of his succession in the lake (Chapter 69, 'The Earling').

Whereas early in the novel Steerpike's attempts to overthrow the structure of Gormenghast and better his own position are viewed with apparent sympathy, he is perceived increasingly as a threat as he develops. The stability of Gormenghast, repressive and obsolescent though it may seem, is better than Steerpike's wanton destructiveness. Also Peake makes a point about Steerpike which finally condemns him as a revolutionary; Steerpike seeks not to overthrow the system, but to destroy its leaders and control it in their place. He is not a Marxist, as Henry Reed suggests, but a natural Fascist.

Titus Groan is certainly a book with a political flavour, but this flavour is the necessary result of its theme, the birth of a young ruler into a society which is about to change. The central topic of the book remains birth itself, and the survival of the baby, with a long meditation on the optimum point of balance between stability and change. If the impression of the book is overwhelmingly conservative, this is because Peake writes much of the book with the imagination of a pre-pubertal child. Adult life in general,

and adult sexuality in particular, are bewildering. All the characters who are sexually motivated come to violent ends; this is obviously true of the Keda-Rantel-Braigon subplot, and if one looks forward to *Gormenghast* it becomes true there too of Fuchsia who dies as soon as she expresses her passion for Steerpike.

With its low, deliberate building of tableaux, its endless meditations on the four major ceremonies of Titus's first fifteen months, and its reluctance to move on from the actual time of Titus's birth, the total drift and significance of the book is decidedly pessimistic. Accepting that life can only exist at all by moving forward in time, Peake sees decay or violence as the only alternatives that the future holds for his characters and therefore he only very reluctantly permits the world of Gormenghast Castle to advance, an inch at a time, feeling its way into the terrifying future.

7 Gormenghast

1. The writing of *Gormenghast*

Gormenghast was written between 1948 and 1949 on Sark, and the manuscript exists in three publishers' dummies with a number of loose leaves. The manuscript shows that the method of composition for *Gormenghast* was quite different from the method of composition for *Titus Groan*, where the author wrote intuitively and impulsively, cutting heavily before the manuscript was typed and rewriting extensively in proof. In *Gormenghast* there was relatively little rewriting but a great deal of reordering. Peake has a much better sense of organisation in this novel than in the preceding one, and has developed a technique of rearranging the completed chapters at a late stage of composition so that they present a balanced and satisfying pattern. In the published text of *Gormenghast* the narrative is divided into numbered and not, as in *Titus Groan*, named chapters. The chapters are numbered 1 to 79, but there is one anomalous chapter, between Chapters 14 and 15, which is headed and not numbered: the heading is 'Irma Wants a Party'. It is with this chapter that the manuscript of *Gormenghast* begins. This suggests that Peake wanted the novel to set off *in medias res* with a gathering of all the characters, just as the birth of Titus provides a gathering of the characters of *Titus Groan*, and the cocktail-party near the beginning of *Titus Alone* provides a similar assembly. It suggests, too, that he was still thinking in terms of the technique of *Titus Groan* where the chapters were titled like pictures and the subjects of the picture then filled in. An alternative heading for this chapter is 'Brother and Sister' which appears on one of the title pages of the manuscript.

This section has a raw texture compared with the characterisation of Prunesquallor and Irma as they are filled out in the remainder of the book. The two figures are loaded with comic detail in this chapter which flattens them as characters and makes them far less sympathetic than their function in the novel as a whole will eventually show them to be. It reminds one, in fact, of the sharpness with which they were caricatured at their first appearance in *Titus Groan*.

'Alfred', said Irma, standing up and lowering one of her iliac crests and raising its counterpart so high that her pelvis looked thoroughly dangerous . . .

(Chapter 14)

Irma's angularity and Prunesquallor's ascetic, birdlike quality are both accentuated by the very deliberate use of comic detail:

He rose, and, cupping his hands over her hips, corrected their angle with the quick jerk of a bonesetter. Then, sitting back in his chair and fastidiously crossing his long, elegant, crane-like legs while going through the movements of washing his hands . . .

(Chapter 14)

When Prunesquallor has engaged in the plot to destroy Steerpike and Irma has embarked on her marriage with Bellgrove, the sharp edges of the characters as presented here are softened and made more human.

In the manuscript of Chapter 14 a passing reference to the Professors is introduced to provide Irma with guests for her party in a brisk thumbnail retrospect. 'The last time I visited their room [remarks Prunesquallor], I remember it was to assure a brace of them that the green rashes which covered their fingers was nothing but an accumulation of ink which had changed its colour owing to its action upon the natural exudations of their paws.' This is omitted from the published text, because as a result of the reordering we have already met the Professors.

Chapter 18 of the published text appears immediately after 'Irma Wants a Party' in the manuscript, and is headed 'Chapter One'. Clearly at this stage of composition Peake intended 'Irma Wants a Party' as an introductory chapter providing a retrospective framework for what was to follow, and 'Chapter One' as the first chapter of the novel proper. 'Chapter One' differs considerably in its details from Chapter 18 of the published text, because in the latter we have already witnessed the death of Deadyawn and the accession of Bellgrove to the Headmastership, and all this has to be allowed for in the revisions. But several features of the chapter have remained unchanged, notably the visual impact that the 'posse of professors' makes on the observer. One can see that in a first chapter the opening paragraph would have provided a spectacular theatrical entrance for the Professors:

Like rooks hovering in a black cloud over their nests, a posse
of professors in a whirl of gowns and a shuffling roofage of
mortar-boards, flapped and sidled their individual way towards,
and eventually *through*, a narrow opening in a flank of the
Master's Hall.

(Chapter 18)

In the text as printed, however, this paragraph remains oddly
successful. We have already seen a good deal of the Professors
and we know them well – we have just witnessed in Chapter 17
the excellent comic scene in which Deadyawn is thrown from his
wheel-chair and, landing on the apex of his skull, remains rigid,
vertical, and upside-down in the middle of the class-room, frozen
into a post by 'premature *rigor mortis*'. This fresh introduction
to them in Chapter 18 now has the effect of a back-stepping for
a fresh, objective look at this group of men, a sense of their
corporate identity as flapping, shuffling figures in a courtyard in
place of the sharp sense of their individual identity which has
already been established for us: 'The professors moved like a
black, hydra-headed dragon with a hundred flapping wings'
(Chapter 18).

A drawing of the courtyard in the manuscript shows that Peake
imagined it as a simple quadrangle surrounded by round arches
which supports the view that the school where Titus is educated
is closely based on Peake's recollection of Eltham College. Eltham
College has been somewhat extended since Peake was a schoolboy
there, but two of the settings in *Gormenghast* are still perfectly
recognisable there. One is the Edwardian redbrick courtyard with
its round arches round which the original school buildings are
arranged, and the other is the large, sunlit upstairs class-room
(now a dormitory) from which the boys of Gormenghast would
leap to swing on a tree-branch and return through a window to
run a gauntlet of shied pellets from the other boys and in which
Deadyawn met his outrageously comical death.

In the manuscript 'Irma Wants a Party' and 'Chapter One' are
consecutive, and the narrative worked perfectly adequately in this
earlier and very much shorter form, because it is in Chapter 18
that the Professors receive their invitations to Irma's party. In
the manuscript the wording shows that it was conceived as a
dinner-party, but in the published version it is altered to read

'Irma and Alfred Prunesquallor hope to have the pleasure of . . . 's company' (Chapter 18), perhaps because the need to have forty people sitting round a table would have made the party scene too static for Peake's intentions, or perhaps because he recalled Titus's Breakfast in *Titus Groan* and felt that another seated meal presented as a set-piece would require him to re-use the same techniques. The interior monologue had served him well with that tableau but he was certainly right to avoid repeating the device on a larger scale.

The next chapter in the manuscript, which follows immediately from the description of the Professors and is headed 'Chapter Two', is printed as Chapter 15 of the published text, and presents Titus escaping from the school-room on his horse. One can see that these three chapters, the introduction and Chapters 'One' and 'Two' in the manuscript, have a simple and strong coherence, setting in train three leading themes of the novel, the Prunesquallors, the schoolmasters and Titus. In the reworking, Peake then finds that cause and effect are following too closely on each other in these sections, and that he wants a more elaborate introduction of the schoolmasters before they arrive at Irma's party, which is the end of the story as far as they are concerned, and a full and considered treatment of the new relationships of Steerpike, Fuchsia and Titus. So he spaces out the material of these seminal chapters and places them further towards the middle of the book, after a full and well-worked introduction.

The moods of these three chapters are well-matched: in the Prunesquallor household the mood is one of riotous farce in a drawing-room setting, the Professors are presented in a crowd-scene which is Dickensian and claustrophobic, with a stress on food, drink, and noisy good-fellowship, and Titus's escape is presented in a spirit of pure romanticism.

It is interesting and important that Titus sees himself as a romantic in this section, Chapter 15 (Chapter Two in the manuscript):

He knew no other world. Here all about him the raw material burned: the properties and settings of romance. Romance that is passionate; obscure and sexless: that is dangerous and arrogant.

The future lay before him with its endless ritual and pedantry,

but something beat in his throat and he rebelled.

(Chapter 15)

Like all romantics, Titus turns away from authority towards nature, as he gallops out on his white horse towards the dawn. The passage quoted is of special interest because it is considerably reduced from the original manuscript. The result is an aesthetic gain, but parts of the cut sections are valuable for an understanding of Peake's purpose with the romantic relationship between Titus and the Thing. 'Romance' in this cut paragraph resembles Wordsworth's spirit of nature acting upon the innocent temperament of a child. Peake writes: 'To the boy it is something that consumes. It lives in the whorls of an imagination no father could uncoil.' And again the insistence on the superior authority of childhood: 'In a boy's mouth it tastes as sharp as an apple. Its body has no past or future. It throbs with the bird that is calling, now, now, over the hill.' This probably owes a good deal to Peake's perception of his own small sons as they ran wild on Sark, and perhaps also to W. H. Hudson, whose *Green Mansions* was a favourite book of Peake's. He planned the Thing, the mysterious wild girl of the forest who enraptures Titus, to resemble Rima, the mystical jungle-bred heroine of Hudson's novel. Alternative names for the Thing, including 'Branch', and 'Leaf', appear in the manuscript making it clear that she was considered a spirit of the forest, a natural force, a pure green creature who obeyed no normal rule of life.

Like the chapter in *Titus Groan* in which Steerpike climbs over the rooftops and witnesses the new day, Chapter 15 of *Gormenghast* deals with the growth of the mind and the expansion of vision. Peake's talent has two outstanding natural strengths which work against each other to create writing of this quality: a talent for creating unique comic character, and a talent for exploring the sensitive mind in solitary meditation as it grows in response to experience. Here Titus, whom we first saw as a grotesque baby with violet eyes in *Titus Groan*, becomes an individual boy who is solitary, thoughtful, delighting in his surroundings, intensely responsive to visual impressions. Titus's vision of the rising sun is a piece of *tour de force* writing comparable with Steerpike's first perception of the coming of dawn in *Titus Groan*:

Three shafts of the rising sun, splintering through the murk,

91

appeared to set fire to the earth where they struck it. The bright impact of the nearest beam exposed a tangle of branches which clawed in a craze of radiance, microscopically perfect and adrift.

(Chapter 15)

In different ways each of the three chapters discussed (the first three chapters of the manuscript printed as 'Irma Wants a Party' and Chapters 18 and 15 respectively) would make an excellent first chapter of the novel. In each of them Peake displays a different technique for his opening paragraph : the first in mid-conversation where we discover the Prunesquallors, the second with a procession of Professors, the third with a solitary dawn. This freshness, this delight in the beginnings of things, is found in all the earlier chapters of the novel, where each chapter seems to make a fresh beginning:

About the rough margins of the castle life . . .

(Chapter 3)

One summer morning of bland air, the huge corroding bell-like heart of Gormenghast was half asleep . . .

(Chapter 4)

Fuchsia was leaning on her window-sill and staring out over the rough roofs below her . . .

(Chapter 5)

In the final re-ordering of his material for the published text the chapter with which Peake chooses to open his novel could well have been written after the main body of the manuscript was complete. Chapter 1 recapitulates the final events of *Titus Groan,* listing the dead and indicating the time that has elapsed in the interim :

Titus is seven. His confines, Gormenghast. Suckled in shadows; weaned, as it were, on webs of ritual : for his ears, echoes, for his eyes, a labyrinth of stone.

This opening, the actual opening of the printed text, is less intrinsically effective than many of the other possible openings that Peake could have used, and certainly less striking than the original opening in the manuscript which surprises the Prunesquallors in the middle of a row:

Irma Wants a Party.
'Very well, then, and so you *shall*!' cried Alfred Prunesquallor.
'So you shall, indeed.'

But the opening as printed, which chronicles, objectively and at a distance, the present state of Gormenghast, gives us an excellent sense of the pace at which the novel is to be read. With their high, rhetorical, formal tone, written as though a series of inscriptions were being made on a monument, the two first paragraphs of narrative prepare us for a work of considerable scale.

The device which follows reminds one that Peake was like a primitive painter in his attitude to novel-writing, prepared to adopt methods from which a more sophisticated writer would shrink. Peake parades for the reader the ghosts of those who have died in the narrative of *Titus Groan*: Keda, Sourdust, Flay, Swelter and Sepulchrave. The effect is rough but strong, like the opening of a folk-tale. Flay is still alive, of course, but he is included among the ghosts because he has been banished from Gormenghast by Gertrude, 'and excommunication is a kind of death' (Chapter 1).

Like the narrative of *Titus Groan* the narrative of this novel is slow, densely packed with language, its surface detailed and thoroughly decorated with intrinsically interesting words, its general shape relatively straightforward. But the structure of this novel is more complicated than that of its predecessor, and in places Peake's powers of organisation break down. In Chapter 3 Steerpike is presented at the heart of an elaborate information system. The technology of the castle is pre-industrial, medieval, but in this section Steerpike has set up for himself an elaborate system of mirrors by which he can see into every room of the castle. It is a useful narrative device because it permits a rapid survey of Gormenghast, reminding the reader of several of the inhabitants and introducing one new one, Craggmire the acrobat, who makes only this one appearance. But coming so early in the narrative the device of the mirrors clearly demands to be referred to again, and preferably tied into the plot in some way. Instead Peake abandons it. Steerpike has several opportunities later in the action at which he might use it, but the device is in fact never mentioned again. As an early element in a large body of narrative

it simply drops out of sight and, like Craggmire, is presumably forgotten.

2. *Gormenghast* – novel or romance?

'Gormenghast', the discarded title for the first of his Titus books, was not Peake's first choice for the title of his second. The manuscript contains sheets of notes in which alternative titles are tried : 'Titus in Shadow', 'Shadows and Passions', 'Landscape with Figures', and many others. In the first volume of the manuscript which is a big publisher's dummy filled with material between February 1948 and December 1948, the alternative titles at the beginning of the volume all have to do with the relationship between Titus and the Thing : they are, 'The Earl and the Cockatrice' and 'Brother and Sister' (as daughter of Keda, the Thing is Titus's foster-sister).

The identity of the Thing modulates constantly as the work proceeds. In the manuscript she is named first 'the Leaf' and then 'Branch'. Both these intensely romantic names were considered by Peake for his daughter Clare, born in 1949, and one can sense that this child in the novel and the actual baby in his family come to represent for Peake the resurgence of life after the war. The instinct for the natural world is felt throughout the novel.

These titles suggest that the Thing was originally a creature to be feared, then an innocent creature to be loved (a sister) and finally a spirit of the forest itself, indistinguishable from the 'Umbra' of the third title to the first volume, 'Titus in Umbra'.

Titus's escape into the forest on his horse occupies an important part of the manuscript under the title 'The Escapade' which was later discarded. Another significant feature of Titus's escape which is dropped from the published text but which feeds meaning into it is that Titus is thought of as fourteen in the manuscript. That is to say he is already adolescent, impelled by swinging emotions which he cannot control and ripe for his first sexual experience from the outset of the book. In the published version this is all changed by making Titus only seven at the beginning of the book. In the first fifty chapters he ages slowly from seven to ten, and then after a rapid transitional chapter (Chapter 51) he is shown

in the remaining twenty-odd chapters ageing from fifteen to seven-teen. In the latter part of the book he has only one encounter with the Thing, in the long, ambitious Chapter 68 which contains two major events : Titus experiences sexual attraction for the first time (its object being the Thing herself), and the Thing is destroyed by a flash of lightning. The total time-span of the published book covers ten years of Titus's life, whereas in the manuscript it covers only three years (from fourteen to seventeen). It is probably as a result of this change that all the characters in the book seem to be on different time-scales. Gertrude does not age at all; Fuchsia, who develops from when one first saw her at the beginning of *Titus Groan* to a woman of nearly thirty, seems hardly to have extended her experience at all. At the beginning of *Titus Groan* at the age of twelve and at her death in *Gormenghast* at the age of twenty-nine she is the same introverted, moody, difficult adoles-cent. Similarly it is difficult to accept that Prunesquallor and Irma have aged seventeen years; at the start of *Titus Groan* they are already decidedly middle-aged, and if one imagines that they are in their fifties in that novel then Irma's wedding takes place when she is approaching seventy. One assumes that Peake did not have a clear plan for the time-scale when he began writing *Gormen-ghast*, and that the ageing of Titus is reorganised retrospectively without relating it closely to the ageing of the other characters.

'The Earl and the Cockatrice' is an essential theme of the book : the quest for something wonderful, magical, outside himself is a persistent element in Titus, and although it is overlaid by the need to vanquish Steerpike it is held in the author's mind as a primary drive in Titus's personality so that his journey out on his horse at the close of the novel is seen as the last of a series of attempts to escape. By this time, of course, the Thing is dead, but the ideal for which she stood remains alive in Titus's imagination.

The flood which destroys Steerpike and cleanses the castle of his presence springs directly from the relationship between Titus and the Thing in the manuscript : there are notes at the end of volume one of the manuscript which indicate the symbolic signi-ficance of the Thing (here called 'the Leaf') and of her death :

The story continues : Titus and the Leaf.
The Leaf is killed in storm.

Titus returns through downpour.
The Universe weeps.

The Universe weeps: the 'Thing' or 'Leaf' is to be seen as the embodiment of the entire natural world. Her death creates a disharmony in the universe, which then mourns her with a flood which engulfs the castle.

In the second volume of the manuscript where Peake is already writing about the flooded castle and the search for Steerpike as the flood rises from floor to floor, Peake's imagination is clearly caught by the complexity of the castle itself, as it was in *Titus Groan*, and one of the recurring possible titles for this section is 'Labyrinth'.

The titles in volume three of the manuscript suggest that Peake sees Titus moving from the labyrinth, in which he hunts down the monstrous Steerpike, into a featureless new world where he must find himself: 'Titus in Chaos'; 'A Castle in Chaos'; 'The Antlers of Chaos'; 'Into Chaos'; 'A Canvas from Chaos'; 'A Corridor through Chaos'. This reminds one in turn that for Peake the act of writing *Gormenghast* was itself a cathartic act, a pouring out of his 'chaos' through the 'gutters of Gormenghast' (see above, p. 54).

The notes in this volume also suggest that at one stage of the planning the earth (in the flood) was to resolve into the four elements, and there is a fascinating short note which reads: 'Present everywhere, like God, but visible nowhere (Flaubert).' This sudden note on the nature of the narrator reflects a growing awareness of the technical difficulties of his art.

The different titles for the book suggest three major preoccupations of the author at different stages of composition. The leading preoccupation is with flight, and this remains constant, from Titus's first rebellion against the authority of the Professors and the Ritual to his last flight on his horse into the dawn. The second is with the eradication of the monster Steerpike from the ancestral home, and the third is with the dissolution and destruction of the home itself.

The idea of flight is bound up with the nature of the Thing, but this character is never successfully brought into focus in the novel. The ideal for which she stands shifts, so that she is required to fulfil perhaps too many symbolic roles. In Chapter 12 the

omniscient Flaubertian narrator moves away from the castle, passing his eye slowly over the details as he progresses: 'The late sunbeams shifted across the ragged floor . . . the claw-shaped head of Gormenghast Mountain shone like a jade carving.' At the end of the chapter the Thing appears for a moment in Gormenghast Castle: 'For one short moment it had stood on a turret at the far end of the terrace and then it was gone, leaving only the impression of something overcharged with life – or something slight as a hazel switch.' She is a genderless 'it', a 'phantom child' who 'hops' from the turret and disappears into the darkness, releasing a current of air which invades the castle to 'clasp' Titus in a 'noose', and to disturb the ancient philosopher who is expounding to three of the Professors his doctrine of death (Chapter 13).

The philosopher is on his deathbed in a room adorned by a gratuitous comic detail so absurd that it suggests that Peake is not at all clear of his artistic intention at this point in the novel; on his dark-red wall is a picture of 'a fairy sitting in a buttercup against a very blue sky' (Chapter 13). One can fairly judge that the episode of the philosopher is bad art: his presence is unnecessary, his death (hastened by one of the Professors, who sets fire to his beard) is not 'earned', his philosophy is not used beyond this chapter. The fairy on the mantelpiece seems tossed in simply to add a momentary twinkle to a piece of writing that had become dead in Peake's hands.

Why, then, is the philosopher in the book at all? His juxtaposition with the appearance of the Thing suggests an answer; following the figure who stands for romantic freedom Peake wished to show its opposite. If the Thing is 'the spirit of life' the philosopher is presumably 'the spirit of death', but he cannot be brought into a focused contrast with the Thing because she is as yet conceived only in imprecise generalities. The philosopher is left with no role, then, other than to oppose life in the broadest of general terms as a form of blanket opposition to the vague freshness that the Thing has introduced: 'Death is life. It is only living that is lifeless' (Chapter 13).

There are ten chapters of the novel which deal with the Thing. They are widely spaced and compose a single narrative: she appears to Titus, he follows her into the forest, she is killed by lightning. Some flavour is added to this simple pattern by her

mischievousness: she throttles a missel-thrush, she teases Gertrude by pretending to be a bird, she steals two of the Bright Carvings as they are thrown to the flames. Yet this saving mischievousness, without which she would be entirely null, is itself puzzling: why should the spirit of nature slaughter a missel-thrush? This occurs at the end of Chapter 40, which shows the Thing 'detached and unearthly' floating 'without weight' from the trees, her face a 'mask'. The chapter ends abruptly with a single sentence in which she begins to pluck the feathers from 'a missel-thrush which, during her long fall through the foliage, she had snatched from its branch and throttled in her small fierce hand'.

Immediately following this, Chapter 41 gives a retrospective account of the Dwellers' attitude to the Thing, who, we suddenly learn, has been 'shunned' as a bastard since the day of her mother's suicide and now lives as an outlaw, stealing the Dwellers' food and damaging their carvings, and inspiring terror both because she is 'supernatural' and because she is the Earl's 'foster-sister' (as the bastard of Keda, Titus's wetnurse). From his indirect presentation of the Thing Peake switches suddenly to a treatment which is, if anything, over-explicit. What was formerly an elusive spirit abruptly begins to look like a psychopath.

This new treatment creates a direct contradiction at the end of Chapter 41: how can the Thing be 'supernatural' in the minds of the Dwellers, if her inauspicious antecedents have always been so thoroughly known? This cannot be accounted for as a matter of 'point of view'. If Peake had presented the Thing through Titus's eyes and then through the Dwellers' one might expect the picture to change, but it is the omniscient Flaubertian author himself who, after Chapter 40, suddenly begins to see the Thing as a destructive, deceitful, wilful child, and the perspective of the Dwellers in Chapter 41 is then invoked to provide a retrospective biography for her which will support this inconsistency. The writer has simply altered course, with a perfunctory effort to cover his tracks.

A reason for this change may be found in Hudson's *Green Mansions*, Peake's direct source for his vision of the Thing. Rima, the wild girl in *Green Mansions*, is also seen from two points of view, that of the South American Indians who are terrified of her, and that of Abel, who loves her. In Hudson's story the character thus perceived is ultimately shown to be a consistent character: the Indians are mistaken in their judgment of her, and in her life

and death Abel finds an epiphany which transforms his own life from the flight of a hunted refugee to the deep satisfaction of a pantheist living at the heart of a green world. These elements, flight, epiphany, and pantheism, are reflected in the relationship of Titus and the Thing. Hudson's Rima is gentle, wise, altruistic, and in the earlier part of his narrative Peake's girl seems cast in this mould, but in the latter part Peake simply changes his mind, perhaps because the figure refused to develop or because her spirituality had become insipid. In Chapter 68 she is a false goddess who deserves death by thunderbolt, although this is also a pathetic, and therefore morally exalting, death. The double response to her death reflects the confusion in her characterisation, and its significance for Titus is brusquely thrust upon the reader:

> The Thing was dead . . . dead . . . lightning had killed her, but had Fuchsia not been there he would have shouted with happiness for he had grown up. . . . At seventeen he stepped into another country. . . . He had become a man.
>
> (Chapter 68)

The conflict of attitudes which is a weakness in the portrait of the Thing can be a strength elsewhere: it reflects the conflict in Titus himself of the impulse to find maturity in flight and fulfilment outside Gormenghast Castle, and the contradictory impulse to find maturity within Gormenghast itself in loyalty, responsibility, and struggle against a loathsome enemy. Fulfilment and responsibility are both necessary to maturity, and Peake finds, as his novel develops, that in Titus these necessities pull different ways, evoking from him a sustained creative effort to resolve the antithetical pressures within Titus the adolescent into the balanced synthesis of Titus the man.

In his characterisation of Titus as a child Peake draws on two main sources. One is his own childhood and the other is the characterisation of Fuchsia in *Titus Groan*. In presenting Titus's solitary meditation in the southern wing in Chapter 9 Peake uses the same method that he developed for the presentation of Fuchsia in her attic in the earlier novel. Titus responds intensely to the empty landing in the southern wing, filling its dusty space with his own emotions, as Fuchsia populated her attic: 'Had he not clenched his hands he would have screamed, for the very lack of

ghosts in the deserted halls and chambers was in itself unnerving.'
Like Fuchsia aged twelve, Titus aged eight revels in the luxuries
of solitary possession: 'He sat down, his back against a yellow
wall, and watched the white motes manoeuvring in the long sun-
beams. "This is *mine! mine!*" he said aloud. "I found it." '

In *Titus Groan* the main characters are characteristically solitary,
and each is presented alone, in turn, like a slowly revolving
statue. In *Gormenghast* the characters exist in groups as well as
alone, and this represents a considerable advance. Instead of merely
being perceived by each other the personalities interact and in-
fluence each other's development. In considering the young Titus,
Peake is forced to think about education, and the way in which the
educative process sets up personal relationships which lead in
turn to personal growth. Titus in the class-room is a pure rebel,
bored and uncomprehending as Peake himself was when the sub-
ject was an uncongenial one, and he evokes with vivid effectiveness
the agonising tedium of a sleepy mathematics lesson in mid-
summer.

> A great clock ticked away monotonously. A bluebottle buzzed
> slowly over the surfaces of the hot window-panes or from time
> to time zithered its languid way from desk to desk. Every time
> it passed certain desks, small inky hands would grab at it, or
> rulers would smack out through the tired air.
>
> (Chapter 14)

The comic *impasse* of Titus's formal education leads the writer to
the problem of his real education, the loves and enthusiasms that
make him what he is. In the unreal settings of *Gormenghast* Titus
is presented with a concern for psychological truthfulness which
is remarkably consistent. His parents play no part at all in his
education: Sepulchrave is dead, and Titus has only three meetings
with Gertrude from birth to the age of seventeen. He must look
elsewhere for models of masculine authority and feminine attrac-
tion.

Prunesquallor, Bellgrove, and finally Flay are the masculine
influences in Titus's development, and his relationships with each
of these reflect Peake's shifting attitude to Titus's relationship
with Gormenghast Castle itself. His first major lesson in love and
moral understanding takes place during his imprisonment in the
Lichen Fort, after he has run away into the forests (Chapter 21):

'Titus had been held prisoner in this fort on two previous occasions for flagrant offences against the hierarch – although he never knew exactly what he had done wrong.' Nominal ruler of the castle, Titus is bewildered by the observances administered in his name by its 'hierarch', Barquentine, successor to Sourdust. Further, the demands on his obedience are divided between the castle and the school to which he is sent: as Earl he is the reason for the continued existence of Gormenghast, but as a growing boy he is brought up in a rough boys' boarding-school within the walls, where he is to be treated as an equal of the other boys until he is fifteen.

The relationship between school and castle is ill-defined, and the effect is of two superimposed dreams. The school is quite large; it requires a staff of forty, there seem to be hundreds of pupils and considerable buildings, and it has a solid Victorian ritual of its own which is punctiliously observed by its 'Professors'. But who are these schoolboys? They are described as 'children of the castle', which indicates that they are the sons of the numerous shadowy domestics. That is just possible, but why should they sleep together in dormitories when their families all live in the same building? Their existence implies a middle class which simply does not exist in Gormenghast Castle apart from the Prunesquallors and the Poet; it was not until the writing of *Titus Alone* that Peake attempted to portray a middle-class society, and the society of the first two books is one of aristocrats and slaves, the Groans and the rest.

These objections disappear when one is actually reading, partly because all the characters in the book assume that they inhabit a rational universe even when they are puzzled by it: they are the coherent elements in the author's and the reader's dreams. Aesthetically the contrast between castle and school is like a contrast between a race-memory dream at the deepest level of sleep, and a detailed nightmare induced at a shallow level by personal anxieties. The mother and the house, both slumbering and timeless, are fixed points in Titus's world which he perceives even in adolescence as though he were a tiny infant: they are enormous, remote, never wholly understood, but always there. Even in *Titus Alone* Titus's sense of his own identity can be confirmed simply by the recollection that the castle and his mother continue to exist.

Gormenghast ultimately provides great security for Titus of the

kind that a rigid religious system can provide for its followers.) α
There is an inflexible code of behaviour provided by the Rituals,
which are there not to be understood but merely to be obeyed.
There is no question of personal responsibility and striking out
one's own line of conduct, and it follows that there is no personal
moral conflict; moral conflict is externalised and takes the form of
a battle between Titus and the Rituals. Man in Gormenghast is
wholly circumscribed in his actions and therefore wholly free in
his own mind.

To move from Gormenghast to the school-room is to move
from aristocratic Catholic certainty to middle-class Protestant
doubt. Peake did not, of course, frame the contrast in these terms,
but the way Titus moves through different codes of conduct in
search of the right ordering of his life irresistibly suggests such
a comparison.

The third imprisonment of Titus within the Lichen Fort
(Chapter 21) itself suggests an advance in his moral education : on
this occasion, unlike the previous two, Titus knows very well what
rule he has broken, in playing truant from a Ceremony, and that
he is justifiably punished. In the course of arriving at this know-
ledge Titus has discovered two forms of love, neither of them
erotic.

Knowing that he will be punished when he returns to the castle,
Titus runs to Fuchsia. Aged twenty, Fuchsia has never loved
anyone and Peake gives a very precise psychological account of the
way in which the girl and the child discover love for each other.
They embrace, passionately, and fall to the floor 'in a dizzy
ecstasy' in the delight of their mutual discovery 'which found no
outlet for its expression save in this physical tumult. . . . In a flash
they had found faith in one another. They dared, simultaneously,
to uncover their hearts.' Thereafter the language becomes mystical
and the new relationship develops into something romantic, pro-
found, and difficult, a matter of twinned destinies and timeless
race-memory. They

> were bound by more than their blood, and the loneliness
> of their hereditary status, and the lack of a mother in any
> ordinary sense, yes, more than this — were bound all at once in
> the cocoon of a compassion and an integration one with another
> as deep, it seemed, as the line of their ancestors : as inchoate,

imponderable, and uncharted as the realms that were their darkened legacy.

(Chapter 21)

The other love which Titus discovers in this chapter is simple friendship with Bellgrove, the Headmaster, who comes to visit the prisoner and stays to play marbles with him on the stone floor of the Lichen Fort. This friendship is less transfiguring than the primal relationship which Titus finds with Fuchsia, but it is of great importance to Titus as the first of his masculine friendships, a male love which he can respond to, and, if need be, against, which frees him from his dream world so that he can behave like a normal rebellious and adventurous boy. In Chapter 26 he escapes from a major Ceremony which belongs to the incomprehensible absolutism of his infancy:

> The voice of the poet droned on and on. A star came out. And then another. The earth swam on through space. The Countess yawned again and turned her eyes to the west doorway. 'Where was Titus?'

(Chapter 24)

Titus has broken the spell in which the others (except Steerpike, who is manipulating the situation to his advantage) are trapped by the Rituals.

The decision to resuscitate Flay, the second of Titus's friends, was probably a late afterthought in the writing of *Gormenghast*, since apart from a reference in the introductory chapter (which was presumably written last) Flay's first appearance in the novel is a very abrupt one, over half-way through the book, in Chapter 24. The reintroduction of Flay alters the whole direction of the book and is the principal element in the complexity of loyalties which makes Titus's moral predicament interesting. His escapes into the forest up to this point have been egotistical romantic flights in search of the Thing, as far as the reader has been able to guess. There is no mention of Titus for over twenty chapters while we attend to Irma's husband-catching, and when Flay suddenly appears it is revealed that he and Titus have already been friends in the forest for some time: this quite fresh departure in the plot, outside the castle, has to be summarised to bring the reader up to date. All this makes Chapter 44 an exceptionally rich piece of writing. Titus brings Fuchsia to see Flay, an emotional

103

occasion for the two who have not met for ten years, and Flay, who, in exile, is the only true believer in the old order of Gormenghast, fires Titus with the will to restore that order. So Titus, having fled from Gormenghast and matured and acquired freedom of choice, is now free to choose, for a time, to return to his home and purge it of corruption.

In Chapter 50 Titus's tenth birthday celebration forms a sustained coda to the first part of the novel, and the second part begins with three transitional chapters (51 to 53) tracing the main characters over the next five years. Bellgrove is married and subordinated to Irma's will, Titus carves boats and occasionally his friend Bellgrove launches one, Prunesquallor makes drawings, Fuchsia makes Titus her confidant, the Countess remains static and immobile with her cats and her birds about her. Flay makes a map of the castle and keeps watch on Steerpike who has become Master of the Rituals and therefore master of Titus himself.

Water imagery and images of drowning dominate these chapters. Perhaps the fact that he was writing the book on Sark gives Peake this powerful body of imagery: the seasons themselves are 'great tides', coming and going round the castle. As well as becoming an island the castle becomes an animate creature, and its inhabitants are affected by its moods 'as though the castle was recovering from an illness or was about to have one. It was either lost in a blur of unfocused memory or in the unreality of a disquieting premonition. . . . A veil was over all things, a veil that no one could tear away' (Chapter 52). The inhabitants live as though under water at various levels: 'The sense of unreality in each individual was different; different in intensity, in quality, and in duration, according to the temperaments of all who were submerged.' Some are inured, and 'others were drowned in it, and walked like ghosts. Their own voices, when they spoke, appeared to be coming to them from far away' (Chapter 52).

Metaphorically submerged by the tides and veiled in fog, the island/castle passes through a phase of withdrawal and depression illustrating the psychological state of Titus's adolescence. The drowning of the castle is also a proleptic image for the flood which overtakes the castle after the death of the Thing and transforms it into a drowning island in a literal sense. The depression is shared by Fuchsia, who allows herself to be prepared for seduction by Steerpike during the phase of withdrawal through

which the castle passes (Chapter 53). At the end of this transitional phase of the novel Steerpike is playing to the full the role of impostor in the dramatic structure of the novel, as pretender to Fuchsia's affections and usurper of Titus's authority.

Fuchsia's response to Steerpike is beautifully observed. She is both flattered and resentful, she can see that he is making skilful efforts to placate her, and she both wants to be placated and wants to act on the new perception of Steerpike that his urgency has yielded her. Steerpike calls her a 'fool' in a rash moment of exasperation, and thereafter Fuchsia is unable to trust her own swinging emotions and is caught in an intense, inward-looking, passionate and specifically feminine muddle.

> 'I will never understand', she said. 'It is no good however much you talk. I may have been wrong. I don't know. At any rate everything is changed. I don't feel the same any more. I want to go now.'
>
> (Chapter 56)

She has been wounded, she wishes to behave properly towards her lover, and she feels desperately confused. At the end of this excellent scene a moment of bleak illumination emerges from her mixed and painful response to Steerpike, and that is that with his elaborate manoeuvres to please her he is losing his touch: ' "Steerpike," she said, "*I think you're going soft*" ' (Chapter 56).

Since Chapter 50 the castle itself participates by a succession of metaphors in the imaginative life of the novel. After the crisis between Steerpike and Fuchsia it, too, is emotionally prostrated: 'The castle was as silent as some pole-axed monster. Inert, breathless, spread-eagled' (Chapter 57). For Steerpike, Fuchsia's awakened suspicion represents a major threat which, again, is associated with the castle itself.

> An indescribable sensation that his power was somehow crumbling away; that the earth was slippery beneath his feet; that in spite of his formidable position, there was that in Gormenghast that, with a puff, could blow him into darkness.
>
> (Chapter 57)

The reasons for the final choice of the title of the novel become clear in this latter part of it: Gormenghast, the castle, is both a sensate being and all things to all men. It reflects the adolescent

depressions of Titus, the incalculable moods of Fuchsia, the ram-shackle condition of the Countess, who has allowed herself to ossify like the 'main massing of the original stone', and against Steerpike it turns a vindictive face. In the flood the castle becomes Steerpike's executioner, driving him into the avenging arms of Titus as each hiding-place fills with water; with the Groans it is a metaphorical extension of their psychological states, and to Steer-pike it becomes a terrible embodiment of the Groans' collective will.

The first two-thirds of the novel, Chapters 1 to 50, are static, a series of tableaux presenting the childhood of Titus and the courtship and marriage of Irma Prunesquallor in vivid juxtaposed scenes. In the last of these tableaux thirty-foot high figures on a shallow lake perform an immemorial mime in honour of Titus's tenth birthday. Here Peake offers some reflections on the nature of his own art which support the notion that this was originally seen as the last chapter of the novel:

> Although a strong strain of the ridiculous ran through every-thing, this was not the dominant impression. . . . There was no laughter but only a kind of relief, for the grandeur of the spectacle, and the godlike rhythm of each sequence were of such a nature that there were few present who were not affected as by some painful memory of childhood.
>
> (Chapter 50)

This could well be a paraphrase of a reader's response to the first two Titus books. The material is consciously grotesque and the detail is farcical; yet the total effect is one of solemnity and 'pain-ful memory', of psychological truths which have been identified and driven home in the midst of the fantasy.

The latter part of the novel, Chapter 51 to the end, is dynamic, moving in a single direction and deriving its impetus from the developing conflict between Titus and Steerpike which gives it a clear dramatic form. Aged fifteen, and freed from the adolescent depression which has held him, with the castle, in a submerged state in the novel's transitional chapters (51 to 53), Titus is able to summon allies in his friends Flay and Prunesquallor to pursue the destruction of Steerpike.

This is Titus's short-term purpose, but what of his longer objective in these last twenty-odd chapters of the novel? If lust

for power is the centre of Steerpike's being, does Titus have an equivalent centre? Given that good impulses are notoriously more difficult to present dramatically than bad ones, Titus's object could broadly be described as 'freedom', but that must be immediately qualified. His childhood objective is, in his own phrase, 'romantic' freedom, an imprecise ideal for which the Thing is an insubstantial symbol. Adolescence and new relationships modify this to a quest for what one may call 'political' freedom within Gormenghast itself, of which the defeat of Steerpike is an indispensable condition. Titus at the close of the novel is free to live in the castle not as though in a totalitarian State, but as master of his own house. Titus chooses not to do this: instead he leaves the purged and redeemed castle and goes out into the unknown. This suggests that 'political freedom is not enough, and that the quest at the end of the novel is for a form of personal freedom. The last chapter yields no more than oblique hints about the nature of this new freedom, and all one can say with certainty is that it is not to be found in Gormenghast Castle. Titus has gained mastery in his home and freedom of choice and he now seeks, perhaps, a wider arena in which to exercise that choice. Gormenghast is the fostering world of his childhood which he must learn both to resist and later to love. Despite the bewildering complexity of its laws and the apparent remoteness of its chatelaine, the castle loves Titus and once he has learnt to love it in return the foundations of his moral growth are laid. Clearly the next stage is for him to leave the family home with its childhood authorities, mother, doctor, and schoolmaster, and match his newly-found identity against the world. Freedom of choice, as such, is not freedom: only by exercising that freedom in multiple, strange and uncharted circumstances will Titus learn to choose wisely, and thereby gain true freedom of choice.

8 Peake's 'Damaged' Art of the 1950s

1. *Mr Pye*

The reception of *Mr Pye* (1953), the third of Peake's novels in order of composition, was disappointing: whereas *Titus Groan* had been written as a private journal and became a sensation and *Gormenghast* had been written as a serious experiment and won a distinguished award, *Mr Pye* was a whimsical piece written to make money, and was remaindered. In this novel Peake turns away from the inward theatre of the imagination and writes directly about two of his constant enthusiasms, Sark and Christianity. One is reminded that he was a Congregationalist, the son of a missionary, and husband of a devout Catholic. Peake himself was suspicious of organised creeds, as his poem 'How Foreign to the Spirit's Earthly Beauty' testifies, but in all his poetry Christianity in a broad sense is a presence which is important to him (see below, Chapter 10, Mystical poems). He wears his religion lightly in his art not because it is unimportant to him but because it fits him like a skin.

The action of *Mr Pye* is simple. Mr Pye is a small fat benevolent bachelor, with a physical and psychological resemblance to Mr Pickwick, who arrives on Sark with the intention of saving the souls of its inhabitants. After a measure of success he becomes an object of dislike among the islanders, and also makes the unwelcome discovery that he is destined to become an angel. The detailed account of his fruitless attempts to discourage his sprouting wings is cleverly done in the manner of Wells's *Wonderful Visit*. Mr Pye's difficulties are mutually resolved when the islanders pursue him and he flies away into the sunset.

Mr Pye is strikingly different in structure and method from *Titus Groan* and *Gormenghast*. It consists of thirty-one chapters, all of rather greater length than the episodes in the preceding books; it is not conceived as an epic, it has relatively few characters, the whole scale of the imaginative enterprise is less than the scale of the Titus books. A familiar world which Peake loved is painstakingly described and its geography carefully mapped out, and within that world three groups, the Sarkese, the

resident English or upper-class community, and the visitors, are clearly distinguished. The characterisation is moderately natural-istic, and yet it is in the characterisation that the closest resem-blances to the methods of the Titus books are found. Swelter and Flay, the fat and the thin elements locked in mortal combat in *Titus Groan*, are reflected here in Miss George and Miss Dredger, the fat and the thin English spinsters whose ancient feud is patched up by the intervention of Mr Pye. After this reconciliation Miss George suffers sudden death, as do too many of the characters in the Titus books including Swelter, her predecessor, who was murdered by Flay. Miss George dies not at Miss Dredger's hands, but as the result of uncharacteristic provocation from Mr Pye him-self, who in a fit of wickedness brought on by the hope that wickedness will free him from his embarrassing wings, snatches at her purple busby, 'for surely Miss George was either bald or had some terrible disease' (Chapter 21). Miss George, contem-plating revenge, looks through the keyhole of Mr Pye's room and sees his wings for the first time; recoiling, she falls down-stairs 'head over heels in prodigious and shattering cycles, the uprights of the banisters being mown down like ninepins as she bounded to her death' (Chapter 21).

It is a rich comic effect, but it clearly derives from the extrava-gant methods of the Titus books and it is not suited to *Mr Pye*, which is naturalistic, and moderate in tone. Also this death has no function in the plot at all, while the comic and monstrous deaths with which the Titus books are littered all have some bear-ing on the action. It seems a pity that Peake could not have allowed Miss George to live so that she and Miss Dredger, newly recon-ciled, could have taken comfort in their friendship after Mr Pye's flight from the island at the conclusion of the tale.

The other death in the book is wholly gratuitous and interrupts an otherwise fine passage in which Mr Pye, his wings spread, races in his carriage to the narrowest point of the island where he will take flight and escape from the islanders:

With the old mill in sight, everything seemed to happen at once. A whistle blew from behind a hedge. Three figures appeared at the top of the mill and one of them screamed. The second figure could not release his grip on the railing he was holding, and it was lucky for him or he might have shared the

fate of the third of the look-out men, who missed his footing
and fell down the precipitous spiral of the stairs, and was dead
before he reached the bottom.

(Chapter 31)

Has Peake become bored with his novel in this last chapter? There
is ample room for excitement in the presentation of Mr Pye's
flight without the introduction of this cheap death, which is, in
any case, an entirely repetitive effect since the cause of death is
precisely the same as that of Miss George: the victim recoils from
the sight of Mr Pye's wings and falls downstairs.

The beautiful opening of the novel, in which Mr Pye approaches
Sark on the ferry from St Peter Port, is flawed by another such
violent and gratuitous accident:

The car tyres that were used as 'fenders' were pulled over the
sides, and the screw began to turn; and, with a shout or two,
and one sudden and quite extraordinarily offensive oath from
one of the sailors who had suddenly slipped and broken his
leg, the *Ormer* began to nose her way out of the harbour.

(Chapter 1)

In the Titus books a mass of detail is essential to the concretion
of Peake's imaginative world, but in this novel where the setting
is an actual known world, the proliferation of comic detail sits
oddly with the rest, and after the death of Miss George it begins
to have a damaging effect on the central narrative. Mr Pye's wings
alternate with a small pair of horns which sprout when he has
been mischievous: the first impression of these effects is comical
and delightful, but when Mr Pye reaches a stage at which wings
and horns are alternating with dizzying speed the device becomes
repetitive and over-worked.

In the Titus books Peake had developed a method of presenting
large tableaux which allows the many crises of *Mr Pye* to be well
controlled: the picnic at Derrible at which Miss George is lowered
like a goddess onto the beach, Mr Pye's refutation of the residents
from the veranda of Miss Dredger's house, and his final flight
from La Coupée are all magnificent set pieces. They take place
in the presence of the whole population of the island, and the
Sarkese are seen as brutish people who turn on Mr Pye with
unreasoning fury like that of the Dwellers against the Thing

in *Gormenghast.* The confined world of the island and its absence
of modern transport or facilities (other than the telephone)
heighten the resemblance to the pre-industrial world of *Gormen-
ghast.* This resemblance is of course momentarily shattered when
Mr Pye travels to London in search of a 'cure' for his sprouting
wings.

The centre of *Mr Pye* is dominated by a magnificent ceremony,
the picnic, which goes disastrously wrong. Again this is a struc-
tural device which Peake has learnt in the course of writing the
Titus books, and it expresses a theme which is persistent in the
Titus books, the theme of rebirth. Miss George, fat and unloved,
is to be lowered through a narrow womb-like cleft in the rocks,
'the chimney' to emerge in the costume of a goddess before the
people of Sark, and this for her will be a moral rebirth parallel
to that of Mr Pye when he leaves the chrysalis of the human frame
and becomes an angel.

As Mr Pye approaches pure goodness its opposite takes visible
forms in the book. The devil is embodied in a goat tethered in
the woods which Mr Pye worships in a desperate attempt to rid
himself of his wings by committing mortal sin; and before this
manifestation the devil has intervened in the novel by sending a
dead whale to wreck the picnic with its offensive smell, thereby
interrupting Mr Pye's attempt to regenerate the islanders.

> Something even more potent than the Great Pal [Mr Pye's
> phrase for God] had interposed its ugly self and plucked the
> prize from the palm of his hand.
>
> (Chapter 16)

'Potent' is a pun: God will triumph in the long term, but evil's
pungent smell can create havoc in the short term. The smell is
a *memento mori* for Mr Pye and a necessary mortification and
rebuff to his mission. He is not to be allowed to win too
easily: 'The shock for the congregation had been cruel. From the
summit of metaphysics and the essence of love they had all
of a sudden been woken to the beastliness of physical decay'
(Chapter 16).

The novel has three wholly serious themes presented in associa-
tion with three major characters, each of whom reflects an im-
portant commitment within Peake's own life. The island is a meta-
phor made concrete and an embodiment of three distinct visions:

an artist's vision of his artefact, an evangelist's vision of a con-
verted world, and a common man's vision of a saint. Throughout
the novel Peake stresses that Sark is the perfect human and
geographical unit, a confined world which exactly corresponds to
the visions within the minds of Thorpe the painter, Mr Pye the
preacher, and Miss Dredger the upright citizen. The island is
variously a cubist painting, a basket of ripe souls and a great
stone ship, and the reprobate, the saint and the 'Sailor' (as Miss
Dredger is nicknamed) find in it appropriate metaphorical expres-
sions of their wishes.

Mr Pye's wishes are the most important of the three, and
contain the visions of the other two figures. At the opening of
the work Sark exactly corresponds to the model of humanity in
his mind's eye: as he approaches the island he remarks that
it is 'just the right size . . . it will do very nicely' (Chapter 1).
He walks over the island learning its geography, and seeing in its
fantastic landscape, its compact size and its population of three
hundred souls the perfect human unit which corresponds to the
vision of mankind which has pre-existed in his own mind. The
Sark that he encounters is a society of old people and sturdy
fishermen with a painter and prostitute thrown in to leaven the
lump, so on the face of it Mr Pye's mission is somewhat absurd.
But the imagery of the evocative opening chapters in which Mr
Pye tramps the island and learns to love it successfully establishes
it as a microcosm of the whole world.

Thorpe the painter, whose technical problems as he battles to
render Sark in his own medium must reflect those that Peake
himself confronted when he lived and painted on the island, is
granted his own specialised vision within the context of Mr Pye's
larger moral vision. During the picnic Thorpe, whose work has
been stagnating and who has come to see the whole of art and
the art-world as a 'racket' suddenly 'sees' a wholly original
painting, 'unlike any other painting yet in the tremendous
tradition of the masters' (Chapter 13). It is to be an abstract based
on the pattern created by the rocks in Derrible Bay:

> Five overlapping rectangles with holes in them. Three zig-zags
> black and grey. A kind of leper whiteness – the paint all thick
> and crusty – I'll mix the stuff with sand. And no moon. No
> atmosphere. Just the core of it all. The heart of bone.
> (Chapter 13)

Because Thorpe's vision lacks moral direction he is not allowed success with his painting: he falls into a pool and forgets the pattern that was in his mind. He dares to laugh at Mr Pye's insistence that art exists only in God, and that he should submit to God's will and recognise that he is 'only the medium – the glass pipe as it were' (Chapter 12). Thorpe seeks to challenge God's knowledge of modern art: has He heard of expressionism and cubism?

One can gauge the importance of these exchanges from the images that Peake uses: his painting is to express the 'heart of bone' which recalls the romantic and fundamental significance attached to 'bone' in the poems, where 'bone' is the core of life and the evocation of death's mystery (see below, Chapter 10, Romantic poems). Mr Pye's reply taps an equally important image from the poems: to be a true artist he must become a 'glass pipe' and be moulded in God's hands as the glass is shaped in the poem 'The Glassblowers' (see below, Romantic poems).

Mr Pye answers Thorpe's sceptical questions about God's expertise with the assertion that God himself is cubism and expressionism, and the metaphor of the island is extended to demonstrate just this point: the island is God's work of art. Thorpe's bitterness is not abated by this reply and he rants on with his resentment of the art-world: 'the amateurs, the Philistines, the Jews, the snarling women and the raging queers' (Chapter 24). He is unable to escape from his cycle of bitterness and self-pity because he cannot look at the island as it is and recognise it as a work of art in itself, as Mr Pye can when he sees a rock as a piece of sculpture, 'an old Abstract', on which he will perch like a gull when he takes flight (Chapter 25).

At its best *Mr Pye* is a work of passive but sensitive receptiveness in which the narrator allows the landscape to breed sober or philosophical reflections in his mind. In all his descriptions of the island the language is well-chosen and the imagery stimulating, and the effect of the whole work is like a rather flimsy pantomime plot written against the background of careful, detailed, naturalistic settings. It is a mixture of disparate elements held together only at one point, by Peake's real interest in Mr Pye as an evangelist.

Despite the flimsiness of the action, the ease with which Peake draws his characters, especially Tintagieu, the gravel-voiced

prostitute, and Thorpe the starving and failed painter, reminds
one that Sark was a natural setting for his imagination. As Mr
Pye finds it the image of man and the summit of art so for Peake
himself it was a natural world and an enclosed community which
corresponded satisfactorily with the images within the theatre of
his own mind. The discrepancies which appear to the reader are not
obvious to the artist because his comic and his picturesque talents
had both been moulded on Sark, and it was natural for him to use
both sides of his talent and weld them together by the force of his
mysticism in this fantasy. It was written quickly and light-
heartedly, with the hope of making some money and the intention
of celebrating a place that he loved, and above all of entertaining
the reader. This itch to entertain is the cause of most of the novel's
weaknesses, but as C. S. Lewis says in his *Experiment in Criticism*,
'one must not munch whipped cream as though it were venison',
and of its slight kind *Mr Pye* is an attractive work.

2. The disintegration of *Titus Alone*

Titus Alone, the third of the Titus books and the last to be pub-
lished, is a very different novel from *Gormenghast* but remains,
in respect of Titus himself, a development from it. Titus has
arrived at a degree of personal freedom by his escape from the
castle and in this novel he uses that freedom by exploring the
'world', which in this novel is not, surprisingly, the real world
but is partly a broad parody of certain contemporary types and
partly a nightmare vision of the future. Having come to terms
with, and then cut away from, his home and family, Titus gains
further emotional growth through the twin experiences of mature
physical love and mature friendship.

Like the latter part of *Gormenghast* (Chapter 50 onwards) the
form of *Titus Alone* is linear and dynamic. It has a good deal of
conflict, and therefore a 'plot', but it also has a good deal of
random incident which is drawn into the pattern only by the
presence of Titus as a common element. Peake called the novel a
'picaresque' and had read and delighted in *Candide,* and in part
Titus Alone can be seen as a comprehensive picaresque parody of
the human condition.

In each volume of the three Titus books as they stand the

manuscripts help one to appreciate the nature of the book. In *Titus Groan* the manuscripts are fluent, prolific, longer than the published text, a volcanic outpouring of invention which drew on Peake's imagination at a deep level and embodied his responses to a whole range of visual and literary stimuli. The manuscripts of *Gormenghast* show that the work was constructed in space, like a pyramid, instead of being written in a chronological sequence. Three seminal blocks of narrative establish the foundations with three leading themes, and the book is then organised round these themes in a scheme which modifies as the work proceeds.

The manuscript for *Titus Alone* shows a return to the largely chronological method of *Titus Groan*, but Peake has developed a capacity for planning since that novel, and the manuscript books are full of notes. The second edition of the novel is rather fuller than the first, but neither of these editions, which had to be assembled by editors in view of Peake's illness, closely follows the notes in the manuscript. This seems to be because the novel modified in his mind as it was written, and as the direction changed so a new set of notes was written out giving the revised arrangements.

The eight manuscript books and loose leaves of *Titus Alone* cover the period 1954–8, and their appearance and legibility steadily deteriorate as Peake's illness progresses. The original title of the book was to have been 'Titus Far from Home', and later in the manuscript this title was dropped in favour of simply 'Titus 3', the third Titus book, indicating that Peake found the question of the title difficult. 'Titus Far from Home' places the interest squarely on Titus and his state of mind, whereas the finished work has at least an equal concern with the satirical vision of evil in the modern world which Peake embodied in the sinister factory governed by the Professor, Cheeta's father, and in the equivocal amorous charms of Cheeta herself. These evil male and female figures correspond to the two figures who love Titus in their different ways, Juno, who becomes his mistress, and Muzzle-hatch, who is his friend.

Peake clearly perceives two kinds of physical love: love itself can be an evil if it is a blind infatuation like that of Titus for Cheeta, which is balanced against his true relationship with Juno. There is no corresponding contrast between the Professor and Muzzlehatch, but then the Professor is a very underdeveloped

figure in the published text, and there are fragments in the manuscripts which suggest that he might have had more of a role if Peake had been able to finish the book as he intended. The portrait of Muzzlehatch itself becomes fragmentary in the later manuscripts and very late in the novel Peake introduces a new figure called the Anchor, who is the embodiment of manly virtues and the replacement for Muzzlehatch in Juno's affections. This character's appearance disrupts the continuity of the novel entirely, and the editors omitted him altogether from the first edition but reintroduced him for the second.

Cheeta's father, the scientist, and his factory are the most important single symbol in the book, and the light that the manuscript throws on this factory is of crucial significance. In the published text Muzzlehatch is unable to describe what he saw in the factory very specifically. He invades the factory in order to leave a bomb which destroys it at the climax of the novel. A note in the manuscript plans for Muzzlehatch to 'stride across the world' searching for the 'centre or heart of science', only to discover that 'it hasn't got a heart'. The factory, then, is 'science' which in turn is modern technological civilisation, and one may take it that Muzzlehatch (with Titus and Peake) is rejecting the modern world *in toto* in Chapter 99 where Muzzlehatch describes the interior of the factory.

> In the broadest way he told . . . of the identical faces: of how he slid down endless belts of translucent skin; and how, as he slid, a great hand in a glove of shining black rubber reached out for him.
>
> (Chapter 99, 2nd edition)

It sounds like part of Chaplin's *Modern Times*. In the manuscript Cheeta's father is specifically described as a 'deathray' scientist, and the word 'deathray' has been cut from the following paragraph in the published text which is otherwise exactly as it stands in the manuscript.

> That her father, the greatest [deathray] scientist in the world, was hanging upside down from the outstretched arm of some kind of brigand did not, in itself, inflame or impress upon her passions.
>
> (Chapter 113, 2nd edition)

The published text of Muzzlehatch's description of the factory makes it clear that the notion of a 'deathray' is present. Muzzlehatch has killed a guard with his knife, and the author intervenes to comment on ancient and modern instruments of death.

> Strange as it seems (when it is remembered how horrible and multifarious are the ways of modern death), yet it is true that a jack-knife at the ribs can cause as terrible a sensation as any lurking gas or lethal ray.
>
> (Chapter 99, 2nd edition)

The factory, then, is evil in a very specific sense: it manufactures instruments of death. Another discarded passage suggests that this 'deathray' worked on atomic energy in some way. This passage, dropped from the end of Muzzlehatch's account of the factory, consists of unrelated sentences: 'a refining . . . a concentration of power', 'smallness becomes synonymous with might', 'the pin-head waits to burgeon like an evil fever, to scar the skins for ever'. These sentences evoke vividly one human response to the atomic bomb, the response that it is monstrous for man to isolate a common element of God's created universe in order to make a deadly weapon of it. So what Peake seems to be contemplating here is a horrific weapon of the immediate future which is like a gas, or a ray, and which burns. When the factory is recognised as evil in this very specific sense its symbolic function in the book is easier to understand, and Muzzlehatch's quest to destroy it makes better sense, than in the present published text.

Another problem connected with Muzzlehatch in the published text is the destruction of his animals and the misanthropy which affects both him and Titus, driving them to escape into the Under-River, where Titus encounters and fights with the dreaded Veil, persecutor of Black Rose. In the published version of the novel Veil is the only wholly evil character, and the others, including the inhabitants of the Under-River, tend to become sympathetic. The Three Companions, Crabcalf, Slingshott and Crackbell, are heavily caricatured (as society's pretentious casualties who are punished for their pretensions) when they first appear, but they move increasingly into favour until they become a stalwart troop of defenders for Titus and Muzzlehatch in the final battle. The vapid social group at Cheeta's party are too lightly drawn to be specifically evil, but in the notes it is clear that for Titus

117

the visit to the Under-River was to have been like a visit to hell with Titus as the leader of a gang of beggars who, tormenting him with mockeries of Gormenghast Castle, anticipate the travesty of Gormenghast presented at Cheeta's party in the Black House at the end of the novel. The beggars are listed as 'eccentrics', and Crabcalf, Slingshott and Crackbell were to have been among them. The savage murder of Muzzlehatch's animals by the scientists from the City belongs to this earlier stage of planning and so does Titus's vision of Juno's drawing-room, seen through its glass ceiling as though he were looking into a goldfish bowl and witnessing the varieties of human folly exposed there.

This original scheme has, then, a universal Swiftian eye presenting a sharply satirical vision of the whole world outside Titus himself. It is not at all surprising that Peake did not sustain this stance of total rejection: he is too good-tempered for that, and becomes mercifully interested in his characters as he creates them, so that instead of being an anonymous mass like his eccentrics of the poem 'As a Great Town Draws the Eccentrics in' (see below, Chapter 10, 'Inward' poems), Peake's 'eccentrics' among the Under-River people become attractively individual.

In the earlier Gormenghast books Peake made his task relatively easy by using a single setting. It is true that he used many aspects of that setting, but the basic geography of the castle is fixed. In *Titus Alone* he has a variety of settings and an increasing number of principal characters: first Titus, Juno and Muzzlehatch, and later Cheeta, the Professor, the Anchor, and the Three. All these figures are highly mobile and scatter and converge with considerable speed. Even without the disability of his illness Peake might have found this new kind of construction difficult to control.

For the picaresque tale of Titus himself the scheme is simple enough. Titus, an innocent from another world, gets into difficulties and Muzzlehatch gets him out of them. As a knowing guide to the young aristocrat Muzzlehatch is like Sancho Panza or Sam Weller, but he is also like Long John Silver. He is at least half a pirate, and in the earlier chapters he has a love-hate relationship with his young friend like that of John Silver and Dick Hawkins. He rescues Titus from the helmeted figures when he wakes to find himself in the City (Chapter 8), from Inspector Acreblade after his fall through the glass roof (Chapter 27), from the column of scientists by concealing him in the Under-River (Chapter 48), from

the murderous Veil (Chapter 61). After this point in their
relationship the structure of the novel alters abruptly with Muzzle-
hatch's insanity and the sudden emergence of two new principal
characters, Cheeta and the Anchor.

Titus is, then, a passive figure: when not being rescued by
Muzzlehatch he is being protected by Juno who feeds him
(Chapter 30), makes him her ward to protect him from the law,
and takes him as a lover (Chapters 42 to 45). After Titus and
Muzzlehatch have rescued Black Rose, Veil's first victim, from the
Under-River and delivered her to Juno, Titus's actions become
discontinuous. He is discovered by Cheeta (Chapter 69) after
obscure wanderings and a mysterious illness which are hardly
accounted for in the text. The rest of the plot, for Titus, consists
of his infatuation with Cheeta and his disillusionment by the
travesty of Gormenghast at the Black House.

With the new relationship with Cheeta comes a new stage in
Titus's passivity; with both Muzzlehatch and Juno Titus had
bursts of temper which gave him momentary independence (Chap-
ters 14 and 45), but with Cheeta he is a complaisant, almost maso-
chistic, victim.

Serious disintegration of the text sets in after Titus's encounter
with Cheeta: the manuscripts become almost impossible to follow,
and the wide differences between the first and second editions
of the novel point to the major problems that confronted the
editors who prepared them for publication. Shattered by the
reception of *The Wit to Woo* in March 1957, sent away for rests
in Sark, Buckinghamshire, and in various hospitals, Peake was no
longer able to control the work as he wished. It is reasonable
to suppose that Cheeta's party at the Black House in which she
torments Titus by parading before him a series of caricatures of
the inhabitants of Gormenghast – Gertrude, Fuchsia, Prune-
squallor and the rest – would have made a truly horrifying impact
had Peake been able to write it as he wished. As it stands, this
black Masque in the published text of both editions seems odd,
confusing, and overwritten, and it requires a major effort of the
imagination to grasp Peake's intention with it. The notes in the
manuscript help one to grasp that intention. They insist constantly
on Cheeta's will to 'Hurt' which is a conscious will deliberately
acted out. Offering no psychological explanation for Cheeta's
perversity, Peake demonstrates his belief in the existence of truly

119

evil people, and Titus, we can take it, has had the misfortune to encounter one of these. The party is expressed as 'a Black Mass' in the notes, and with this phrase Peake indicates the intensity of the evil that he intends to convey by Cheeta's 'ghastly charade' of Gormenghast characters. It is a deliberate act of blasphemy, cutting away at the loves and beliefs which have sustained Titus since he was a child, and thereby seeking to destroy his identity: a piece of diabolical brain-washing. It is fair to conclude that what we have is a pale imitation of what Peake could have done, at the height of his powers, with Cheeta's 'Black Mass'. Like the Masque at the close of a Jacobean tragedy in which mass murder is organised with fiendish ingenuity, Cheeta's 'Black Mass' should thrill the audience with a sense of being exposed to an epitome of brilliant wickedness. Some details of the charade still manage, perhaps, to evoke the *frisson* of horror for which Peake is hoping.

> There were the aunts, the identical twins, whose faces were lit in such a way that they appeared to be floating in space. The length of their necks; their horribly quill-like noses; the emptiness of their gaze; all this was bad enough, without those dreadful words which they uttered in a flat monotone over and over again.
> 'Burn . . . burn . . . burn . . .'
> (Chapter 106, 2nd edition)

Other passages from the Black Mass, though, which are perhaps intended to have a horrifying effect, are written with such an imbalance of diction that the total impact is farcical and bizarre by turns.

> Under a light to strangle infants by, the great and horrible flower opened its bulbous petals one by one: a flower whose roots drew sustenance from the grey slime of the pit, and whose vile scent obscured the delicacy of the juniper. This flower was evil, and its bloom satanic, and though it was invisible its manifestations were on every side.
> (Chapter 102, 2nd edition)

After a ludicrous opening phrase which seems drawn from the genre of 'sick' humour, this paragraph settles into an extended metaphor, the 'flowers of evil' expressing the atmosphere of the Black House, which depends heavily on the deployment of a

sequence of clumsy adjectives of which 'vile' is the least felicitous, but 'great', 'horrible', 'satanic', and 'bulbous' are little better. If this was seriously intended as an impressive setting of mood for the Black Mass it is a notable failure.

The other major reason for the failure of Cheeta's Black Mass as it stands has to do with the structure of the whole work. In the planning Peake has one of the characters, Muzzlehatch, in two places at once: he is simultaneously planting a bomb at the factory and arriving at the Black House, which is 'a hundred miles to the South' of the factory. A long cancelled passage from the manuscript shows that Cheeta's father was also in two places at once, both at the factory and participating in the travesty. This passage also amplifies the relationship between Cheeta and her father, which remains shadowy in the printed text, and shows that it is a bond of hatred: 'Cheeta was the only thing he feared', and he is glad that she has gone to the Black House and is out of his way. Another useful note here shows the Professor assuaging his conscience with the thought that he is 'only an instrument of the Government'. The whole state of this modern world, then, is malignant and murderous in the notes, and the factory is an emblem of its wicked moral condition.

The destruction of the factory and the mocking of Gormenghast are important symbols balancing each other at the climax of the narrative, a twin crisis for Titus himself and for this world of the future, which is now rid of the deadly contamination at its centre. Peake clearly worked as hard as his condition would permit at this climax which exists with many repetitions and alternative versions in the manuscript. The text of it in the second edition is a representative selection built up from the manuscripts by the editor.

In terms of what precedes it in the published text this climax has not been adequately prepared for. We do not find Cheeta coherent enough to be able to believe in the importance of her relationship with Titus, and it follows that we cannot believe in the threat to Titus's personality from the Black Mass itself, though clearly that threat is fully felt and intended by the author. The work as a whole is unbalanced by the failure of the Black Mass; the travesty, the party, and Cheeta herself are pale and theoretical presences by comparison with the solidity of Muzzlehatch and Juno. Equally it is difficult to believe in the factory as a threat to

mankind, although the cancelled passages help to give that threat its due weight and Muzzlehatch's action its due glory. The narrative feels truncated from the entrance of Cheeta onwards, and the Cheeta-Titus relationship, the Anchor-Juno relationship and Muzzlehatch's war against science are mere torsos, striking indications of what Peake would have done with them in possession of his full powers. Probably as his illness gained on him Peake devoted a disproportionate amount of energy to the conclusion of the novel, hoping to go back and fill in the preparation for the crisis once the crisis itself was mapped out.

Despite the sad state of its latter part, *Titus Alone* is an important addition to the two earlier Titus books, and apart from the masterly handling of Titus's own moral growth its most interesting and original feature is the creation and presentation of Muzzlehatch. This friend is an anarchist, a pirate by inclination with the flavour of the sea surrounding much that he does, a self-contained mature man whose solid friendship with the boy and whose mature love for Juno do not conflict with a comfortable self-knowledge. As he drives home Muzzlehatch reflects, unblushingly, on his own imperfections.

> His unfaithfulness; his egotism; his eternal play-acting; his gigantic pride; his lack of tenderness; his deafening exuberance; his selfishness.
>
> (Chapter 33, 2nd edition)

His self-centredness is healthy and unashamed, like that of the spivs and soldiers who fascinated Peake in his 'Head-Hunting' poems of the 1930s and the war (see below, Chapter 10, 'Head-Hunting' poems), and one can see Muzzlehatch as the successor to these aliens, the last and richest portrait in a series which includes Long John Silver, Captain Slaughterboard, the sailor in *The Rhyme of the Flying Bomb*, 'Caliban' (in a poem in *The Glassblowers*), those vigorous male extroverts who inhabit their skins with confidence and are at peace with themselves. With his monkey on his shoulder (a friendly monkey, unlike Steerpike's 'Satan' in *Gormenghast*) Muzzlehatch plays a pirate in his favourite daydreams.

> I am leaning on the rails of a ship. The air is full of spices and the deep salt water shines with phosphorous. I am alone on

deck and there is no one else to see the moon float out of a cloud so that a string of palms is lit like a procession. I can see the dark-white surf as it beats upon the shore; and I see, and I remember, how a figure ran along the strip of moonlit sand, with his arms raised high above his head, and his shadow ran beside him and jerked as it sped, for the beach was uneven; and then the moon slid into the clouds again and the world went black.

(Chapter 29, 2nd edition)

The languages of *Treasure Island*, *The Ancient Mariner* and *The Tempest* mingle here to give an authentic sense of Muzzlehatch's strange individuality and support the fascination that this older man holds for the young Titus, who plays Dick Hawkins to his John Silver, Wedding Guest to his Mariner, and perhaps even Ferdinand to his Prospero.

Finally, there is a notable virtue in the construction of *Titus Alone* which argues an advance from the earlier Titus books. *Titus Groan* and *Gormenghast* are both studded by sudden deaths with which Peake spurs on his action and abruptly removes unwanted characters. *Titus Alone* has very few deaths, and all of them are significant: the death of Veil is a 'comic' death, in the sense that it represents a victory for good over evil in the Under-River, and the deaths of Black Rose and Muzzlehatch himself are pathetic deaths. Both are tragic victims of a corrupt world. The death of Muzzlehatch is in intention heroic as well as tragic: having sacrificed his mental stability to the pressures of the technological future, Muzzlehatch gives up his life in a great cause (that of protecting Titus from the helmeted figures) after he has already destroyed the heart of darkness and the source of corruption in the factory. His sprawled corpse at the close of the novel is like a monument to a lost golden age which he himself has worked to revive, and as the reader's vision swings away from him he becomes a giant emblem of the earth, 'sprawled as though to take the curve of the world' (Chapter 117, 2nd edition). Apart from the two helmeted assassins, who suffer just retribution, there are no other deaths, although Cheeta, who runs screaming into the forest from the Black House, suffers 'dramatic' death in the sense that she has been hounded from the stage by shame.

3. *Titus Alone* as the last of the Titus books

If one looks at *Titus Alone* from one's knowledge of Peake the man, its failures of organisation, and the uneven quality especially of the later chapters, appear as tragic reflections of its author's illness, but if one considers it purely as an artefact following the two earlier Titus books it emerges as a brave attempt to deal with a teasing artistic difficulty. Like most romantic and neo-romantic artists Peake experiences strain in adjusting from the delightful inner world of his imagination to the objective world of adult responsibilities; many romantic artists never make this adjustment, and the crises and early deaths among Yeats's 'tragic generation' in the 1890s reflect this refusal to adjust, this determination to cling to the reality of the inner life even at the expense of life itself. Peake's own horizons are broader than that, and his poem 'The Glassblowers' (see below, Chapter 10, Romantic poems) is a notably successful example of a romantic temperament applying itself to the outer world.

In the three Titus books there is an obvious progression from an inward to an outer world, and this progression has its own logic which is in turn reflected in the changes of narrative technique in the books. For much of *Titus Groan* and for the first fifty chapters of *Gormenghast* the narrative is expository, and despite its gloomy extravagance and its succession of sudden deaths the reader feels paradoxically at home, taking a child's pleasure in Gertrude, the Prunesquallors, the Ritual and (later) Bellgrove as fixed points for which one feels affection simply because of their permanence.

At the breaking point in *Gormenghast*, where the narrative method becomes dramatic instead of expository, a change of direction has become an aesthetic necessity; the revelation of Titus's world is complete, and Peake moves on to explore his inner development in the stress of action.

The anguish that Titus experiences in the outer world of *Titus Alone* must in part reflect Peake's own anguish in the struggle to control new material and to relate Titus's old identity, dependent on and circumscribed by Gormenghast Castle, to his new circumstances. The many alternative titles for *Titus Alone* indicate the way in which Peake perceived this problem.

Titus Lost
Titus Alone
The Wilds of the Mind
Titus in Wilderness
Titus Haunted

'Lost', 'In Wilderness', and 'Haunted': Titus is all these things, and Peake's problem is to hold in balance the three unstable elements in a difficult equation: Titus's inner development, the relationships and experiences in the action which contribute to that development, and the inherent evil and irrationality of the outer world which contribute to the psychological decay of Muzzle-hatch and of Titus himself. This last concern was sometimes upper-most in Peake's mind as the subject of the book, as the alternative title 'The Wilds of the Mind' indicates.

At its best *Titus Alone* is a fine psychological study of an 'innocent' or 'primitive' man seeking an appropriate adjustment to a world of the near future. This future probably follows a cataclysmic war of some kind from which the Under-River people are refugees; Veil was a prison guard in that war and the Black Rose was one of his charges. Ideologically it is an evil world, worshipping and perfecting a destructive technology, and socially it is a trivial world. The cocktail party into which Titus tumbles is a gathering of anaemic self-advertising literary amateurs muscling for each other's praise, perceived as a grotesque assembly of beasts: 'The giraffe-men and the hippopotamus-men. The serpent-ladies and the heron-ladies' (Chapter 21, 2nd edition).

On the face of it it is surprising that Titus should choose to remain here instead of returning to the pre-industrial security of Gormenghast Castle, now purged of Steerpike. Titus's initial response to this future state is inverted with time: at first he hates the people and admires the technology, particularly of the flying machines which he sees as 'a fleet of fish-shaped, needle-shaped, knife-shaped, shark-shaped, splinter-shaped devices' (Chapter 20, 2nd edition). He later learns to fear the purposes to which tech-nology is put, and to love some of the people, notably Muzzle-hatch who, like a liberal in a communist country, has made his own partial adjustment to the regime and to the worship of machines: he does own a car, though by the standards of the time it is a decayed machine (but wonderful to Titus), and keeps

a zoo which is disapproved of by the scientists but tolerated until Titus impetuously destroys a mechanical spy sent to observe him, and brings down retaliation on Muzzlehatch.

Muzzlehatch's insanity following the destruction of his zoo is a double calamity for Titus: it deprives him of his natural protector at a time when he is becoming ensnared by Cheeta, and it removes a new-found source of authority and an important influence in his moral education. Titus's sufferings when he is left 'Alone' are entirely credible, particularly when he suffers pangs of nostalgia for Gormenghast.

In a striking little scene early in the novel Titus has run away (for the first time) from Muzzlehatch and sees a vision of pure evil: two lesbians, 'be-jewelled, deep-bosomed women', who 'smiled at each other with unhealthy concentration' have flashed past him in two separate cars driving (impossibly, or diabolically) abreast (Chapter 15, 2nd edition). This vision of perverted womanhood, which anticipates Cheeta's role in the novel, provokes regret for his lost home: 'How was it that they were so self-sufficient, those women in their cars, or Muzzlehatch in his zoo – having no knowledge of Gormenghast, which was of course the heart of everything?' (Chapter 15, 2nd edition).

The absence of Gormenghast creates a vacuum of authority within the novel which Muzzlehatch and Juno respectively can only partially fill. Although he functions effectively as a father-figure for Titus, Muzzlehatch himself is an instinctive anarchist (or nihilist, perhaps), so that the quest for moral authority in that quarter is met with teasing riddles reminiscent of the Philosopher's doctrine of death in *Gormenghast*:

> There is no point in erecting a structure . . . unless someone else pulls it down. There is no value in a rule until it is broken. There is nothing in life unless there is death at the back of it. Death, dear boy, leaning over the edge of the world like a bone-yard.

> (Chapter 14, 2nd edition)

This doctrine is at odds with Muzzlehatch's personal magnificence. He is an 'intellectual ruffian', a 'ravaged god', who quells the rebellious mule and camel (Chapter 14), makes love to Juno, drives at speed and with relish, rescues Titus and the Black Rose, and conducts himself, until his mind decays, with gallantry and

zest. Since he has no philosophy Titus can learn from him only by following his glamorous example, which he does with complete literalness by making love to Juno himself. In fiction this triangle of two men loving a single woman often argues a displaced homosexual bond, but here it is more a master-pupil relationship in which the pupil has learnt his lesson too well.

The relationship with Juno is a temporary comfort to Titus, but is in the end equally powerless to fill the vacuum created by the loss of Gormenghast. Juno is wise, powerful and beautiful, and were she also an exacting and deeply loving mistress this relationship could become as bracing a source of discipline and as rich a source of moral education as any relationship that Titus is likely to form. But her attitude to Titus is beautifully drawn by Peake as indulgent, maternal, ultimately shallow: she knows that Titus will eventually leave her so she refrains from investing too much emotion in him. Whether Titus would have responded equally if she had allowed herself to love him to the depths of her passionate nature, as she eventually loves the Anchor, is a teasing question which Peake sketches and then leaves in the air. Although Juno is judged lightly by the novel, the effect of her relationship with Titus is damaging since it gives him just enough confidence with women to expose himself to Cheeta's cruelty.

Flawed though the narratives of Titus's relationship with Cheeta and of his humiliation at the Black Mass inevitably are by the progress of Peake's illness, one can recognise that Cheeta and her father fill, in an inverted and diabolical sense, the power vacuum which Juno and Muzzlehatch have failed to fill. Cheeta is an un-person, not merely less than human (as her animal name indicates) but the opposite of human. Hatred is the strongest human bond recognised by Cheeta, and the emotion on which her relationship with Titus is based, and Titus's painful nostalgia for Gormenghast, which bubbles to the surface in his feverish ravings, provides Cheeta with a weapon. The incomplete state of the text can permit her Black Mass to seem merely silly, but if one reads the whole novel with sympathetic attention to the psychological portrait of Titus then the Black Mass emerges, in conception at least, as a piece of diabolical wickedness. In this confusing world Titus's recollection of Gormenghast has become his only certainty, the one fixed pole by which his sense of iden-

tity remains intact. Muzzlehatch's insanity and Titus's own illness make insanity a real risk for him, but even that is not the worst consequence that the Black Mass could have, nor does it appear to be the consequence that Cheeta intends: by showing the one thing he loves to Titus as an object of ridicule and hatred Cheeta wishes, it seems, to substitute hatred for love in his soul and make him an un-person like herself. Cheeta is the devil, and like the devil she becomes dazzled by pride and overestimates her own powers so that the inconceivable happens: instead of learning to hate Gormenghast Titus learns to see Cheeta for what she is.

All Peake's published novels, the three Titus books and *Mr Pye*, have a constant pattern of metaphor presenting birth and rebirth as images of moral growth. An angel newly-hatched from the human chrysalis, Mr Pye when he takes flight from Sark represents death in the limited sense that he withdraws from the sight of men, and birth in the absolute sense of becoming one with God. The patterns of birth and rebirth in the Titus books are less direct in their meaning and generate a wider range of responses than the specifically Christian metaphor presented in *Mr Pye*. In the Titus books the literal birth of Titus at the opening of *Titus Groan* is balanced by his metaphorical rebirth when he rebels against the rituals at the end of that novel, and in *Gormenghast* his romantic ride out into the dawn is a proleptic image for his final decision to cut loose from the castle after saving it from Steerpike, so that after having been reborn as an individual child he seeks to be again reborn as a man. *Titus Alone* is like a sustained trauma attendant upon this second rebirth: Titus is neither free nor un-free of Gormenghast, and he must either struggle to be fully born or he must return to the castle, and be stifled in the womb from which he has half emerged. Therefore the sombre tone of *Titus Alone* is entirely appropriate to its subject, since the fantastic picaresque narrative is itself an extended metaphor expressing a struggle of the utmost psychological importance.

The closing chapter of the novel shows that the struggle is successful. Although he has learnt in time to resist Cheeta and the modern technological world for which she stands, flight from this world does not mean, for Titus, a return to his previous world, and it seems certain that he would never have returned to the

castle in any subsequent book: 'He had no longer any need for home, for he carried his Gormenghast within him' (Chapter 122, 2nd edition).

This is considerable advance on the twilight state of mind indicated at the opening of the novel:

> He had been through much since he had escaped from Ritual, and he was no longer child or youth, but by reason of his knowledge of tragedy, violence, and the sense of his own perfidy, he was far more than these, though less than *man*.
> (Chapter 3, 2nd edition)

To become man, then, is the object of Titus's quest, and in her stupidity Cheeta pushes him towards this object by provoking him too far.

The metaphors of birth and growth in the Titus books lead to this moment where Titus arrives at manhood. The notes that Peake left for 'Titus 4' show that Titus is to continue his travels and grow old away from Gormenghast, his life probably following a pattern similar to Peake's own life after he had left China. Peake was only eleven, of course, at that time, whereas Titus is seventeen when he leaves Gormenghast, but it seems likely enough that some of the sense of a fabulous, lost, forbidden world with which the author invests the castle is derived from his own recollection of a wonderful mysterious country from which he was suddenly removed with abrupt finality.

If the sequence of the four novels can be seen in a way as a history of Peake's own growth as a literary artist, in which he moves from a delighted contemplation of the inner life towards a marriage between his romantic temperament and the objective world outside himself, then it is fair to say that, in the novels at least, this marriage is not achieved. Without the tragic intervention of his illness it probably would have been achieved, and the imaginative world explored by Titus in 'Titus 4' might well have been apprehended with an intensity as confident as that of the poem 'The Glassblowers'. *Titus Alone* as it stands does not have that kind of confidence; nor would this be appropriate to it, since the central theme of the novel has to do with the absence of confidence, the failure of identity, and the agonising struggle to recover those things. *Titus Alone* is like a long pause between sleeping and waking in which nightmares mingle disquietingly

with the light of day, and only in the last moments of the novel does the sleeper become aware that he is now fully awake.

9 Shorter Prose Pieces: Black Rites, Black Arts, Black Mass

The Black Mass in *Titus Alone* recalls the inverted worship in *Mr Pye* which is hinted at as the most profound of Mr Pye's sins when he is endeavouring to rid himself of his angelic wings. Mr Pye makes his way to the Dixcart valley and there venerates a goat:

> 'O, thou,' said Mr Pye in a faraway and most peculiar voice, after which he added 'hail'. The goat nodded its head. . .
>
> (Chapter 23)

The goat has a devil's mouth, 'a thoroughly unpleasant line, where Satan had obviously been at work' (Chapter 23).

Mr Pye draws a circle of power on the ground and then begins to cast spells: this is treated lightly, but the potential consequences for Mr Pye's soul are serious.

> As he began to scratch further signs inside the circle and light a short black stub of candle, he thought of the Great Pal, but instead of being afraid, as he had been for the last week, he now rejoiced at his insurrection.
>
> (Chapter 23)

The most blasphemous of Peake's ideas is not represented in any of the longer prose works, but appears in a short piece called 'Boy in Darkness', in which an evil controlling intelligence known as the Lamb is discovered in an underground world. This is a horrifying creation, and much of its *frisson* derives from its obvious association with the Paschal Lamb. This Lamb has the qualities of Christ in reverse: it takes men and turns them into beasts, it is soft, delicate and childlike in its manner and wicked in its soul, where Christ was masculine and commanding in his manner and innocent in his soul, and it can destroy with its will. Two of its creations, the Goat and the Hyena, which have been turned from men to beasts and now worship the Lamb as their creator in ignorance of the past, threaten to seize a boy visitor (clearly Titus, though not named) and make him one of them. The story was never intended as part of the Gormenghast story, but is a separate episode involving a Titus figure which was commis-

sioned for a collection of fantastic stories. This story is too dark and pessimistic to have fitted the imaginative world even of *Titus Alone*.

In 1963, when he was almost too ill for any work at all, two short stories by Peake appeared in *Science Fantasy*. They had been written earlier, during the 1950s at Wallington, and were found among his papers and published, in an enterprising spirit, by Michael Moorcock. The first of these, 'Same Time, Same Place', presents a single bizarre idea as an interesting object in its own right, and the surrounding characterisation and setting is sketched in as a perfunctory framework. One would guess that Peake would have revised this story for publication if he had been able to. A young man escaping from his parents' stifling suburban domesticity meets a mysterious stranger, a dazzling blonde who is always seated when he meets her at Lyons Corner House. After a week of meetings they arrange to marry, and as he arrives at the Registry Office the young man sees through an upper window that his intended bride is a dwarfish freak belonging to a family of freaks: a man with 'the longest neck in the world', a tattooed man, a man with horses' hooves, and a bearded lady.

The outlook of this story seems adolescent; the interest in physical deformity for its own sake is balanced by the young man's irrational rebelliousness against his elderly parents, combined with a sense of unreality about those parents. The young man's stated age is twenty-three, yet he behaves as though not yet out of his teens: he is completely under his parents' control, to the extent that he dare not reveal his marriage plans to them even when he sets out for the Registry Office, and the marriage seems to mean nothing to him beyond the ceremony itself, since he has obviously made no arrangements to set up a home. He wishes to go through the marriage ceremony with her for idealistic schoolboy reasons as a high and decorous expression of his admiration for her fine eyes.

The bride herself is described with an exquisitely cool sense of the macabre:

A something in white trotted like a dog across the room. But it was no dog. It was vertical as it ran. I thought at first that it was a mechanical doll, so close was it to the floor. I could not observe its face . . .

It stopped when it reached the flower-laden table and there was a good deal of smiling and bowing and then the man with the longest neck in the world placed a high stool in front of the table and, with the help of the young man with the goat foot, lifted the white thing so that it stood upon the high stool. The long satin dress was carefully draped over the stool so that it reached to the floor on every side. It seemed as though a tall dignified woman was standing at the civic altar.

('Same Time, Same Place', *Science Fantasy* 60 (1963), p. 63)

After this horrifying vision the narrator hurries home to his parents' house in the suburbs, never to leave it again.

The story is a complete inversion of the normal values associated with marriage: the bride is a monster, the outside world is dangerous. To attempt adult love is itself a punishable exercise, and the young man dare not tell his parents. To redeem himself he must become a child again and revert to dependence on his parents: 'I remember how I stared with love at the ash on my father's waistcoat, at his stained moustache, at my mother's worn-away shoe heels. I stared at it all and I loved it all. I needed it all' (p. 65). The story reads almost like the work of a regressive psychopath: it is a dreamlike, crippled, hopeless rejection of maturity.

To say this is not to suggest that Peake was himself such a person – obviously he was not – but rather to show that the positive, loving and energetic aspects of his nature had their obverse which here receive an unconscious but clear expression. It is a necessary lapse, a therapeutic retreat, a transvaluation of the kind that takes place in all dreams and is here translated directly into fiction.

'Danse Macabre', published in the next issue of *Science Fantasy*, was written for his family to be told at the fireside one Christmas. Unlike the preceding story it is of a recognisable genre of tale of horror as practised by Poe and M. R. James. Like Poe, Peake derives much excitement from observing the growth of horror within the mind of his narrator, but also, like James, he has a prosaic and naturalistic setting for a supernatural tale. A man and his wife have separated and their clothes refuse to accept the separation and rejoin each other for a weekly dance followed by love-making. This cycle is broken by a meeting between the

133

estranged pair, both wearing the clothes which lead this independent life: husband and wife struggle against the will of their clothes which is too strong for them and they are left dead while their disembodied spirits perform again the 'danse macabre'.

Apart from the inherent absurdity of a first-person narrative spoken by a disembodied spirit, who is solemnly given 'We were both dead' as his closing line, this is a powerful story. The estrangement of the pair is caused by a perversion of the love impulse similar to Cheeta's perversion in *Titus Alone*: 'evil' has entered the narrator's temperament and forced his wife to leave him, 'seeing no hope for us but only a strengthening of that perverse and hideous *thing* that drives men to their own destruction, the more the love, the more the wish to hurt' ('Danse Macabre', *Science Fantasy* 61 (1963), pp. 52-3).

A perverted temperament, the narrator necessarily has a distorted vision of good and evil. The empty suit of clothes horrifies him for reasons which he cannot himself establish:

> Being exactly above the headless creature [the animated dress-suit] I found that I was forced to see down into the horrible darkness of that circular pit whose outward rim was formed by the stiff, white collar.
>
> (p. 50)

The headless suit of clothes is, of course, more loving and more true to life than the narrator himself, who, because he has embraced evil as his good, sees love itself and the reunion with his wife, at a chance dinner-party, as aspects of an evil will at work:

> Then there came to us the long shudder and the beginning of the *malevolence*. All I could see of her now was her ice-blue dress but an evil of some kind, a malevolent evil, was entering our clothes. . .
>
> (p. 54)

This 'malevolent evil' is normal passion itself, which the narrator's nature denies.

This story is a very much more sophisticated narrative than 'Same Time, Same Place'. The subject of that story was marriage and the subject of this story is love, but whereas in the earlier

story marriage was treated with unconscious perversity, in this one
the narrator's own inverted scale of values is consciously exploited
as a narrative device : it is a coherent and autonomous piece inviting
us to contemplate its narrator's, not its author's, psychology. The
author and the reader both know that love is good, but for the
purpose of the fantasy the author presents a narrator who lives
by the assumption that love is evil, and the result is a fable which
contains perversity and horror among its elements, but is not in its
totality perverse and horrifying.

In three other short prose pieces, 'The Connoisseurs', 'The
Glassblowers', and 'The Weird Journey', Peake applies his tech-
niques of inversion and transvaluation. The first piece is based
on an idea which was also used for an unpublished play presented
at Smarden in 1952, the second is a prose rendering of the subject
which Peake later made famous in his poem, and the third is a
piece of dream-prose which is as close as Peake came to 'automatic'
writing.

'The Connoisseurs' appeared in *Lilliput* XXVI (January 1950),
pp. 58-9. It is sub-headed 'Preciosity', which indicates precisely
the perversity with which Peake proposes to deal. The story is more
streamlined than the playlet; it has only two (instead of three)
characters who are nameless, the 'connoisseurs' of the title, and
they are a basic Peake antithesis, the fat man and the thin man.

> One a little plumper than he would have chosen and the
> other a little less upright. But both were fastidiously groomed.
> Their hands were very similar, soft and rather womanish.
>
> (p. 58)

They are anti-men, these two figures, who pick at art instead of
creating it, and observe life instead of living it. One of them
owns a Chinese vase which may or may not be genuine : to deter-
mine this one must examine the interior to see whether a crab
is engraved there, and to get at the interior the owner breaks the
vase. The critics have arrived at the destruction of art by competing
with one another in fastidious aestheticism.

> 'The patina upon the crimson cranes – what do you feel? Just
> a shade too obviously encrusted – just a shade?'
>
> (p. 59)

The satire is crude and the point obvious, but the narrative

of this little story is a testimony to Peake's spirit and capacity for comic characterisation even within the space of a vignette.

In 'The Glassblowers' and 'The Weird Journey' Peake's talent with evocative language as such is shown at its best. 'Pans and puns and tricks of the memory' are the sources of fantasy in Forster's *Aspects of the Novel*, and in these two pieces a taste for puns and an inherent verbal contradictoriness give the work its energy and specific flavour. Far more than in the poem of the same name the prose 'Glassblowers' is a work in which the artist writes deliberately 'against' the subject, finding beauty in something which is inherently alien to him. The virile violent artisans who blow the television tubes are themselves 'aliens' like the self-contained spivs and soldiers of the poems : they are the antitheses of his effeminate aesthetes in 'The Connoisseurs', or the critics, Jews and 'raging queers' of the art world whom Thorpe the painter so resents in *Mr Pye*.

His fascination with the violence and roughness of these men is sharpened by the contrasting delicacy and perfection of their craftsmanship :

It is the ballet of glass. It is the ballet of dark hours; of furnace-heat. It is the ballet of sweat. The ballet that not one of these deft craftsmen knows for such. Rough-clothed, rough-headed, drenched with sweat, they are yet as delicate as dancers.

('The Glassblowers', *Convoy* IV (July 1946), pp. 23-7)

The line 'It is the ballet of gold sweat' in the poem is created by a boiling down and reduction of this paragraph to its essentials, and illustrates the way in which Peake's massive prose style is adapted and refined for the purposes of his poetry.

'The Weird Journey', published in *Harvest* I (1948), pp. 58-61, is an impressive piece of prose which illustrates some of the naked essentials of Peake's prose technique. It is a plaything, a story without a subject built up from a series of phrases and devices. Clearly the artist has begun by concentrating on the word and allowed the word to release the image and the image to release meaning. One is reminded of the techniques by which he arrived at the appropriate names and phrases in the Titus books, exchanging comical names over the table with his family and writing out strings of euphonious syllables in his notes until he hits on the right sound.

The opening paragraph of the piece illustrates beautifully this progression from word-play to meaning:

> Once upon a time-theory, when, alone on the great bed, I found that no sooner had my head left the pillow than I fell wide awake.
>
> (p. 58)

This depends for its effect on a group of familiar rhetorical figures from conventional narrative which are here subject to twists and adaptations which give them new and unexpected sense. 'Once upon a time-theory' is left to germinate a theme for the unshaped narrative, while the felicitous 'I fell wide awake' establishes a technique for the next paragraph in which set phrases are inverted and fixed assumptions contradicted.

> I could remember nothing save that I had come out of darkness – a kindly, muffling darkness, a daylight darkness, a summer of sepia, and that I was now in brilliance, the brilliance of night, very thrilling to the bones.
>
> (p. 58)

Darkness is visible, then, and brilliance belongs to the night. A slight adaptation of this technique makes nonsense of further set phrases, 'not a cloud in the sky' and 'brand new riding-boots'.

> I could not tell what size I was at first, but a sensation of height pervaded me, and glancing downwards it was not easy at first-sight to perceive what footwear I favoured, although not a cloud lay between my head and a brand new pair of snakeskin striding boots.
>
> (p. 58)

This associative exploitation of set phrases gives a sense of the familiar to the totally fantastic situation which begins to unfold under Peake's hand. Clearly he was writing intuitively with little notion of what would come next from sentence to sentence, and the opening phrase, 'Once upon a time-theory', begins to suggest a theme for the piece: a journey backwards into time. With its 'purpose most immediate' after 'years of stillness' this journey awakens recollections of Bunyan and releases into Peake's imagination a set of striking but unstable Christian images which whirl round the central figure, the man retracing his tracks down the

highway of his past life. A simile for the dreamer's coat sets off
these images:

> My jacket, black and tarnished though it was, spread like the
> wings of some great fowl behind me – some fowl of hell.
>
> (p. 59)

The 'fowl of hell' promptly fills Peake's imagination with its
opposite, fowls of heaven, who appear as parrots tearing past
'with bibles in their beaks'. Peake fuses the two suggestions,
coloured birds and sacred text, by giving the parrots the colours of
the spectrum, 'red, orange, yellow, green, blue, indigo, violet,
in that order of rotation', and making each bird in the sequence
hold a different book of the Old Testament in its beak. This
sequence suggests in turn the sequence of the Christian year with
its cycle of readings, the parrots becoming a congregation which
intermittently screams 'Amen' (after which they shut their beaks
'with a clang' to avoid dropping their bibles).

The Christian year prompts the notion of 'holiday', and on
the right of the sleeper appears the sea bordered by innumerable
empty deck-chairs, while on his left are the middle-class suburbs
of childhood:

> A grey mountain-range was dotted with prawn-coloured villas,
> each one a replica of its neighbours. In the garden of every
> villa sat something that was smoking a pipe. I turned my head
> away quickly.
>
> (p. 59)

The holiday is an open, the suburban childhood a closed, prospect.
The shutting out of the suburban horizon by a grey mountain is
reinforced by the faceless pipe-smoking creature which seems to
be suburban man, sub-human because he has forfeited dignity
and achievement and is content to be part of an anonymous middle-
class: the dreamer fears him and turns his head away 'quickly'.

What the dreamer fears, unconsciously, is his own childhood,
which had been 'surrounded by high grey acres of wallpaper and
photographs gone yellow of marriage groups and dogs' heads
and faded cricket teams' (p. 60). Grey and yellow link the walls
and the photographs to the mountains and the beach, and this
connection once recognised makes the piece a composite recollec-
tion and projection of the dreamer's childhood in which the pipe-

smoking thing is both the dreamer's father and the dreamer's own future self; hence the fear and the refusal to look closely.

This fear of mediocrity seems to become the subject of the story, and the narrative is sustained by the need to probe and exorcise the fear. The villas, the beach, and the sun above converge to meet at a central point marked by the dreamer's own head. The sea floods the villas, and the amalgam is then obliterated by the sun which descends like a golden omelette over the dreamer: 'it melted and trickled over my face, and shoulders, a soft petal of fire, like a blob of honey settling into a fold of my sleeve' (p. 61).

The dream described in this story releases a fear which the waking man has declined to acknowledge. Since the story seems to have been written intuitively and the phrases and images permitted to breed from sentence to sentence by a process of passive association, one can regard the resulting narrative as an unplanned and unmodified sample from Peake's sensibility in a state of tranced, musing, word-drunk meditation. It is as close as he comes in all his prose-work to a direct transcription of a dream, and as such it is a revealing example of his habits of composition.

10 The Poems

1. 'Head-Hunting' poems

Peake published two volumes of poems during his working life: *Shapes and Sounds* (1941) and *The Glassblowers* (1950). Since his illness in 1960 three more volumes have been published: *Poems and Drawings* (1965), *A Reverie of Bone* (1967), *Selected Poems* (1972); the prevailing mood is one of romanticism, with some bleak war-time poems, a number of poems of self-analysis, and a large group of what one may call 'head-hunting' poems where Peake makes verbal portraits similar to the pencil sketches which he habitually made in his London haunts. The poems as a whole divide, broadly, into those which are inward-looking and those which express the objective world.

Peake's poetry differs from his prose in an important respect; it is economical. His prose narrative is ample and sometimes verbose, while the poetry tends towards short lyrics employing well-honed diction. Also, his poetry seems to have become more complex as he grew older: the earlier poems have an attractive clarity while some of the later ones are perhaps wilfully obscure.

Many of the 'head-hunting' poems were written in the 1930s and appear in *Shapes and Sounds*. One of the best is 'The Cocky Walkers', the product of observation in London which is written with conscious use of Peake's training in painting and draftsmanship.

> Grouped nightly at the cold, accepted wall
> Carved with a gaslight chisel the lean hands
> Cry out unwittingly for Rembrandt's needle.
> ('The Cocky Walkers', *Shapes and Sounds*)

Here Peake shows his fascination with life which is young, arrogant, virile and completely itself: the life of the 'spiv' who reappears in his poem 'Caliban', also written in the 1930s but not collected until *A Reverie of Bone*.

> As much himself is he as Caliban
> Is Caliban or Ariel, Ariel.
> I shook with jealousy to see a man
> Strut with such bombast to his burial.
> ('Caliban', *A Reverie of Bone*)

The poem describes possibly the same 'spiv' whose face illustrates *The Craft of the Lead Pencil* (p. 11), with his insolent raised eyebrows, downturned eyes, snaggle-teeth, pendulous fag and scrawny moustache. This short poem, 'Caliban', sets up an antithesis between the poet and his subject; the poet envies the confidence of the spiv and experiences a spasm of self-contempt: 'Loathing my piebald heart that strikes ambiguous/Chords in my breast.'

This early use of the tension that exists in much of the most significant poetry in English, including the whole of Yeats, between the self and the 'other', the external identity, recurs in many of Peake's most successful poems.

The theme, the tone, and much of the language of 'The Cocky Walkers' reappears in 'Sing I the Fickle, Fit-for-Nothing Fellows', where the modern corner-boys are compared with their piratical ancestors.

> I think their forebears gave the Spaniard trouble
> And in the mêlée made a job of it
> With bleedy cutlass –
> ('Sing I the Fickle, Fit-for-Nothing Fellows',
> *The Glassblowers*)

The contemporary lives may be empty, but they conceal a latent potency which excites the poet's admiration. This sense of great strength which lies unused is conveyed in a series of images suggesting emptiness, idleness, fecklessness, and the dangerous possibility of sudden violent action.

> Sing I the way they tilt the cocky hat,
> The lightning tongue that spins a cigarette
> Along a slit.

'An Ugly Crow Sits Hunched on Jackson's Heart' is similarly full of dangerous and unrealised potency. It is an opaque poem, using a dark setting lit with vivid splashes of colour and present-

ing an obscure figure, both threatened and threatening, who is the direct product of a dream that Peake had shortly after the war of a murderous figure haunted by a crow.

> An ugly crow sits hunched on Jackson's heart
> And when it spreads its wings like broken fans
> The body of his gloom is torn apart
> Revealing sea-green pastures and gold towns.
> ('An Ugly Crow Sits Hunched on Jackson's Heart',
> *A Reverie of Bone*)

Within Jackson is a highly coloured nostalgia of pastures and 'gold towns' which is released by the crow. No doubt a Freudian would find a rich playground in this poem, with the crow as a distorted recollection of the mother, and the image of the crow in a nightmare conjuring up a repressed and almost nauseating nostalgia for a lost childhood. Jackson's mysterious vision makes him a sympathetic alien, a figure with whom one can partly identify by virtue of the partial insight into his mind afforded by the crow's intervention which tears apart his 'gloom'.

Gloom is a favourite Peake word and reappears in 'His Head and Hands were Built for Sin' to express the interior world of another dangerous alien.

> His head and hands were built for sin.
> As though predestined from the womb
> They had no choice : an earthish doom
> Has dogged him from his fortieth gloom
> Back to where glooms begin –
> ('His Head and Hands were Built for Sin', *The Glassblowers*)

As well as the male alien, Peake's 'head-hunting' poems include several portraits of women, placed in small dramatic episodes which characterise them within the space of a few lines : poems like 'Palais de Danse', 'The Strawberry Blonde' or 'Poem', and 'And Then I Heard her Speak'. They are less good than the poems about 'Calibans', spivs and brutes, probably because Peake understood women all too thoroughly. A gentle man who devoted his own life to his art, he recognised aggressive masculinity as something that most men have, but which was missing from his own temperament. All his poems about the male 'alien' have a quality

of excited inquiry into the unknown, but with his female charac-
ters the personalities seem to hold no mystery for him. A figure
like the empty-headed little danseuse of 'Palais de Danse' is
observed with lucid, sceptical detachment.

> Observe her, one of that bright million . . .
> Unknown to her
> One foot is tap-tap tapping on the floor:
> Her neck supports a brittle
> And thoughtless miracle . . .
> ('Palais de Danse', *Shapes and Sounds*)

Like one of Sweeney's nightingales in Eliot's poem, she personifies
the meretricious glamour of her sleazy world perfectly, but the
poet's attention soon slides away from her to the music, evoked in
this remarkable line: 'The crimson jazz is bouncing on the
boards!'
 The striking synaesthetic impact of this line is caught and held
to the end of the poem, the music itself becoming a thick and
tangible substance, 'the marrow of the Congo drums', into which
the danseuse herself 'melts', in the arms of a 'small shiny man'
(who could easily be Sweeney himself). An urban society which
has lost all spiritual values and given itself over to mindless sen-
sual gratification is well-evoked in this poem, and provides a set-
ting for the two short pieces, 'The Strawberry Blonde' and 'And
Then I Heard her Speak'. The first of these (untitled in *The
Glassblowers*) is a frankly sensational treatment of the murder
of a Piccadilly prostitute.

> What panther stalks tonight as through these London
> Groves of iron stalks the strawberry blonde?
> Strung through the darkness each electric moon
> Throbs like a wound.
> ('Poem', *The Glassblowers*)

The note of early Eliot seems to be present again, particularly
in the streetlamp as a throbbing electric moon ('Rhapsody on a
Windy Night'), and this vigorous little poem is an entertaining
example of what Peake can do when he chooses to write for fun
on a lurid theme. The second poem is based on an actual experi-
ence: the shock of an encounter at a bus-stop with a mysteriously
beautiful girl who proved, when she spoke, to have a thick

143

Cockney accent: 'Her shrill voice shattered/The alabaster of her brow's/Rare symmetry' ('And Then I Heard her Speak', *The Glassblowers*). The conclusion of the poem is sophisticated: the voice and the face together make for 'An edged/And more fantastic beauty', a bitter-sweet quality which saves the girl from mere sugary prettiness. The girl is completely realised in this tiny poem, and yet again the interest lies not in her as a girl but in the point that she illustrates, in this case an observation about the effect of a voice on one's hasty first assessment of character.

The best of Peake's alien poems are two similar pieces about adolescence, 'The Boy', and 'The Burning Boy'. The first of these is again based on an actual event, a meeting with a young starving Welshman at Christmas after the outbreak of war in 1939. It contains many of the same words as the other poems about threatening aliens, the 'fag' at the lip, the 'huddled' figure of the young man, but this alien is only a threat in so far as he is a disquieting reflection of the poet himself: 'There he stands forever/In me, unless into some stone I grow.' This turning in on the self from an image of a youth dominates 'The Burning Boy', a picture of universal adolescence where Peake seems to be taking the recollection of his own adolescence as his model.

> The burning boy! Half freshness, and half heavy
> With the enormous throbs of the first Garden!
> The eagle whets her blood-red beak within him.
> ('The Burning Boy', *Shapes and Sounds*)

The image of the violent youths in 'The Cocky Walkers' becomes an aspect of the self expressed in voluptuous late romantic imagery, where the passions of adolescence are compared to flowers imperiously scattered, *fleurs du mal*.

> The boy that stamps his teens away like flowers
> Beneath impetuous feet, his lilies dying,
> Entwined with nightshade and the dagger'd roses,
> Finds in the death of days a fever growing.

Death, nightshade, roses, lilies: a catalogue of familiar romantic images gives way to more explicit language, 'passion', 'spasm', 'climbing blood', 'naked on a crag of tumult'. Peake captures successfully the violent swinging between triumph and despair and the bewildering simultaneous guilt and innocence which

characterise adolescence, and he embodies in his language a rich youthful response to Keats and Blake, Baudelaire and Yeats.

2. 'Inward' poems

Many of Peake's best poems spring from the new direction in his work indicated by 'The Burning Boy', and take the form of self-examination, studies of his own responses and sensibility as man and artist. In 'Coloured Money' the Renaissance image of life's abundance as 'wealth' is caught up and sharpened by Peake: 'I am too rich already, for my eyes/Mint gold, while my heart cries/ "Oh cease!".' Flooded with images of gold, this tumultuous and highly-coloured poem argues that the wealth of beauty brings an early surfeit to the fine sensibility, which longs for emptiness, 'Hollowness', peace, and the freedom to 'Prance immune among vast alchemies'.

> To prance! And laugh! My heart and throat and eyes
> Emptied of all
> Their golden gall
> ('Coloured Money', *Shapes and Sounds*)

This is a puzzling conclusion to what is otherwise a considerable poem, and it is perhaps an anticipation of the occasional wilful obscurity that Peake allows himself in his later poetry. What are 'vast alchemies'? And since the purpose of alchemy is to make gold, in what sense is the artist set free of his gold ('Emptied of . . . golden gall') when he prances 'among' alchemy (or 'alchemies')? Peake's luxurious intuitive writing breeds some fine effects, but at the expense of the occasional silly line.

'Coloured Money' carries its own irony in relation to Peake's life: he was never able to cope with money, at any time, and possibly in finding that he had a surfeit of life's wealth he was also reflecting that wealth in the mundane sense had not yet (in the 1930s) come to him at all.

Several other poems about the nature of the artist's perception of his world appear in *Shapes and Sounds*: 'I, while the Gods Laugh, the World's Vortex am', 'What is it Muffles the Ascending Moment?', and a long, ambitious poem which begins as follows:

K 145

> If I could see, not surfaces,
> But could express
> What lies beneath the skin
>> ('If I could See not Surfaces', *Shapes and Sounds*)

In this poem perception is a mystical activity. Hearing, sight and touch, are avenues towards the inner meaning of the objective universe. Underlying the beauty of young girls is the 'Rhythm titanic' of the universe which created them: underlying the sound of the sea is the music of the 'hot earth' from which the artist himself derives his energy. From this discovery, that the beauty of women and his own strength derive from invisible sources, he moves to the intuition that only within himself, in the 'lost archives' which are still 'unexcavated by these eyes', will he find the understanding of the primal forces of the universe which he seeks.

This is a difficult poem which seeks to express a great deal in a small space. The unseen forces behind the visible world are expressed in images which are sometimes confused, as in the following mixed metaphors (author's italics):

> Then would I know my music wells
> From the hot earth, and comes
> *Astride* the long *sea-organ*
> Of man's ocean.

It has the marks of a young poet flexing his muscles, excited by his own strengths and not yet quite living in a mature relationship with any fixed system of belief. He is narcissistic, making discoveries about the nature of his own identity and absorbed in his own impulses and perceptions.

A clearer treatment of the question of identity appears in the poem 'I am Forever with Me', where the poet uses the romantic device of a *Doppelgänger* to grasp certain aspects of his own nature. The *Doppelgänger* is presented in the opening lines.

> I am forever with me; I am always
> Companion to the ghost-man whom I nurture.
>> ('I am Forever with Me', *Shapes and Sounds*)

The ghostly other self plays many roles: he is a 'boy of shoddy

glamour' like the youths in the 'spiv' poems, and he is the dis-
honest embodiment of an uncontrolled libido, a 'pilferer', and a
'penny pirate'. When examined more closely he also becomes a
'Gabriel', an angelic embodiment of conscience. In the last stanza
the poet reflects that the divided self is a universal condition.

> For everyone, the double man : the torture,
> The struggle and the grim perpetual laughter.
> For everyone his Gabriel and his Mocker,
> The stillness, and the fountain, and the Master.

The last line, though compressed, seems to yield a meaning which
adds to the poem : the poet's 'stillness', his inner stability, and his
'fountain', the source of his inspiration, are both aspects of the
other self, which is also the 'Master', the ordering and controlling
force which permits the artist to organise his impulses into art.
This last line lifts into the light, then, an aspect of the *Doppel-
gänger* which has been suggested throughout the poem : as well
as being the unregenerate *ego*, embodiment of the lower passions,
he is the noble *superego*, embodiment of clarity, reasonableness
and intellectual rigour. The poem as a whole presents a powerful
self-scrutiny where the poet recognises in himself violence, sen-
suality, reason and virtue by turns, each of which is a role played
by his inner or other self.

Despite the claims made for the controlling aspect of the mind
in the last line quoted above, the prevailing mood of the poem is
caught by the first stanza.

> Drifting through starlight on a bruise-blue harbour,
> Or wounded raw with the bright stones of winter,
> There I am with me, haunting for ever,
> My ghost-man, and my lover.

Obviously the *Doppelgänger* is an equivocal companion, both
pleasurable and tormenting, both 'lover' and 'ghost-man'. Bound
to each other, the poet and his companion conduct their relation-
ship in circumstances of ecstatic delight, 'drifting through star-
light', and 'embracing' in 'summer arbours', as well as experi-
encing the decorous adversity of 'the bright stones of winter'. A
pleasurable, sensuous self-absorption with a flavour of adoles-
cent melancholy, which is itself a source of pleasure, charac-

terises this rich poem, which presents complex and ambiguous emotions in clear diction and precise imagery.

The 1950 volume, *The Glassblowers*, contains another group of later poems which address the question of the nature of the artist. Three short pieces, 'The Rebels', 'As a Great Town Draws the Eccentrics in', and 'Times of Half-Light', take up again the topic of the passions within an artist which was treated in 'I am Forever with Me'. In these poems the other self is daemonic and threatening, more 'ghost-man' than 'lover', an uncontrollable force invading the mind, characterised as 'rebels', 'eccentrics' or 'forsaken monsters shouldering through the mind', respectively.

The best of these pieces is a single eight-line sentence of verse :

> As a great town draws the eccentrics in
> So I am like a city built of clay,
> Where madmen flourish, for beneath my skin,
> In every secret arch or alley way
>
> That winds about my bones of midnight, they
> Lurk in their rags, impatient for the call
> To muster at my breastbone, and to cry
> For revolution through the capital.
>
> ('As a Great Town Draws the Eccentrics in', *The Glassblowers*)

One can guess that this poem was important for Peake : it seems to anticipate the whole of the 'Under-River' sequence in *Titus Alone* where the gleaming city of the future is riddled with underground passages leading to a dank system of tunnels beneath a river which is inhabited by life's failures and rejects : the writer whose books have been remaindered, the lost ex-prisoner, the failed schoolmaster, old people on the verge of death. The correspondence between the poem and the novel is made clearer by the manuscript of the novel, which shows that Peake planned to make Titus the leader of a band of 'eccentrics' who were to turn on him and become his tormentors.

The great town is, of course, London of Peake's 'head-hunting' days, and the first two lines link this outer city to the inner city of Peake's mind, which is in a state of pre-revolutionary turmoil : the anarchic forces within him are prepared to overthrow his

inner order, which is itself 'built of clay' and ripe for destruction.

This poem was first published in *The New English Review Magazine* (July 1949). Peake's illness was not to manifest itself for another two or three years, but already he seems to be frightened of his own mind and of the images it could release, and this poem seems to look forward to the letter he wrote to his wife when he was first admitted to hospital ten years later in 1959: 'I will never write about mad people again . . . I have played too much around the edge of madness' (*A World Away*, p. 128).

Throughout his life he also retained his strong, though not clearly focused, religious impulse, and in one of his finest poems on the nature of the artist's mind he perceives that the forces controlling him and permitting him to create art can be seen as God-given rather than daemonic.

> I have become less clay than hazel-rod,
> For to the great lake of your consciousness
> The tremors bend.
> And the diviner's fist, my double-yard
> Of earth's become, to clutch the alchemies
> And make an end.
> > ('I have Become less Clay than Hazel-Rod', *The Glassblowers*)

With a phrasing and intonation similar to that of 'If I could See, not Surfaces', Peake presents the divine will and the daemonic forces brought into precarious harmony by the image of water-divining. He himself had the knack of water-divining, and uses this fact to set up a vivid metaphor in which his own 'double-yard' of earth, his six feet of man's flesh, becomes a sensitive instrument in God's hands as the hazel-twig is in his own. Here the difficult word 'alchemies' seems to be used in a meaningful way to signify the mysteries of the created world (God's precious object, perhaps), and to focus the concentric images in which God's hand holds the poet, whose own hand may 'clutch the alchemies' – the process of creating beautiful things which is granted to him – by virtue of this submission to the Divine will.

This is the only poem in which his inspiration is directly attributed to God, but even here the daemonic forces persist in the form of a 'warlock': the hazel-twig will break 'unless the warlock loose the straining rod'. This invites comparison with his

charming little song about the writing of a poem of which the first verse runs as follows:

> The paper is breathless
> Under the hand
> And the pencil is poised
> Like a warlock's wand –
> ('Poem', *The Glassblowers*)

The 'warlock', the magical agent who enables the poet to achieve utterance, is cleansed here of the threatening characteristics of the other aliens, the rebels, the eccentrics and the smouldering monster, but he remains a representative of the daemonic force. The creative process needs the daemonic and the divine forces equally, and the fusion of the two is expressed in a fine water image:

> Unless the warlock loose the straining
> Rod, the emerald hazel cracks
> Death at the palm.
> Unless your shrouded waters bring
> Love's climbing wave, wherefore this stick
> Of splintered doom?

The daemonic forces under the ground, the 'shrouded waters', must be united with the image of God's love in the first stanza, 'the great lake of your graciousness', by the agency of love itself, 'love's climbing wave'. The daemonic 'wand' is the immediate source of art, working within the context of a baptismal lake of love and graciousness: the passionate daemonic and intuitive aspect of the self can be trusted to lead the artist once it has been harnessed to the larger, cooler, less positive and more perceptive 'divine' aspect of the self.

This order of priority faithfully reflects the order of priority in Peake's own creative life; his art is determined first by his intuitive response and aesthetic preference, his sense of what is delightful and beautiful, and secondly by his intellectual and moral faculties. In this he is a determined and consistent neo-romantic, but some of the later poems suggest that he feels betrayed by the daemonic forces and by his own intuitions:

> We are the haunted people,
> We, who guess blindly at the seed

That flowers
Into the crimson caption . . .
('We are the Haunted People', *A Reverie of Bone*)

A poem in the late volume *Poems and Drawings* published shortly before his death, called 'Poem', seems to be an inversion of 'Each Day I Live is a Glass Room' (*A Reverie of Bone*) which describes the effort needed to make positive contact with the visible and tangible world. The poet lives behind the glass walls of his consciousness and must break through them, daily, with 'the thrusting of my senses' in order to reach and express the subjects of his art.

Each day I live is a glass room
Unless I break it with the thrusting
Of my senses and pass through
The splintered walls to the great landscapes –
('Each Day I Live is a Glass Room', *A Reverie of Bone*)

The later poem presents a situation the reverse of this. The artist trapped in his consciousness hears voices seeking to penetrate his mind as a bird tries to break open an egg to release the new chick:

Out of the overlapping
Leaves of my brain came tapping . . .
Tapping . . . a voice that is not mine alone . . .
('Poem', *Poems and Drawings*)

The delightful world to which the artist used to respond with ready intuition continues to send messages but he can no longer decipher them. He is imprisoned in his own mind, and in the poem 'Heads Float About Me', written in hospital, he is the victim of the daemonic force which he can no longer direct: floating heads surround him:

Terrify me that they deny the nightmare
That they should be, defy me . . .
('Heads Float About Me', *A Reverie of Bone*)

The despair of these poems has an immediate physiological source in his illness, of course, but it also reflects, with considerable honesty, a sense that his romanticism has betrayed him.

3. War poems

The intuitive response to life makes for rich, immediate and colourful poetry but tends to leave one with few defences against adversity. Peake's Christianity sometimes comes to his aid in his war poems, but in others his resentment of the conditions of being a soldier obliterate other intellectual and moral controls and is released into verse which expresses little beyond helpless anger. In 'Had Each a Voice what would his Fingers Cry?', for example, the artist's hands, compelled to handle a rifle, are betrayed:

> His fingers that were trained to bind
> The shadows of his mind
> To paper with slim lead.
> ('Had Each a Voice what would his Fingers
> Cry?', *Shapes and Sounds*)

The fingers long to scream 'Treachery' against this abuse. *Shapes and Sounds* contains several competent elegiac poems arising from the war: a mood of pathos and solemnity is one that Peake achieves tactfully in 'London, 1941', and 'The Spadesmen' (both reprinted in *Selected Poems*). 'The Spadesmen' successfully combines two contrasting images: the dead soldier as Christ, and death as a mass-produced article on the assembly lines of the munitions industries:

> They have supplied the Judas and the flails:
> The ten-a-minute barbed-wire crown-of-thorns
> Are in construction . . .
> ('The Spadesmen', *Shapes and Sounds*)

For each soldier the 'grave is scooped', the 'cross is varnished', and the culminating image successfully gives the 'mound of Golgotha' an added meaning:

> The spadesmen have been working overtime
> To raise so high a mound of Golgotha.

In 'The Two Fraternities' and 'Is there No Love can Link Us?' (both from *Shapes and Sounds*) the theme of the mysterious alien recurs, and Peake considers a topic which absorbed Wilfred

Owen: the nature of the enemy, and the comradeship in death which brings mystical communion with him.

> This hectic moment of fraternity,
> This *you* . . . this *me* . . .
> ('The Two Fraternities', *Shapes and Sounds*)

'Is there No Love can Link Us?' is written with a fine sense of energy. Life is a transitory suspension in time, erased in a moment. Before that moment it is the soldier-poet's urgent duty to capture and express the subtle relationship between himself and his dying victim.

> Is there no thread to bind us – I and he
> Who is dying now, this instant as I write . . . ?
> ('Is there No Love can Link Us?', *Shapes and Sounds*)

The attempt fails: life is too complex and its passing too swift for the poet to identify this relationship. He concludes, with honest despair, that death itself is the only common ground between himself and his enemy.

> Only this sliding
> Second we share: this desperate edge of now.

Peake's hatred of the war prompted a number of poems which he refrained from publishing in *Shapes and Sounds*, and which did not appear until they were collected in *A Reverie of Bone* in 1967.

They fall into two main groups: the sententious poems, written early in the war: 'Fort Darland', 'May 1940', and 'The Time has Come for more than Small Decisions', and the poems written after his visit to Belsen at the end of the war, 'Victims', and 'She whose Body was in Pain'.

'May 1940' is an uninhibited treatment of the Sussex landscape set in sharp contrast with the uncertainty of the future and the horror of the war. This May in Arundel and the Arun valley is compared with the same 'faint fable-month' of previous years.

> . . . rare, ungraspable, an echo
> Of other maytimes when the thought was single
> And the green hesitation of the leaf
> Was prophecy for richness with no hint
> Of darkened hours, and of being parted . . .
> ('May 1940', *A Reverie of Bone*)

The poet turns in disgust from man, who has 'defiled' God's image in which he is made, to nature: 'Be proud, slow trees. Be glad, you stones and birds. . . . Be glad you are not fashioned in God's image.'

'May 1940' is a very strong poem in a traditional mould, clear, straightforward, and rooted in a single setting. 'The Time has Come for more than Small Decisions' is more complex and in a way more rich, but certainly less clear. The poet is at war with himself, 'no less than Albion', and seeking to understand and define his own attitude to the war. Enraged by the lies of statesmen, he nevertheless respects and responds to 'man's bravery', because he has an intuition that valour is 'unnatural', and that man has to struggle to achieve courage while 'Fear, a bat between the shoulder-blades/Flaps its cold webs'. After this fine Gothic image the poem disintegrates: perhaps the problem of fear was too personal for Peake, and the emotions prompted by it too conflicting, for him to contain them within a single short lyric. In the 'head-hunting' poems energy and courage in others fascinates him (in 'Caliban', especially), but here the demand for these qualities creates a new problem. He recognises himself as a contemplative and for a contemplative man to be called to action sets up a conflict which generates flight in two directions: into the extreme romantic world of the Titus books and of the poem 'A Reverie of Bone' (see below), and into the hard forms and clipped diction of some of the best of his soldier poems. In 'Victims' and 'She whose Body was in Pain', Peake as War Artist can combine the roles of active and contemplative, since to observe was, after all, his duty in Belsen, and these poems are integrated and powerful pieces in consequence.

> . . . No silence flowered
> About them, and no bland, enormous petals
> Opened with stillness. . . .
> ('Victims', *A Reverie of Bone*)

The decorous trappings that death demands – silence, flowers, 'gentle light', 'white hands', and 'childhood's angels' – are denied these dying prisoners, the background to whose deaths is instead the 'twisting flames' of the flame-throwers burning down the infested huts of the liberated camp, and of the incinerators in which their predecessors at Belsen were slaughtered: 'In twisting flame their twisting bodies blackened.'

Peake's two longest poems, the title poem of *A Reverie of Bone* and the ballad called *The Rhyme of the Flying Bomb* were both written during the war, and present in extended form Peake's divided response to it. 'A Reverie of Bone' is a highly romantic, Gothic, inward-looking poem full of decorative material included for its own sake, while *The Rhyme of the Flying Bomb* is an objective and bare fable, written in the metre of the *Ancient Mariner*, which embodies two of Peake's leading moral impulses, his reverence for Christ and his love of children.

The first two stanzas of 'A Reverie of Bone' appear in the seventh manuscript volume of *Titus Groan* and must have been written in April or May 1942. By the end of May 1942 Peake was in the Military Hospital at Southport with a nervous breakdown and was to remain there for six months. 'A Reverie of Bone' certainly has the mood and imagery of a work which is written in full retreat from the outside world.

> I sometimes think about old tombs and weeds
> That interwreathe among the bones of Kings
> With cold and poisonous berry and black flower.
> (Stanza 1)

Like the young Keats in a fit of depression, Mervyn Peake makes a tapestry of the most sensuous and extravagant words that he can find to place between himself and the world. Bone is the subject of his reverie, but it could equally be the moon, nightingales, beautiful women, melancholy; what matters is the reverie itself.

> . . . I ponder
> On sun-lit spines and in my reverie find
> The arc-ribbed courser and his mount to be
> Whiter than sexless lilies and how slender . . .
> (Stanza 2)

Probably the original inspiration for the poem is the whalebone
that he found in Sark and kept with him for the rest of his life
but this becomes ribs of horses and men, which in turn become
the chalk-cliffs of Sussex. After meditating on these correspon-
dences the poem returns to its original image, the 'bones of Kings',
and focuses on a specific prince, the ghost of a royal horseman
whom the poem now identifies as a hero of romance. The tone is
one of luxurious indulgence in the macabre: the poet finds the
dead prince's bones beautiful, heroic, free of the encumbrances of
the flesh:

> What is more exquisite than to be free
> Of all that presses on the crying core
> Of the long bones . . .
>
> O Prince in purple you are lovelier now,
> Your bracelets, curls and lips and eyelids gone . . .
> (Stanzas 22 and 19)

This is, of course, highly extravagant and unbalanced work,
interesting more for its implications than for its quality as poetry.
It can be seen as a sustained death-joke, in which the poet sets up
an absurd proposition – death is beautiful – and then takes it
seriously, pushing the subject to a point at which it ceases to be
high romantic and becames high camp, like the Philosopher's
doctrine of death in *Gormenghast* or the doctrine of death which
Peake was to give to Muzzlehatch in *Titus Alone*.

> O passionless, amoral, unearthly whiteness
> Emptied, of ardour like a thought of crystal
> Scoring a circle in the air of time:
> Closer to darkness is this loveless lightness
> Than to the wanest breath of colour . . .
> (Stanza 30)

It is like a soap-powder advertiser's nightmare, in which a des-
perate quest for a new simile to describe ultimate whiteness reaches
its logical, if ludicrous, conclusion: whiteness is 'closer to dark-
ness' than to anything else.

The wish embodied in the poem is clear: it is a wish for death,
silence, the luxury of stillness, peace, suspended consciousness.

Perhaps he was able to find these things, for a time, in the hospital at Southport.

The Rhyme of the Flying Bomb, first written in 1944 and eventually published in 1962, when it was dedicated to Peake's youngest child, Clare, is a very much better poem than 'A Reverie of Bone'. The ballad stanza controls Peake's invention and imposes an economy of effect, cutting epithets to a minimum so that the central metaphors are allowed to make their impact cleanly, as in this image of the anthropomorphic house set dancing by the bomb's blast.

> . . . a singular song it was, for the house
> As it rattled its ribs and danced,
> Had a chorus of doors that slammed their jaws
> And a chorus of chairs that pranced.

The images of ribs and jawbones are the same as the central images of 'A Reverie of Bone', but here they are part of a tightly controlled formal pattern, not objects of luxurious meditation. A V2 rocket has landed on London, destroying the house where the child lived and leaving the baby in a 'golden drain', where a sailor finds it. The baby's nursery has been demolished, and as the wall-paper pours into the street the nursery-beasts depicted on it become animated:

> Through streets where over the window-sills
> The loose wall-papers pour
> And ripple their waters of nursery whales
> By the light of a world at war;
>
> And ripple their wastes of bulls and bears
> And their meadows of corn and hay
> In a harvest of love that was cut off short
> By the scythe of an ape at play –

The wall-paper could well be composed of Peake's own illustrations to *Rhymes without Reason*, of which the most successful is:

> There's nothing makes a Greenland Whale
> Feel half so high and mighty
> As sitting on the mantel-piece
> In Aunty Mabel's nighty.

The wallpaper stands for the whole beautiful visible world, which is now denied to the baby by the 'ape', the spirit of war. The Cockney sailor is well characterised, and the details of bomb-damaged London are beautifully caught in a series of surrealistic images.

> . . . the dazzling streets
> Are empty from end to end
> With only a cat with a splinter through the heart
> And an arm where the railings end.

In the latter part of the poem a church is destroyed by a V2, and the sailor and the baby, sheltering in the church, are destroyed with it.

At the moment of death they are granted a pause in time in which they engage in dialogue with each other. The baby, now identified with Christ, seeks to bring the sailor to a state of grace. But the sailor fears death, and the baby points out to him that he is already saved by his act of love (in seeking to rescue the baby) so that his lack of faith is no longer an impediment to grace:

> 'O sailor, saviour, you rescued me
> And I would not have you cry.
> If you have no Faith yet your act was Love,
> The greatest of the three.'

The moment of death is expressed in a complex system of symbols. The flying bomb is itself the cross, the instrument both of torture and of transfiguration, the flesh and blood of the baby flowing over the sailor, who thus takes his first sacrament. A dead horse, buried by the ruined church, rises and approaches the sailor and the child:

> The crash of its hooves on the hollow stones
> Was like the gongs of God.

Like one of the horsemen of the Apocalypse, it announces the presence of death, but simultaneously by its own example demonstrates the truth of resurrection.

4. Love poems

Like his war poems, Peake's love poems come in two kinds:
those which are focused, specific, objective, stimulated by a single
object or event, and those which are somewhat inward-looking
and self-regarding. These latter tend to be slight lyrics like 'In the
Fabric of this Love', which appears in *A Reverie of Bone*, or the
early poem 'To Maeve', which first appeared in Walter de la
Mare's anthology, *Love*. This poem is a graceful treatment of
a metaphor but has little to do with the girl who is observed,
since the fragile image of 'the slender gazelle' usurps the poet's
interest:

> You walk unaware
> Of the slender gazelle
> That moves as you move
> And is one with the limbs
> That you have . . .

The group of love poems published in *The Glassblowers* tend to
be more mature than this, and communicate successfully a sense
of springing from an actual relationship: 'Oh, this Estrangement
Forms a Distance Vaster', 'Love, I had Thought it Rocklike',
'And are You then Love's Spokesmen in the Bone?', 'My Arms
are Rivers Heavy with Raw Flood', and 'Grottoed beneath your
Ribs our Babe Lay Thriving'. The last two poems, inspired by
pregnancy and the birth of a child, are particularly attractive and
convey a rich sense of truthfulness to experience. 'Grottoed
beneath Your Ribs . . .' successfully combines Peake's interest in
the way the body is constructed and the articulation of the skeleton
with his taste for linguistic extravagance and his sense of awe in
the presence of new life:

> Grottoed beneath your ribs our babe lay thriving
> On the wild saps of Eden's midnight garden . . .

The child descends in the womb as the moment of birth
approaches:

> Grottoed beneath your ribs, our babe no more
> May hear the tolling of your sultry gong
> Above him where the echoes throb and throng
> Among the breathing rafters of sweet bone . . .

The child moves out of reach of the mother's heart-beats, the 'sultry gong', and the mother's body becomes a house with 'breathing rafters' which the child prepares to leave on its first adventure (like Titus leaving Gormenghast). As the waters begin to break the child is seen as a land mass separating from its parent continent at the creation of the world 'Like Madagascar broken from its mother', an image recalling the Renaissance use of the globe of the world to illustrate the nature of man. Man and the universe being in harmony, the child is born as the sun rises, and the new life begins simultaneously with the new day:

> Grottoed no longer, babe, the brilliant daybreak
> Flares heavenward in a swathe of diamond light.

Another successful use of the earth to illustrate events in man's life appears in the poem 'Tides', from *A Reverie of Bone*. This is a mystical poem as well as a love poem. The woman is a mysterious creature like a placid island beset by the violence of the sea and the pressure of volcanic forces within 'Torrents that course beneath your gentle clay'. At once intimate and strange, the woman presents a teasing problem. Through his love-making the speaker feels that he understands what drives her, because he has taken the measure of her heart-beats: 'For I have heard the drum-throbs momently/Quicken with mine.' But this familiarity is denied by 'a remoteness' which 'Lingers/About you like a vestment of the moon'. Through her mysteriousness the woman becomes goddess-like, and the poet willingly accepts that it is his life's task to learn to understand her. The last stanza addresses her in a tone of prayer: 'Lady I become/Each day, each hour of this little journey/We make together, less alone.' Like a Byzantine image of the Virgin, the beloved is an exalted and inscrutable figure which the lover will perceive clearly only when he has reached the end of his journey or arrived at a state of grace.

5. Mystical poems

Peake is not afraid of the emotional expression of religious feelings and the reverence for his beloved in 'Tides' spills over easily into a reverence for all life. The poems on the nature of the artist and the war poems embody a mystical element, and it is a

short step from these to the poems celebrating nature's abundance and God's munificence such as 'Thunder the Christ of it', 'When God Pared his Fingernails', and the remarkable poem 'Dead Rat', all of which appear in *A Reverie of Bone*.

'Dead Rat', is the product of a walk over Burpham Down from his father's country home. The rat, 'flowered with frost' after a winter's night, mutely pleads its right to be regarded with dignity. Like a Christian martyr prepared for burial, the rat has 'Little forepaws so beseechingly/Crossed on your breast'. A delight in the created universe invests the dead rat with beauty, and questions all the conventional responses: 'Were I a farmer I would call you vermin.' The poem is particularly successful because it is simultaneously rooted in a specific object and giving expression to a mystical idea. The farmer who sees the rat as the 'villain of my crops' who 'gnaws my wealth' contrasts with the poet who perceives 'beauty in your body', and 'beauty in your little hands'. Setting, time and season are all specified, and the thesis of the poem is unforced but irresistible: 'Rats even have a right to live.' The language is spare and specific with a high nominal content, and the tone remains neutral and understated: the total impact is of a poem of great maturity and control.

The poem 'When God Pared his Fingernails' was written early, probably before the war, and some lines from it appear in the manuscript of *Titus Groan* at the point of Peake's remarkable experiment with the perception of darkness which accompanies Steerpike's climb over the rooftops in Chapter 19, 'Over the Roofscape'. The 'fingernail' is one of the images that Peake uses to describe the appearance of the moon in a discarded early draft of Steerpike's solitary vigil, and it finds its place as an organising image in this powerful short poem:

> When God had pared his fingernails
> He found that only nine
> Lay on that golden tablet
> Where the silver curves recline . . .
>
> ('When God Pared his Fingernails', *A Reverie of Bone*)

The nine nails form the glow on the horizon of God's created world, but the tenth nail, the 'nail of sin', has escaped: 'I saw it running through cold skies.' The new moon is the eternal rebel, the

individualist, 'fierce and thin', alone above the created world which is bound by the other parings in a cloak of light derived from God's 'hands of cloud'. In this tiny poem of only twelve lines the relationship between the moon and the other nine nails which 'gleam in one long line' has to be worked for, but it forms a coherent pattern of significance: the created world is obedient to God's will, the vagrant moon has sought to escape him and is condemned to circulate, dependent but alone, as a symbol of the isolation and sterility which man brings on himself by sin.

Peake was alive to the absurdity of barriers between Christians, and he expresses his indignation in a simple poem deploring the 'insolence', 'ignorance', 'intolerance' and 'bitterness' of sectarianism.

> How foreign to the spirit's early beauty
> And to the amoral integrity of the mind
> And to all those whose reserve of living is lovely
> Are the tired creeds that can be so unkind.
>> ('How Foreign to the Spirit's Early Beauty', *A Reverie of Bone*)

The 'amoral integrity', the faith in a notion of love which is free from all moral laws, is an important element in his attitude to Christianity and prevents him from making a full commitment to any one 'coven' of Christians: 'For love rang out before the chapel bell.' His religion is rooted in a veneration for life which recognises Christ as a heroic and tortured human being, and as an immortally wise infant, but which delights in the beauty of the created world as a more direct mode of worship: he is a natural pantheist.

His pantheism takes the form of a sense of heightened life in the poem 'To Live at all is Miracle Enough', in which the poet in wartime takes his own continued being as evidence of a Divine providence in the natural world.

> Nor greed nor fear can tear our faith apart
> When every heart-beat hammers out the proof.
>> ('To Live at all is Miracle Enough', *The Glass-blowers*)

Here the earth has been 'swung out of sunlight into cosmic shade' by the wicked destructiveness of the war in which Peake found

himself, but his own identity and the truth of his imagination deny
the war, reducing the strength of the machines to 'a beetle's
wings'.

6. Romantic poems

The elements in Peake's more objective poems, the figures of the
spiv, the beloved woman, the bleak wartime landscapes, form a
boundary of objective perception on the outer aspect of his mind,
and the mystical and romantic poems take place well within that
boundary. Some of his romantic poems break down altogether
this division between the outward-looking and the inward-looking
poetry and show a synthesis of the objective and subjective aspects
of his talent: a synthesis achieved by meditation on romantic
symbols which are sympathetic to his temperament, as though he
had refined away the content of his imagination to isolate the
elements of major importance to him as an artist.

Like Blake he is fascinated by the power of the tiger, like Yeats
he is enchanted by the grace of the swan, and in *The Rhyme of
the Flying Bomb* and other poems he finds in the horse a metaphor
of virility and nobility. The poem 'Swans Die and a Tower Falls'
is redolent of Yeats throughout, and binds characteristic Yeatsian
images into a successful pattern. The swan and the tower are
familiar Yeatsian symbols for the soul and the aspiration of man,
but here they seem to be transmuted into simpler images of the
female and the male principles, which are perishing with the
passage of time.

> Swans die, and a tower falls,
> And our cities hear cold bells
> Toll the nepenthe
> Of earth, air, and sea,
> Flesh, fish and bird,
> Morality and amorality,
> Ploughshare and sword . . .
>> ('Swans Die and a Tower Falls', *The Glass-
>> blowers*)

The cadences recall Yeats's 'Sailing to Byzantium' and some of the
imagery seems drawn directly from that poem: compare 'Fish,
flesh and fowl, commend all summer long' and Peake's 'earth,
air, and sea,/Flesh and bird'.

It is a regretful poem with a *fin de siècle* flavour of dry-eyed acceptance of mortality, ending with a pagan injunction to live and be merry.

> Then laugh! and laugh again
> Before the end
> Of our fleet span, sweet friend! . . .

The end of civilisation has arrived. 'Light crumbles in lost halls', and no Christian promise of an after-life is offered in extenuation; only the present exists, and it is the duty of man to dance among the ruins while a little time is still left.

One of his purest poems of the imagination is a strange lyric which creates and withdraws three fanciful images: equestrian 'tiger-men', centaurs, and a man with antlers whose death-cry is heard 'through a blood-dark dawn' at the end. No contexts are given and no explanations are offered: the effect is of three instantaneous visions of mystical beings from an incalculable past who are glimpsed for a single moment:

> When tiger-men sat their mercurial coursers,
> Hauled into shuddering arches the proud fibre
> Of head and throat, sank spurs, and trod on air –
> I was not there . . .
> ('When Tiger-Men Sat their Mercurial Coursers', *The Glassblowers*)

The poem has just three stanzas, the second and third following precisely the metre of the first (quoted above), and the concluding line 'I was not there' closes the poem and denies any further inquiry into the images: they may well have some significance, but since the poet himself 'was not there' he cannot be expected to explain. Stanzas 1 and 2 both deal with horses, the tiger-men's mounts and the centaurs who 'thundered to the rain-pools,/Shattered with their fierce hooves the silent mirrors' (Stanza 2). The surging lines and the vigorous vocabulary give one a vivid sense of the identity of these creatures, straining, violent, the '*shuddering* arches' and '*proud* fibres' of the tiger-man's courses receiving special emphasis, while the bearded centaurs of Stanza 2 are 'clamorous', and fierce, and 'thunder' and 'shatter' are the verbs which express their actions. The antlered man in Stanza 3 is significantly different from these horse-like creatures. They

are positive and energetic, while his role is one of passive suffering.

> . . . through a blood-dark dawn a man with antlers
> Cried, and throughout the day the echoes suffered
> His agony and died in evening air –

A parallel with the crucified Christ obviously suggests itself, but the poet does not allow the parallel to be a precise one: it is not the antlered man who suffers and dies, but 'the echoes' which reverberate his single cry at dawn. The phrase 'evening air' gives a wonderful sense of relief after the 'agony' which the antlered man has undergone, since the 'blood-dark dawn', but again it is the echoes, not the man, which have 'suffered his agony', and which are relieved by death at the end of the day.

Possibly the poem expresses a contrast between the ancient religions, which were heroic, amoral, rooted in an admiration for strength and virility (the qualities of the horse and the tiger), and the Christian religion, based on the torture of a mortal man. But whether this is the subject of the poem or not is deliberately left open; the poem seems designed to lodge in the mind, and feed the imagination without allowing an easy analysis of the sense. It is a beautifully composed and balanced piece, and a triumphant product of Peake's purified technique in his shorter lyrics. Other poems in the same volume, *The Glassblowers*, notably 'All Eden was then Girdled by my Arms', 'With People, so with Trees', and 'Absent from You, where is there Corn and Wine?' display the same technical maturity: a capacity for evoking mystery by expressing startling, and often beautiful but puzzling images in a very precise verse form.

It was a happy accident for his work as a poet that Peake was sent to Birmingham by the War Artists Commission to make drawings of the process of making a television tube. The stimuli for all his romantic poetry other than 'The Glassblowers' itself are, even at their best, derivative. The horses, swans, eagles, and mysterious and mythical beasts that animate his poems are made his own, but they obviously belong to an established body of romantic imagery in literature and painting. English romantic writers are not characteristically stimulated by urban or industrial subjects (one may cite Wordsworth's 'View from Westminster Bridge' and Richard le Gallienne's 'Iron Lilies of the Strand' as

honourable exceptions which nevertheless go to prove the rule), and it is arguable that this divorce from the leading features of ordinary life has been a major limiting factor in all romantic art in England from Blake to the present. Peake is a good poet, but most of his work is undeniably good second-rate: the work of an enthusiast who has read widely and enjoys imitating what he likes. 'The Glassblowers' brings all the resources of his considerable technique as a poet, with his rich linguistic inventiveness and his capacity for startling visual effect, to bear on an entirely original subject.

> Here, in this theatre of fitful light,
> The dancers cast their long and leaping shades,
> Their heavy feet thud on the firelit stage,
> For they are dancers of the arm and hand,
> The finger-tips, the throat and weaving shoulders:
> Between the head and feet a rhythm of clay,
> A rhythm of breath is wheedling alchemy
> From the warlock sand.
> ('The Glassblowers', *The Glassblowers*)

Characteristic Peake words are here: 'alchemy', 'warlock', 'rhythm of clay', 'fitful light', each fitting perfectly into place in his treatment of an industrial subject. His draftsman's fascination with the way in which the body is articulated gives him his perception of the glassblowers' 'finger-tips . . . throat and weaving shoulders', and the glass tube becomes 'warlock sand', a magician's wand. Peake is unabashed in his delight in the glassblowers' workshop and his discovery that it is like a magical cave:

> O factory fantastic! Cave on cave
> Of crumbling brick where shackled lions rave
> And howl for gravel while their blinding manes
> Shake radiance across the restless gloom.

Again, the violence of a noble animal, the simple delight in alliteration and the use of richly evocative language ('radiance', 'crumbling', 'gloom') are constant elements in his poetry which find appropriate use here. The quest for a simile for the molten glass results in a series of dazzling images, 'throbbing fire-globes',

'ripe chameleon pears', 'a breast or a tongue or a serpent', leading to this climactic example of delight in sheer visual effect:

> See, it is spinning through the shadowland
> Shaped like a sphere or giant worm of flame,
> A slug of light, a snake, or fruit of air . . .

In some of the 'head-hunting' poems Peake makes effective use of an urban setting, but in this poem he manages a unique synthesis of the instinctive sensuality of the neo-romantic poet that he was with a rich expression of a fragment of the everyday world. This balance between his inner and his outer vision is never again so completely achieved in poetry or prose.

Bibliography

Place of publication is London unless otherwise given.

1 Works by Mervyn Peake

A. Longer prose fiction (in chronological order)
Titus Groan, Eyre and Spottiswoode, 1946 (Penguin, 1968)
Gormenghast, Eyre and Spottiswoode, 1950 (Penguin, 1969)
Mr Pye, Heinemann, 1953 (Penguin, 1972)
'Boy in Darkness' in *Sometime, Never*, Eyre and Spottiswoode, 1956 (Three stories by Mervyn Peake, John Wyndham and William Golding)
Titus Alone, Eyre and Spottiswoode, 1959 (Revised and enlarged, Eyre and Spottiswoode and Penguin, 1970)

B. Other original works (in alphabetical order)
A Book of Nonsense, Peter Owen, 1972 (Posthumous nonsense rhymes, drawings and a prose piece)
Captain Slaughterboard Drops Anchor, Country Life, 1939
The Craft of the Lead Pencil, Wingate, 1946
Drawings by Mervyn Peake, Grey Walls Press, 1949
Figures of Speech, Gollancz, 1954
The Glassblowers, Eyre and Spottiswoode, 1950 (Poems)
Letters from a Lost Uncle from Polar Regions, Eyre and Spottiswoode, 1948
Poems and Drawings, Keepsake Press, 1965 (Limited edition)
A Reverie of Bone: and Other Poems, Rota, 1967 (Limited edition)
Rhymes without Reason, Eyre and Spottiswoode, 1944
The Rhyme of the Flying Bomb, Dent, 1962
Ride a Cockhorse and Other Nursery Rhymes, Chatto and Windus, 1940
Selected Poems, Faber, 1972

Bibliography

Shapes and Sounds, Chatto and Windus, 1940 (Poems)

C. Contributions to periodicals and collections

'What is Drawing?' (With a drawing: 'A Head'), *Athena* VIII (April 1957), p. 21

'The Glassblowers' (Prose predecessor of the poem), *Convoy* IV (July 1946), pp. 23–7

'The Weird Journey' (Prose piece), *Harvest* I (1948), pp. 58–61

Drawing ('Chinese Girl'), *International Stage and Film Review* (February 1962), p. 27

Belsen Drawings, *The Leader* (30 July 1945)

'The Connoisseurs', *Lilliput* XXVI (January 1950), pp. 58–9

'Four Nursery Rhymes' (Poems from *Ride a Cockhorse* with new illustrations), *Lilliput* XXVI (May 1950), pp. 36–41

Drawings in the *London Mercury*:

London Mercury XXXIV (May – October 1936). Portraits of Edith Evans (p. 402), Ernst Toller (p. 494). Designs for *The Insect Play* (p. 342)

——————————— XXXV (November 1936 – April 1937). Portraits of Walter de la Mare (p. 165), W. H. Auden (p. 385). Imaginative drawing (p. 409)

——————————— XXXVI (May – October 1937). Portraits of George Barker (p. 124), Ruth Pitter (p. 237)

——————————— XXXVII (October 1937 – May 1938). Portraits of John Gielgud (p. 12), Margot Fonteyn (p. 157)

——————————— XXXVIII (May – October 1938). Portraits of James Stephens (p. 61), Sarah Gertrude Millin (p. 240), Charles Madge (p. 404)

———————————XXXIX (October 1938 – May 1939). Portraits of Lawrence Binyon (p. 12), Elizabeth Bowen (p. 112), C. Delisle Burns (p. 305), James Bridie (p. 584). Two female nudes (p. 505)

'Caliban' (Poem collected in *The Glassblowers*), *New English Review Magazine* 1 (September 1948), p. 48

'As a Great Town Draws the Eccentrics in' (Poem collected in *The Glassblowers*), *The New English Review Magazine* III (July 1949), p. 42

'How a Romantic Novel was Evolved' (with reference to *Titus Groan*), *A New Romantic Anthology*, (ed.) Stefan Schimanski and Henry Treece, Grey Walls Press, 1949

'All Eden was then Girdled in my Arms' (Poem collected in *The Glassblowers*), *Phoenix* (Autumn 1946), p. 19

'Drawings for the *Ancient Mariner*' (Eight drawings), *Poetry London* x (December 1944), pp. 196–204

'Same Time, Same Place' (Short story), *Science Fantasy* XX (1963), pp. 57–65

'Danse Macabre' (Short story), *Science Fantasy* XXI (1963), pp. 46–55

'The Enforced Return'; 'If the Earth were Lamp-lit' (Poems collected in *The Glassblowers* as 'The Vastest Things are those We may not Learn' and 'Poem', 'It is at times of half-light', respectively), *Strand* CXII (November 1946), p. 58

'An Ugly Crow Sits Hunched on Jackson's Heart' (Poem collected in *The Glassblowers*), *The Wind and the Rain* v (Autumn 1948), p. 95

Cartoon (Patriotic treatment of a young soldier), *World Review* (August 1940), p. 2

'London Fantasy' (Prose piece), *World Review* (August 1949), pp. 55–9

D. Unpublished works

Broadcast material:

'Alice and Tenniel and Me', Talk for Radio, 12 December 1954

'As I see It – The Artist's World', Talk for Radio, Pacific Service, 26 May 1947
'As I See It – Book Illustrations', Talk for Radio, Pacific Service, 22 September 1947
'For Mr Pye – An Island', Play for Radio (Adaptation of *Mr Pye*), 10 July 1957
'The Rhyme of the Flying Bomb' (Reading of the published poem), 26 August 1964
'Titus Groan' (Adaptation of *Titus Groan* and *Gormenghast*), 1 February 1956
'Titus Groan – The Reader Takes Over' (Discussion of *Titus Groan* between Peake and a panel of critics), 20 June 1947
'The Voice of One', Play for Radio, 18 December 1956

Unpublished plays for the stage:
The Connoisseurs (One act). Amateur performance, 1952, Smarden
Mr Loftus. Not performed
Noah's Ark. Not performed
In the Cave. Not performed
The Wit to Woo. Performed 1957, Arts Theatre Club

Other unpublished works:
The Great White Chief of the Umzimbubu Kaffirs (Juvenile)
Nonsense Rhymes (*The Moccus Book*)
The Touch of the Ash (Narrative poem)

E. Illustrations to works by other writers, including selected contributions to periodicals
Austin, Peter, *The Wonderful Life of Tom Thumb*, vols. I and II, Stockholm, Radio Sweden, 1954/5
Balzac, Honoré de, *Droll Stories*, Folio Society, 1961
Carrol, Lewis, *Alice's Adventures in Wonderland* and *Through the Looking-Glass*, Wingate, 1954
———————————, *The Hunting of the Snark*, Chatto and Windus, 1941
Collis, Maurice, 'The Extremities of Celestial Piety', *Harvest* I (1948), pp. 21–8
———————————, *Quest for Sita*, Faber, 1946
Coleridge, Samuel, *The Rime of the Ancient Mariner*, Chatto and Windus, 1943
Crisp, Quentin, *All This and Bevin Too*, Nicolson and Watson, 1943
Drake, H. Burgess, *The Book of Lyonne*, Falcon Press, 1952
———————————, *Oxford English Course for Secondary Schools*, vol. I, O.U.P., 1957
———————————, 'Yak Mool San', *London Mystery Magazine* I, (June 1949), pp.25–35
Fay, Gerard, 'The Man who Returned to Dublin', *World Review* (August 1948), pp. 54–6
Grimm, J. and W., *Household Tales*, Eyre and Spottiswoode, 1949
Haynes, D. K., *Thou Shalt Not Suffer a Witch*, Methuen, 1949
Hole, Christina, *Witchcraft in England*, Batsford, 1945
Joad, C. E. M., *The Adventures of the Young Soldier in Search of a Better World*, Faber, 1943
Judah, Aaron, *The Pot of Gold: and Two Other Tales*, Faber, 1959
Laing, A. M., *Prayers and Graces*, Gollancz, 1944
———————————, *More Prayers and Graces*, Gollancz, 1957
Palmer, E. Clepham, *The Young Blackbird*, Wingate, 1953
Sander, A., *Men: A Dialogue Between Women*, Cresset Press, 1955
Stevenson, R. L., *Dr Jekyll and Mr Hyde*, Folio Society, 1948
———————————, *Treasure Island*, Eyre and Spottiswoode, 1949

Wykes, Alan, 'Three Gifts', *Strand* CXII (December 1946), pp. 82–7, 103
————, 'At the Lantern', *Strand* CXII (March 1947), pp. 100–5, 107
Wyss, J. D., *The Swiss Family Robinson*, Heirloom Library, 1950

2. Secondary sources, including items in periodicals (selected)

'Brodie', 'First Impressions of Literary People: Mervyn Peake and the Fantasies of an Extremely Lively Imagination', *Books of Today* (New Series) 1 (January 1946), p. 5
Brogan, Hugh, 'The Gutters of Gormenghast', *The Cambridge Review* (23 November 1973), pp. 38–42
Brophy, John, *The Face in Western Art*, Harrap, 1963
————, *The Human Face*, Harrap, 1945
————, *The Human Face Reconsidered*, Harrap, 1962
Burgess, Anthony, Introduction to Penguin edition of *Titus Groan*, Penguin, 1968
————, 'The Price of Gormenghast', *Spectator* (20 June 1970), pp. 819–21
Collis, Maurice, *The Journey Up: 1934–68*, Faber, 1970
Crisp, Quentin, 'The Genius of Mervyn Peake', *Facet* 1 (1946), pp. 8–13
————, *The Naked Civil Servant*, Jonathan Cape, 1968
Denvir, Bernard, 'Mervyn Peake', *Studio* CXXXII (July 1946), pp. 88–90
Gilmore, Maeve (Mrs Maeve Peake), 'Profile of Mervyn Peake', *Folio* (January–March 1961), pp. 8–11
————, Preface to a *A Book of Nonsense* (q.v.)
————, Preface to Catalogue for the Exhibition, *Mervyn Peake: Word and Image*, The National Book League, January 1972
————, *A World Away: A Memoir of Mervyn Peake*, Gollancz, 1970
Hamilton, Alex, 'Mervyn Alone', *Guardian* (5 January 1972), p. 8
Hassall, Christopher, *Ambrosia and Small Beer: The Record of a Correspondence between Edward March and Christopher Hassall*, Longmans, 1964
Lloyd, A. L., 'An Artist Makes a Living', *Picture Post* (21 December 1946), pp.22–4
Moorcock, Michael, 'Architect of the Extraordinary', *Vector 9* (June 1960), pp. 16–19
Morgan, Edwin, 'The Walls of Gormenghast: An Introduction to the Novels of Mervyn Peake', *Chicago Review* XIV (Autumn–Winter 1960), pp. 82–92
Tube, Henry, 'Mervyn Peake', *Spectator* (15 July 1966), p. 81
Witting, Clifford, *The Glory of the Sons: A History of Eltham College*, Eltham College, 1952
Wood, Michael, 'Gormenghast', *The Cambridge Review* (23 May 1964), pp. 440–3

Index

Works by Mervyn Peake, and books illustrated by him, are listed under 'Peake, Mervyn'. Fictional names and places are given in inverted commas. The following abbreviations have been used:

TG: Titus Groan
G: Gormenghast
TA: Titus Alone
P: Mr Pye
C: The Connoisseurs
W: The Wit to Woo
CS: Captain Slaughterboard Drops Anchor

171

Index

174

Index